THE ARTISTS IN PERSPECTIVE SERIES

H. W. Janson, general editor

The ARTISTS IN PERSPECTIVE *series presents individual illustrated volumes of interpretive essays on the most significant painters, sculptors, architects, and genres of world art.*

Each volume provides an understanding of art and artists through both esthetic and cultural evaluations.

BOGOMILA WELSH-OVCHAROV is a doctoral candidate in art history at the University of Utrecht. She is author of *The Early Work of Charles Angrand and His Contact with Vincent van Gogh.*

VAN GOGH

in Perspective

VAN GOGH
in Perspective

Edited by
BOGOMILA WELSH-OVCHAROV

A SPECTRUM BOOK

Prentice-Hall, Inc., Englewood Cliffs, New Jersey

Library of Congress Cataloging in Publication Data

WELSH-OVCHAROV, BOGOMILA, comp.
Van Gogh in perspective.

(Artists in perspective series) (A Spectrum Book)
Bibliography: p.
1. Gogh, Vincent van, 1853–1890. I. Title.
ND653.G7W42 1974 759.9492 73–19718
ISBN 0–13–940437–6
ISBN 0–13–940429–5 (pbk.)

Cover: *A Bugler of the Zouave Regiment*,
Amsterdam, Rijksmuseum Vincent van Gogh

EDITOR'S NOTE:
Except where otherwise noted, all translations of,
footnotes to, and insertions within the various
authors' texts have been supplied by the editor.

© 1974 BY PRENTICE-HALL, INC.
ENGLEWOOD CLIFFS, NEW JERSEY

A SPECTRUM BOOK

1 2 3 4 5 6 7 8 9 10

Printed in the United States of America

PRENTICE-HALL INTERNATIONAL, INC. (LONDON)
PRENTICE-HALL OF AUSTRALIA, PTY. LTD. (SYDNEY)
PRENTICE-HALL OF CANADA, LTD. (TORONTO)
PRENTICE-HALL OF INDIA PRIVATE LIMITED (NEW DELHI)
PRENTICE-HALL OF JAPAN, INC. (TOKYO)

CONTENTS

Acknowledgments / Key to Abbreviations *xi*

INTRODUCTION 1
Bogomila Welsh-Ovcharov

PART ONE / **Personal Reminiscences
and Early Critical Appraisals**

Vincent in Dordrecht (1877)* *16*
P. C. Görlitz

Vincent in Amsterdam (1877–78)* *19*
M. B. Mendes da Costa

Vincent in Cuesmes, the Borinage (1880)* *22*
Gustave Delsaut

Vincent in Nuenen, North Brabant (1884–85)* *24*
Anton C. Kerssemakers

Vincent in Antwerp (1886)* *27*
Victor Hageman

* In the starred items dates refer to a period in Vincent's life; elsewhere they denote
the selection's original year of publication.

Vincent van Gogh (1886–87)* *29*
 A. S. Hartrick

Vincent van Gogh (1886–87)* *33*
 François Gauzi

Artists' Impressions of Vincent in Paris (1886–87)* *35*
 Valadon, Pissarro, and Signac

Emile Bernard on Vincent (1886–87)* *37*
 Emile Bernard

Gauguin on Vincent (1888)* *42*
 Paul Gauguin

A Reminiscence by Vincent's Sister-in-Law (1890)* *50*
 Johanna van Gogh-Bonger

Early Review Notices (1888–91) *52*
 Several art critics

Vincent, an Isolated Artist (1890) *55*
 Albert Aurier

Vincent as Colorist (1890) *58*
 Frederik van Eeden

The Man Transcends the Artist (1891) *61*
 Johan de Meester

Style as Affirmation of a Personality (1891) *65*
 Octave Mirbeau

Vincent's Paintings at the Bernheim Jeune Gallery (1901) *68*
 Julien Leclercq

Vincent and Socialism (1906) *72*
 Julius Meir-Graefe

Vincent and Gauguin as Classicists (1909) *78*
 Maurice Denis

Introductory Appreciations (1911) *81*
 H. P. Bremmer

Vincent and Impressionism (1911) *88*
 Pierre Godet

Vincent van Gogh (1923) *92*
 Roger Fry

A Singular Nomad in France (1928) *96*
 Henri Focillon

Van Gogh and Schizophrenia (1922) *99*
 Karl Jaspers

Van Gogh as an Epileptic (1932) *102*
 Francoise Minkowska

A Review of Psychiatric Opinion (1937) *105*
 Sven Hedenberg

Vincent as a Psychopath (1941) *110*
 Gerard Kraus

PART TWO / Recent Iconographic and Stylistic Studies

The Popularity of van Gogh (1953) *114*
 Fritz Novotny

Van Gogh's Symbolism (1965) *121*
 Jan Bialostocki

Literary Inspiration in van Gogh (1950) *126*
 Jean Seznec

Van Gogh and Color Theory (1961) *134* -
 Kurt Badt

The Potato Eaters (1942) *137*
 J. G. van Gelder

Van Gogh's Relationship with Signac (1962) *142*
 A. M. Hammacher

The Yellow House (1953) *149*
 Douglas Cooper

On van Gogh's Copies (1943) *156*
 Carl Nordenfalk

On a Painting of van Gogh:
 Crows in the Wheatfield (1946) *159*
 Meyer Schapiro

 Biographical Data *169*

 Notes on the Editor
 and Contributors *171*

 Selected Bibliography *177*

ACKNOWLEDGMENTS / KEY TO ABBREVIATIONS

For substantially facilitating my research, I should like to thank the following persons: Professor J. G. van Gelder, Dr. V. W. van Gogh, Miss Gera Hartog, and Mr. J. Storm van Leeuwen. In addition, I am grateful to the staffs of the modern art sections at the Rijksbureau voor Kunsthistorische Documentatie, The Hague, and at the Musées Royaux des Beaux-Arts de Belgique, Brussels.

The seasoned advice of the series editor is also very much appreciated. Above all, I wish to thank my husband for sacrificing much time and effort in various editorial tasks.

Complete Letters	=	*The Complete Letters of Vincent Van Gogh*, 3 vols. (Greenwich, Conn.: New York Graphic Society, 1958).
De la Faille	=	J.-B. de la Faille, *The Works of Vincent van Gogh* (Amsterdam: Meulenhoff International, 1970).
F ____/H ____.	=	The numbering for works by Vincent as found in the *catalogue raisonné* listed immediately above. The *F* refers to the original edition of this catalogue (published in Paris and Brussels: Van Oest, 1929); and the *H* to the edition (published in Paris and New York: Hyperion Press, 1929), in which only the paintings were included.
Letter/Letters	=	The standard numbering of Vincent's correspondence, irrespective of place or date of publication.
Rewald	=	John Rewald, *Post-Impressionism from Van Gogh to Gauguin*, 2d ed. (New York: The Museum of Modern Art, 1962).

VAN GOGH

in Perspective

INTRODUCTION

Bogomila Welsh-Ovcharov

The place of Vincent van Gogh in the select pantheon of founding fathers of modern painting has long been assured. Admittedly, for the English-speaking world this became evident only with the popular success of Irving Stone's novel about the painter—*Lust for Life,* published in 1934 [1] —and with the favorable public reaction to the exhibition of 127 works by van Gogh at the Museum of Modern Art in New York in 1935.[2] Yet, as argued brilliantly by Fritz Novotny (in his article included in this volume), van Gogh's hard-won popularity transcends mere curiosity about "the painter who cut off his ear." A knowledge of his work has become one of the prerequisites of a sound general education in the liberal arts. The widespread public interest in special van Gogh exhibitions and in the great permanent collections of his work in Amsterdam and at the Kröller-Müller Museum in Otterlo, the Netherlands,[3] promises to continue unabated. In short, the plateau of esteem which Vincent's reputation has enjoyed in recent years appears to have secured his position among the very greatest artists of Western civilization.

Continued esteem does not, however, guarantee a sound understanding of his work. As every serious student of Vincent's art knows, the history of van Gogh studies is replete with disagreement and controversy. The stylistic origins of his art have been no less widely debated than has the relative importance of his various artistic periods; also, the

[1] *Lust for Life: A Novel of Vincent van Gogh* (New York: Longmans-Green, 1934).

[2] See A. H. Barr, Jr., *Vincent van Gogh* (New York: The Museum of Modern Art, 1935; reprint ed., Arno Press, 1966).

[3] The approximately 650 works by Vincent now at the Rijksmuseum Vincent van Gogh were housed, from 1931 to 1973, at the Stedelijk Museum, also in Amsterdam. The museum at Otterlo was opened in 1938 and now owns approximately 250 works by Vincent, most of which were available for public viewing in the Kröller-Müller residence in The Hague by the early 1920s.

nature and significance of his "madness" has provided only one focus, among many, for discussions about the relationship of his life to his *oeuvre*. Since the present collection of writings is intended to contribute to the clarification of these and other related problems, it includes the greatest possible variety of critical approaches. Reminiscences by personal acquaintances have been balanced by the accounts of more disinterested writers. Studies of style have not been allowed to outweigh discussions of iconography and content. Finally, an effort has been made to include, in addition to art historical investigations, contributions from such fields as psychiatry and aesthetics. Except for required annotations on questions of fact and references to related materials, differences in points of view among the authors have been presented without comment for independent evaluation by the reader.

The published correspondence of Vincent van Gogh is certain to remain the primary and indispensable source of documentation for both the thought and the work of this artist.[4] As has often been noted, these volumes of letters bear comparison with the novels of Dostoevsky, forming a similarly majestic body of confessional literature. The frequent references to the letters in virtually all writing on van Gogh should in themselves lead the interested reader to investigate this fascinating body of documentation. Yet there are problems. For art historians in particular the lack of a substantial number of letters written in 1886 and 1887, when Vincent and his brother Theodore (1857–91) were living together in Paris, constitutes a serious gap in the record. It was during this critical two-year period that Vincent experienced directly the gradual emergence of the neo-Impressionist and Symbolist movements in art and forged the component elements of his own mature style of the subsequent Arles, St. Rémy, and Auvers periods. In order to close this gap somewhat, almost all surviving firsthand accounts of Vincent while he was in Paris have been included in this anthology, along with a number of the equally rare eyewitness accounts from other periods. Section I, therefore, commences with personal reminiscences about a painter whose striking behavior invariably made an indelible impression upon his friends and acquaintances.

The publication history of the extant letters must also be considered if one is to appraise fairly the further source literature about van Gogh which has appeared over the years. During the period 1893–95 and again in 1897 the painter Emile Bernard published in the *Mercure de France* (an influential Paris art journal) extracts both from the twenty-one letters he had received from Vincent and from a limited selection of Vincent's letters to Theo. He again published Vincent's let-

[4] E.g., the *Complete Letters*, or the four-volume *Verzamelde Brieven van Vincent van Gogh* (Amsterdam: Wereld-Bibliotheek, 1955), in the original languages.

ters to him in book form in the so-called Vollard edition of 1911.[5] Only in 1914, however, did Theo's widow, Johanna van Gogh-Bonger, succeed in having the more than six hundred surviving letters from Vincent to Theo published in full.[6] Moreover, although virtually all of Vincent's letters from the Arles and later periods were written in French, the earlier letters from the Netherlands and Mrs. Van Gogh-Bonger's important biographical introduction were written in Dutch, thus presenting a formidable barrier to students of van Gogh not familiar with that language. Scholars able to read German had an advantage, however, for the year 1914 also witnessed the appearance of a full translation of this publication into German.[7] Significantly, except for a limited selection,[8] an English translation of the letters did not appear until 1927–29.[9] This irregular history of publication helps to account for the preponderant interest in all phases of Vincent's career which was manifested relatively early in German-speaking areas, the striking disinterest of the French in his Dutch periods, and the late entry of the English-speaking countries into the serious study of Vincent's whole career. Of course, these phenomena are as much a reflection of national bias in art as they are the result of the availability of published information, which in turn depends on the "felt need" of the reading public. Nonetheless, the publication history of the letters enables us better to evaluate the relative quantity and quality of information upon which individual authors have based their writings about Vincent.

Although the letters comprise the most basic and detailed record of Vincent's activities, their augmented and integrated publication following World War II [10] has by no means led to general agreement about the meaning of the life or the work of Vincent. After all, his intention in writing the letters was not to produce an autobiography or even a critical exegesis of his own art, although they do provide us with fundamental knowledge in both these areas. Instead, they were written as part of a continuing dialogue with Theo and others revolving around the question of how best to realize one's chosen mission in life. In this

[5] *Lettres de Vincent van Gogh à Emile Bernard* (Paris: Ambroise Vollard, *chez* Crès, 1911).

[6] *Brieven aan zijn Broeder* (Amsterdam: Maatschappij voor Goede en Goedkope Lectuur, 1914).

[7] *Briefe an seinen Bruder,* trans. L. Klein-Diepold and C. Einstein (Berlin: Paul Cassirer, 1914).

[8] *The Letters of a Post-Impressionist,* trans. A. M. Ludovici (London: Constable and Company, 1912).

[9] *The Letters of Vincent van Gogh to his Brother, 1872–1886* and *Further Letters of Vincent van Gogh to his Brother, 1886–1889* (Boston: Houghton Mifflin, 1927 and 1929).

[10] See n. 4, above.

respect Vincent's observations are highly discursive, spanning a wide
range of practical and theoretical ideas. Not surprisingly the letters have
been cited in support of mutually opposing interpretations of almost all
aspects of his career and personality. In fact, they represent for the
study of Vincent what the Bible represents for Christianity—the funda-
mental and "inviolable" source of truth, which nonetheless has pro-
duced a myriad of competing sects, each with its own definitive inter-
pretation. Since Vincent's legend has from the beginning evoked a high
degree of emotional fervor, it is especially necessary to guard against
a too selective or one-sided interpretation of the "holy writ."

An acquaintance with the actual *oeuvre*, either in the original or
in reproduction, has been as important a factor for van Gogh studies as
the limited availability of the letters. For this reason, it is useful to have
some knowledge of the exhibitions and publications which, haltingly,
brought Vincent's art into general public view.[11] The most important
landmark in the history of van Gogh exhibitions and publications doubt-
less was the appearance in 1928 of the four-volume *catalogue raisonné*
of the artist's painted and graphic *oeuvre*. The compiler of this edition
(written in French) was J.-B. de la Faille, a lawyer by training. Al-
though marred by the inclusion of a number of forgeries or improper
attributions,[12] this work succeeded in providing sorely needed general
access to a photographic record of Vincent's work. Almost four decades
elapsed between Vincent's death and the virtually complete publication of
his *oeuvre*; and this work, along with subsequent revisions and a number
of complementary catalogue studies of specific periods by other schol-
ars,[13] has provided a research tool the lack of which had been a formida-
ble handicap to all earlier writers on Vincent.

Indeed, before 1928 obstacles to acquiring a general knowledge of
Vincent's art were so great that few early accounts are totally free of
errors of fact or omission. Nonetheless, personal contacts and public
exhibitions did allow certain authors to gain firsthand knowledge of
Vincent's art, even during his lifetime, and a sizable number of early
accounts contributed positively to building the legend of Vincent. It
thus has seemed appropriate that Section I should include several of
these early critical appraisals of works included in exhibitions held

[11] For a more detailed recent survey of this process, see A. M. Hammacher, "Van Gogh and the Words," in de la Faille, pp. 9–37.

[12] Especially the forgeries exhibited at the Wacker Gallery and elsewhere in Berlin during the years 1927–29; see "Rejected Works" in the 1970 edition of de la Faille, pp. 587–97. However, de la Faille was scarcely alone in these misattributions, which he quickly corrected in *Les Faux Van Gogh* (Paris and Brussels: Van Oest, 1930).

[13] Principally W. Vanbaselaere, *De Hollandsche Period in het Werk van Vincent van Gogh* (Antwerp: De Sikkel, 1937); M. E. Tralbaut, *Vincent van Gogh in zijn Ant-werpse Period* (Amsterdam: A. J. G. Strengholt, 1948); and W. Scherjon and W. J. de Gruyter, *Vincent van Gogh's Great Period* (Amsterdam: De Spiegel, 1937).

during the artist's lifetime and during the commemorative year 1891 (see "Early Review Notices" in this volume). Beginning with an apparently isolated comment by Gustave Kahn on the 1888 Indépendants exhibition, there is striking uniformity in the critics' opinions that Vincent was striving for a command of the same elements of bright color contrast, "decorative" effect, and synthetic design which are otherwise associated with the neo-Impressionist and Symbolist movements. Although his unique personal temperament and stylistic idiosyncrasies invariably are noted by the critics, he is by no means treated as an outsider to contemporary artistic developments in Paris, as was often the case in reviews written during the years following his death. In addition, the pioneering critical study of Vincent's work, which was published in 1890 by Albert Aurier, appeared in print two years prior to Aurier's examination of Gauguin's work and yet clearly anticipated important aspects of the later attempt by the critic to define Symbolist or "Ideiste" art.[14] The almost equally influential article of 1891 by Octave Mirbeau assumes both a literary and a mystical context for Vincent's work, although this posthumous tribute also planted the seed of the belief that the artist's "madness" had influenced his personal style.

If Mirbeau was the sower of this seed, Gauguin was its most assiduous cultivator. In his earliest reminiscence of Vincent, the essay "Natures Mortes," which he published in January, 1894, Gauguin appears at pains to prove two points—first, that Vincent was the martyr both of a malicious bourgeois society and of his own simple-minded Christian beliefs and, second, that Vincent was in some manner driven to "madness" by this tormenting conflict.[15] In judging this brief essay, it is difficult to decide, because of the ambiguous irony in which Gauguin has clothed his narrative, just how determined he was to characterize Vincent as totally mad. Both self-interest and some degree of personal sentiment might easily have precluded any overt assertion on this point at a date so closely following the deaths of both Vincent and Theo. Yet, by 1903, in *Avant et Après* Gauguin was not only willing but eager to document Vincent's madness by recounting the notorious episode in Arles of the mutilated ear. As several authors have noted, Gauguin's objectivity, not to say veracity, is frequently open to question, at least in matters of detail. Nonetheless, he remains our only firsthand witness to the events portrayed in both accounts, which sufficiently warrants their inclusion in this volume.

The reader should recognize, moreover, that Gauguin's narration of events also comprises an interpretation of Vincent's behavior and per-

[14] For an analysis of the 1891 Aurier article on Gauguin, see S. Lövgren, *The Genesis of Modernism*, rev. ed. (Bloomington: Indiana University Press, 1971), especially pp. 152–58.

[15] See also M. Roskill, *Van Gogh, Gauguin and the Impressionist Circle* (London: Thames and Hudson, 1970), pp. 204–6.

sonality. This is illustrated in the story of Vincent's nursing back to health a severely burned miner from the Borinage and then experiencing a vision of Jesus Martyr in the person of this same victim of social injustice.[16] Yet, despite his deep involvement with and attachment for working-class people throughout his life, in his work Vincent never depicted either them or himself in the guise of Jesus or any Christian martyr. Indeed, while writing in 1890 to Gauguin's then friend and fellow Symbolist Emile Bernard (Letter B21) Vincent emphatically rejected any use of biblical imagery in favor of landscape and figural motifs observed directly from nature (that is, neither from memory or as visions). While this approach did not rule out for Vincent the expression of ethical and religious content, it does contrast significantly with the use by both Bernard and Gauguin of traditional Christian imagery, however transformed, in a number of major paintings. Particularly during the period following his departure from Arles, Gauguin painted a series of self-portraits in which his own visage was fused with that of the suffering or martyred Christ.[17] As such, these "portraits" reflect a projected visionary identification between himself and the Christ figure that he also attributes to Vincent, albeit indirectly, in the stories of the injured miner and the mutilated ear. In any case, Gauguin's accounts of his encounters with Vincent reveal the intense significance which both artists attached to their brief, traumatic period of habitation together. Along with the accounts of Bernard, they also constitute source documents of cardinal importance in determining Vincent's relationship to the Symbolist movement.

In summary, a review both of Vincent's correspondence and of the surviving personal reminiscences about him suggests an impression of the artist in many ways at odds with the traditional notion of Vincent as an untutored genius who created his art in opposition to all conventions, artistic and social. With his extraordinary temperament, he certainly often experienced great tension and conflict with other human beings, including those he loved or admired most. Nevertheless, there is little reason to consider him underprivileged in terms of access to the mainstreams of development in Western art. His knowledge of painting

[16] Since immediately upon returning to Paris from Arles Gauguin related the story to Emile Bernard, who recapitulated it in an unpublished portion of a letter of January 1, 1889, to Albert Aurier (cited in Rewald, pp. 267–68), in this case Gauguin may be assumed to have learned of the episode directly from Vincent. However, in a later version of the story (see "Gauguin on Vincent," n. 1, in this volume), he changed Vincent's vision of Jesus Martyr to one of Christ resurrected and added that his own *Portrait of Vincent* (see "Gauguin on Vincent," n. 4) was executed immediately after hearing Vincent's account of the miner and having a vision which associated Vincent with ". . . a Jesus preaching goodness and humility."

[17] See G. Wildenstein, *Gauguin* (Paris: Les Beaux-Arts, 1964), catalogue nos. 323, 324, 326, and 327.

was built upon an involvement with art which led back to his youth;[18] already in the Brabant period his work represented a progression beyond, rather than a misunderstanding of, Realist canons of design. His study of color theory and his deep admiration for Delacroix and Millet considerably predated his arrival in Paris in 1886. A voracious appetite for literature made him one of the best read among the major painters of the Impressionist or post-Impressionist movements, particularly in the area of French Realism. While in Paris, in 1886 and 1887, he enjoyed varied opportunities to see and benefit from the work of his French contemporaries, and through his relationship with Theo, who worked for the important Goupil art firm, he had further contact with the art world. It was upon the solid body of experience accumulated during this Paris period that the achievements of the Arles, St. Rémy and Auvers periods were to be founded. Even during his confinement in the hospital, although removed physically from Paris and subject to intermittent mental crises, van Gogh was kept aware of events by his brother, and his work betrays not the slightest trace of stylistic stagnation. On the contrary, it continued to develop with great force and cohesion. As the early source materials clearly document, although largely self-trained, Vincent was neither a naive nor a primitive painter in any significant sense. By the time of his death, moreover, this fact was appreciated by a surprising number of fellow artists and contemporary critics.

Many authors represented in Section I either were acquainted with Vincent personally or knew his work from direct viewing in Paris (that is, during 1886 and 1887 at Vincent's *atelier,* and thereafter as it was accumulated by Theo from Vincent, displayed at the shop of Père Tanguy or occasionally presented in public exhibitions). However, because of the removal of Theo's collection to the Netherlands immediately following his death in 1891, very little of Vincent's work was exhibited outside that country for at least a decade. Even in his native land, the impressive tributes by Frederik van Eeden and Johan de Meester (included in this volume) were not followed by a steady flow of serious interest, although recent research indicates that Vincent was not as unknown there during the 1890s as was once assumed.[19] This decade of critical quiescence created a hiatus in the appreciation of van Gogh which partly explains the difference in approach between the first and second generation of authors represented in Section I. The latter group of writers had not been part of the Parisian artistic ambience during Vincent's lifetime and thus viewed his work from a more distant perspective. Since, as discussed

[18] See J. G. van Gelder, "Juvenilia," in de la Faille, pp. 599–609.
[19] See Hammacher, "Van Gogh"; and J. Joosten, "Van Gogh Publicaties 9–15," *Museumjournaal,* 14. nos. 3–5 (1969) and 15, nos. 1–3 (1970).

above, his letters were published rather irregularly and the illustrated *catalogue raisonné* of his work by J.-B. de la Faille appeared only in 1928, it was inevitable that only a very few non-Dutch writers had a broadly based and intimate knowledge of both Vincent's *oeuvre* and his thought.

Given this situation, it is not surprising that several early retrospective exhibitions of Vincent's work played a crucial role in establishing his reputation, first among artists and critics, then gradually among the general public. Apart from a series of commemorative exhibitions held in Paris and the Netherlands, the 1901 exhibition at the Bernheim Jeune Gallery in Paris doubtless produced the most significant historic consequences. The virtual exclusion of works from the pre-French periods doubtless served to abet an unqualified acceptance by the Parisian art world of Vincent as an honored member of the French school of painting. This was the unfeigned, if mildly xenophobic, message contained in Julien Leclercq's important catalogue essay (included in this volume), which may be considered not only an ultimate tribute from a leading Symbolist critic but also a springboard for much of the later writing on Vincent, particularly in France. While it certainly is an oversimplification to view Vincent as the one and only major stylistic source of Fauvism, the numerous references in the literature of art to his influence on the *Fauves* accurately reflect the extraordinary impact of Vincent's art on other artists as the new century commenced, not least of all on Picasso.

The flurry of major van Gogh retrospective exhibitions in Paris, Amsterdam, Berlin, Hamburg, and Dresden in 1905 may be described as a tidal wave following upon the storm warning of the Bernheim Jeune exhibition of 1901. After 1905, Vincent's work was exhibited fairly regularly, particularly in the Netherlands and Germany. Major exhibitions in Paris, Amsterdam, and Munich during 1908 and 1909 provided a second great wave of opportunity for Europeans to see van Gogh's work. And while Great Britain remained largely unaware of Vincent's art until 1910, when Roger Fry brought the exhibition "Manet and the Post-Impressionists" to the Grafton Galleries in London, it would be fair to say that throughout the first decade of the century, the "rediscovery" of Vincent by the French *Fauves*, the German *Die Brücke*, and other stylistically related movements was as historically meaningful as was the discovery of Cézanne by Picasso and the Cubists.

If one examines the state of critical knowledge about van Gogh as these momentous events in art were unfolding, one finds that the balance of interest definitely was swinging away from France toward Germany and the Netherlands. In Paris it was chiefly the practicing artists who had demonstrated in their own work the regenerative power of Vincent's example and thus secured his reputation. However, this creative phenomenon was scarcely accompanied by a determined attempt in French critical circles to understand Vincent in terms of his own

artistic background. Either through premature death or lack of sustained interest, the more important Symbolist critics had relinquished their dominant position to less knowledgeable writers.[20] True, in his "De Gauguin et de Van Gogh au Classicisme" of 1909 (included in this volume), Maurice Denis produced a valiant and quite thoughtful, if somewhat abstractly theoretical, attempt to unite Vincent and Gauguin as kindred spirits. And in 1910 the Swiss writer Pierre Godet admirably refined the message of Leclercq's 1901 essay by defining the relationship between Vincent and the French Impressionists with remarkable precision (see Godet's article in this volume). Yet, perhaps due in part to the lack of sufficient access to both the art and the correspondence of van Gogh, French authors continued for a number of years to treat him as some kind of saintly madman whose chief contribution had been the breath of fresh northern air which he introduced into the art world of Paris (see, for example, the brief essay by H. Focillon included in this volume). Although a fair number of paintings by Vincent remained in French collections and although the Bernheim Jeune Gallery continued to display his work, the Cubist movement ushered in a protracted period of relative disinterest in Vincent's art in France, especially in terms of serious critical and historical evaluation.[21]

In contrast to France, and excluding the special case of the Netherlands, it was in Germany that Vincent's popularity swelled to greatest proportions. Until the advent of Nazi power, an almost constant stream of exhibitions and publications fed the seemingly insatiable appetite of the German public for knowledge about the Dutch painter. Popularized biographical literature doubtless was an important factor in this process, but translation of the letters and publication of related firsthand documentation provided a more salutary basis of knowledge and judgment than was available elsewhere. Berlin and Munich played especially important roles in the exhibition and sale of works by Vincent, a development which culminated grotesquely in the scandal surrounding the large number of forged van Gogh paintings which were put on display in Berlin in 1927 and the years following.[22] Moreover, if German interest in van Gogh gradually assumed the proportions of a national epidemic, it was in large part because the original "virus" had been nurtured there as elsewhere by a single writer, the art critic and historian Julius A. Meier-Graefe.

In the late 1890s, while living in Paris, Meier-Graefe "discovered"

[20] Aurier died in 1892 and Leclercq in 1901. Fénéon's further interest was limited to a brief introduction for an exhibition catalogue of 1908.

[21] Among the earlier book-length studies in French, Théodore Duret's, *Van Gogh* (Paris: Bernheim Jeune, 1916) was marred by the inclusion of several misattributed paintings, and most others were of the "vie romancée" type, although Florent Fels, *Vincent van Gogh* (Paris: H. Floury, 1928) contains valuable documentation.

[22] See n. 12, above.

Vincent and embarked on a study of his life and work with a thorough-
ness unparalleled among other writers on Vincent for years to come. By
1900, he had published his first article on van Gogh, and his three-volume
history of late nineteenth-century painting published in 1904 and trans-
lated into English in 1908 was unprecedented in its assignment of major
historical importance to the then little-known Dutch painter.[23] Although
his style of writing tends to an extensive use of hyperbole and metaphor
and his conception of Vincent as the martyr-hero of modern society is
open to question on numerous points of fact, Meier-Graefe was the first
to examine van Gogh's career in a scientific manner. In fact, his treat-
ment of Vincent contained an unprecedented wealth of insight into a
broad range of biographical, artistic, and cultural considerations. His
further assertion in 1906, that "for Germany's youth, which vacillates
between art and applied design, Van Gogh has arrived at the right
moment," [24] not only reflected the author's own previous deep involve-
ment with the decorative tendencies of the *Art Nouveau* movement, but
it also proved uncannily prophetic of events to come in the artistic life
of Germany, especially with reference to *Die Brücke*.

The German historian's closest counterpart in the Netherlands was
the critic and aesthetician H. P. Bremmer. Having practiced painting
himself, Bremmer was less concerned with Vincent's place in the history
of art and the painter's psychological makeup than with demonstrating
the great strength of van Gogh's personal artistic vision. The didactic
sobriety with which he analyzed a series of works selected from all of
Vincent's major periods in his *Vincent van Gogh: Inleidende Beschou-
wingen* [Vincent van Gogh: introductory observations] of 1911 con-
trasts markedly with the sense of drama and passion that had informed
the writing of Meier-Graefe. This does not mean that Bremmer's interest
in Vincent was less intense than that of Meier-Graefe. It was the Dutch
writer's advice, for example, which guided the choices made by Mrs.
Helene Kröller-Müller in accumulating her magnificent permanent col-
lection, of which the large group of works by Vincent from all periods
comprises the greatest single glory. Like Meier-Graefe and in contrast
to the tendency of others (Roger Fry for example) to choose Cézanne
over van Gogh in a hypothetically polarized view of the post-Impression-
ist movement, Bremmer gave his greatest attention to the work of his
fellow countryman, despite his otherwise remarkable catholicity of
taste. And like Meier-Graefe in Germany, Bremmer undertook in the
Netherlands a ceaseless program of writing, lecturing, and direct in-
volvement both with artists and art collectors in order to propagate a

[23] See credit note in Meier-Graefe's article included in this volume; the same author's
biographical study, *Vincent*, 2 vols. (Munich: Piper, 1921; English tr., 1922) also
enjoyed widespread circulation.
[24] Quoted from the article translated in this volume.

cohesive interpretation of Vincent, which profoundly affected the Dutch national consciousness.

Another more specialized category of literature about van Gogh is comprised by the psychiatric studies which flourished during the interval between the two world wars. Their common focus was a precise definition of Vincent's madness and its effect upon his art. This genre of study was a typical product of the period which saw the appearance of the Dada and Surrealist movements in art and which also experienced a general fascination with Freudian and other investigations in the area of "abnormal psychology." The cardinal issues in this debate about Vincent's mental illness are summarized in the final group of writings found in Section I.

Like the presumed historical antagonism of van Gogh and Expressionism versus Cézanne and Cubism, the "mad" versus "not mad" controversy suffers from oversimplification. Certainly, self-mutilation and suicide are not the acts of someone fully and constantly in control of his rational faculties, and Vincent's letters often attest to the recurrence of mental strain and crisis. Nevertheless, in view of the extremely fragmentary records which have been preserved about these events, and the limited range of psychiatric knowledge available to those who actually attended to Vincent's health in Arles, St. Rémy, and Auvers, one may conclude that the arrival at a sound clinical diagnosis of a specific defined psychosis presents formidable, and possibly insuperable, problems. In any case, the exact character, the relative seriousness, and the frequency of Vincent's mental crises have yet to be satisfactorily determined. Suffice it to say that the diagnosis of schizophrenia advanced by Karl Jaspers in 1922 (see his article included in this volume) subsequently has proven generally unacceptable within the psychiatric profession itself. And the original and subsequent diagnoses of epilepsy, whatever their basis in medical fact, offer scant reason to hypothesize an "epileptoid" style of art, precisely because of the periodic and only temporarily debilitating character of the attacks.[25] Above all, few today would doubt that the vitality of Vincent's creative drive and artistic vision continued to the very end of his life, a fact which early diagnoses of a genuinely abnormal psychosis were at pains to deny.

It is not, however, primarily because of the relevance to Vincent's art of a medical diagnosis of one or another psychosis that writings by psychiatrists have been included in this volume. Rather, they have been included, first, for the insight into the development of Vincent's style which each selection contains and, second, for the background which

[25] See Minkowska's article, included in this volume, n. 2. In fact, Hans Prinzhorn, in his influential *Bildnerei der Geisteskranken* (Berlin: J. Springer, 1923), describes the art of disturbed epileptics as limited to slavish copying.

the lively debate among psychiatrists has provided for interpretations by critics and art historians. On the latter point, no less-qualified authors than Roger Fry and the team of W. Scherjon and W. J. de Gruyter have described Vincent's late development as somehow dependent upon his supposed mental instability.[26] Likewise, it has been the exceptional author who has found no traces of psychological tension in such works as Vincent's *Bedroom in Arles* (Fig. 9) and the *Crows in the Wheatfield* (Fig. 25). Perhaps unexpectedly, psychiatrists initially were among those most insistent on the idea that a disturbed mental state could prove beneficial to an artist's attainment of his highest powers. This somewhat romantic association between "madness" and "genius" underlies the examinations of both Jaspers and F. Minkowska (included in this volume), and it informs much other writing on Vincent as well. While such a causal association is open to question in reference to analytical methodology and the exclusion of other cultural determinants,[27] it at least has focused attention upon the heightened expressive power of Vincent's late work. On this cardinal point, medical, art historical, and other opinion have achieved a remarkable unity of agreement.

In contrast to the earlier source materials and critical appraisals contained in Section I, the selections in Section II are of more recent vintage and written by art historians uniformly familiar with the wide range of pertinent documentation and original works by the artist. Since the evidence for their interpretations is presented as such, there is relatively little need for introduction beyond a brief characterization of the basis on which the articles were selected. Principally selection has aimed at the broadest possible balance between articles emphasizing iconography or content and those emphasizing style, as well as wide coverage of the various periods of Vincent's career. Hence differences in areas of interest and methodology among the authors of Section II are considerable, despite the high level of research common to all. A general frame of reference is provided in the already mentioned article by Novotny on "The Popularity of van Gogh," which establishes both the

[26] Fry wrote of Vincent's late work: "The agitation of his own mental state . . . has by now become the real theme of his art. His vision of nature is distorted into a reflection of that inner condition." From a review in 1923 which was incorporated into *Transformations* [London: Chatto and Windus, 1926], p. 184. Scherjon and de Gruyter (*op. cit.*, p. 23) stated: "In van Gogh's case it would be a mistake to suppose that mental unbalance did not influence and accelerate certain processes of growth and change, which can be traced in his work. That surging, coiling, wheeling and writhing quality in the line of his later canvases obviously pertains in some way to his malady."

[27] Frequently, psychiatric writers seem first to presume a particular malady and then to seek out supporting evidence from the letters, while overlooking such factors as the artist's peculiar training, stylistic debts, and powers of compositional synthesis.

profundity and the complexity of Vincent's innovative artistic vision within the context of post-Impressionism. With a similar flexibility of focus, Jean Seznec has explored the multiplicity of methods by which Vincent was able to incorporate in his art his vast knowledge of literature without becoming a "literary" painter. Doubtless Seznec's interest in literature of the Renaissance and later periods conditioned his approach, which is more than justified by the innumerable references to literature found in van Gogh's correspondence. On another level of interpretation, Kurt Badt is able to view Vincent's use of color basically as a radical break with Renaissance and a return to medieval precedents. Likewise, Jan Bialostocki cites iconographic precedents reaching as far back as the Middle Ages, while simultaneously stressing both the uniquely personal and contemporary nature of the Dutch artist's iconography.

The concern of art historians for stylistic development and for the documentation of specific influences has, atypically, appeared relatively late in the literature about van Gogh. Among both his detractors and supporters, the early characterization of Vincent as an irrational genius and the concentration of analysis upon biographical factors tended to postpone the emergence of articles devoted to the study of style. This aversion to tracing influences in Vincent's art deserves respect in so far as it opposes the reduction of his painting to a patchwork of borrowings from other artists. No one would wish to see van Gogh's Brabant work explained merely as the by-product of influences from Israels and Millet, or the mature style of the Arles and later periods described as no more than the aftermath of his contact with French Impressionism and neo-Impressionism. Neither should one innocently consider as all-powerful the influence which Gauguin (in *Avant et Après*) claimed to have exercised when the two artists worked together in Arles, a point stressed by Douglas Cooper in his article on Vincent's *Yellow House*.

Resistance to art historical research is carried too far, however, when one refuses to admit the value, indeed the necessity, for any great artist of enriching his own storehouse of experience by learning from others, including both predecessors and contemporaries. Few major artists have left a more moving or tangible indication of the mutual need for contact with other artists than has Vincent. His letters abound with references to the work of other painters, knowledge of which he sought to acquire in a variety of ways. He was an avid collector of reproductions of all kinds, a devoted museum-goer when opportunity allowed, and an inveterate seeker of personal contacts with other artists, as is indicated by what we know of his behavior in Paris and in his deeply felt wish to form a "studio of the south." His catholicity of taste was so broad that it even included a great number of minor and conventionally academic artists—to the dismay of some of his *avant garde* friends and acquaintances. Yet, it was with the help of this wide-ranging,

if somewhat eclectic, knowledge of the work of other artists that Vincent was able to evolve his series of idiosyncratic and very personal styles.

Despite the obvious difficulties in providing an adequate depth of coverage in an anthology devoted essentially to critical writings, a sampling of major art historical viewpoints has been provided in Section II. The choice necessarily excludes a number of equally important writings, but the aim here has been to provide the broadest possible coverage in reference to period, style, and medium of execution. In this selection a preference has been given to authors who have challenged previously held opinions. While not attacking the earlier interpretation of the *Potato Eaters* (Fig. 2) by Bremmer, J. G. van Gelder has discovered in this same work elements of a religious-humanist content, borrowings from other artists, and, through his own empirical method of analysis, an expressive distortion of form which the earlier critic had expressly ruled out. Similarly A. M. Hammacher, in stressing the importance to Vincent of the early work of the future neo-Impressionist Paul Signac, provides—as does Cooper in his article on the *Yellow House* —a counterbalance to other writers[28] including Ake Meyerson who have forcefully argued that Vincent was directly inspired by the so-called "School of Pont-Aven." All these discussions have contributed to the determination of Vincent's position in relation to the Realist, Impressionist, neo-Impressionist, and Symbolist movements in France.

In another vein, Carl Nordenfalk, writing about the artist's later copies after Millet, Delacroix, and Rembrandt emphasizes Vincent's independence of artistic vision despite his use of specific models or precedents. The final contribution to this volume is by Meyer Schapiro, who, like Nordenfalk, is a medievalist equally at home in more recent periods of art. His famous essay on the *Crows in the Wheatfields* is in sharp contrast to the several other interpretations of this all-but-final work which can be found among the other writings collected here.[29] Like Bialostocki, Schapiro ascribes symbolic meaning even to Vincent's distortions of perspective and thus suggests yet another possible level of interpretation. At the same time, his assignment of apocalyptic significance to the *Crows* involves an appraisal of Vincent's psychological makeup which may be evaluated in the light of the earlier opinions of psychiatrists and others presented here. In addition to breaking much new ground in terms of approach, the essays in Section II point out the rich and varied substratum of style and iconographical meaning that is concealed beneath the outward appearance of simplicity in Vincent's art.

In conclusion, while it does not represent an exhaustive collection of study materials, this anthology embraces a broad spectrum of source

[28] E.g., Ake Meyerson, "Van Gogh and the School of Pont-Aven," *Kunsthistorisk Tidskrift*, 15 (1946), pp. 135–49.

[29] See in particular the views of Fry, Minkowska, and G. Kraus.

documents and interpretations. No particular school of thought has been favored, although most major critical trends have been represented. And the diversity of opinion about Vincent presented here in no way indicates a diminishing in the universal and intense appreciation of his work which will certainly extend into future generations. The early verdict of Vincent's friend the painter Anton Ridder van Rappard still stands: "Whoever had observed this toiling, struggling, and sorrowful existence could not but feel sympathy for a man who demanded so much of himself that it ruined both body and mind. He belonged to that stock from which great artists are born." [30]

[30] Translated from J. van Gogh-Bonger's "Introduction" to *Brieven aan zijn Broeder,* p. xxxiii.

PART ONE / Personal Reminiscences and
Early Critical Appraisals

VINCENT IN DORDRECHT (1877)

P. C. Görlitz

I was receiving room and board from Mr. and Mrs. Rijken[1] and functioning both as an apprentice teacher and as a volunteer with the book and art shop Blussé and Van Braam, when Mr. Vincent van Gogh reported to assume a position as salesman and accountant. . . .[2]

He was a special kind of person and had, in addition, a special outward appearance. He was well built, with red hair which stood straight up from his scalp and with a homely face full of freckles, which nonetheless completely changed and brightened up whenever he became enthusiastic about something, as occurred rather frequently. Van Gogh provoked amusement because of his attitudes and behavior, since he behaved, thought, felt, and lived differently from others his age. He prayed a long time at the dinner table, nourished himself no better than a hermit—eating, for example, no meat or sauces—and he invariably wore on his face an expression of absentminded thought and deeply serious melancholy. Yet, whenever he laughed, he did so with such heartiness and joviality that his whole face appeared transformed.

By nature he was thrifty, which, moreover, he had to be, since his income was as small as my own, indeed, even smaller, thanks to his

Most of this reminiscence by the secondary school history teacher Mr. P. C. Görlitz has been translated by the editor from a letter to M. J. Brusse. Brusse quoted it in "Onder de Menschen; Vincent van Gogh als Boekverkopersbediende," *Nieuwe Rotterdamse Courant*, May 31 and June 2, 1914 (Letter 94a in *Complete Letters* gives the full text in English). However, the episode of the Bible illustrations has been translated and interpolated from another letter (A7) by Görlitz, which he wrote to Frederik van Eeden upon reading the latter's 1890 article on Vincent (included in this volume), but which letter was not known to Brusse. (Editor's footnotes.)

[1] Mr. P. Rijken, a dealer in baking provisions, also provided a reminiscence of Vincent for Brusse, *ibid*.

[2] The position was obtained through family connections in the merchandising of art.

position as a novice. In addition, he did not wish to appeal to his parents for supplementary funds. . . .

Upon arriving home in the evening, he found me at study, since at the time I was preparing for my qualifying examinations to become a teacher in the secondary school system; after a word of encouragement for me, he himself went to work. And this effort was not concerned with art, as one might have expected, but with religion.[3] Evening after evening, van Gogh pored over the Bible, extracting excerpts and ideas for sermons, for at the time (he was then approximately twenty-five years of age) strict piety was the core of his being. Only during walks which we took together did the abundance of picturesque settings and prospects in Dordrecht prompt him to point out things which he found beautiful.

He was extremely modest, very timid in some respects. On one occasion, after we had known each other for a month, he asked me, again flashing his irresistible smile, "Görlitz, you might do me an enormous favor, if you wish to."

I answered, "Well, speak up, what is it?"

"Oh, since this is really your room, I'd like your kind permission to hang a few Bible illustrations on the walls."

I naturally gave my permission immediately, and in feverish haste he dedicated himself to his work. Within a half hour the whole room was decorated with biblical pictures and with *ecce homo* images; and beneath each Head of Christ van Gogh had written, "Ever sorrowful, yet always joyous." [4]

This Bible saying reproduced his own mood as clearly as was possible. Upon one Christian holiday—I believe that it was Easter—he framed every representation of Jesus in palm branches. I was not a pious person, but I was moved when I observed *his* piety.

His religious sentiment was encompassing and noble, anything but narrow, since, although he then was an orthodox Protestant, on Sundays he attended services not only of the Dutch Reformed Church, but also— and on the same day—services of the Jansenist, Roman Catholic and Lutheran faiths. And when I expressed my surprise and astonishment at this, he answered with a good-natured smile, "Do you imagine, Görlitz, that God can not be found in the other churches?"

He lived as an ascetic and permitted himself only a single luxury, a pipefull of tobacco. Cigars were too expensive, but he smoked tobacco with pleasure and often.

He became perceptibly more melancholy, and his daily work cost him increasingly greater effort. He was not suited to his job, and the

[3] Yet, in Brusse, "Onder de Menschen," other witnesses recall having seen pen drawings of landscapes by Vincent.

[4] From 2 Cor. 6:10.

job was not suitable for him. Between chores of accounting, an appealing text or a pious thought would suddenly occur to him which he would then write down. He could not resist the urge; it was too strong for him. And if he were required to provide information to the usual sort of mostly female clients who were interested in the engravings displayed by Mr. Braat,[5] he forgot the interests of his employer and stated precisely and without dissimulation his opinion about the artistic merit of such items. As stated already, he was never meant to be in business. His dream was to become the leader of a religious community, and this wish never left him, even though he denied, or, rather, considered it unwarranted, that a knowledge of Latin and Greek should be required for the profession of preacher. . . .

And so did he muddle along in order to leave undisturbed his parents' belief that he was satisfied. However, when, on the occasion of a job interview, I lodged overnight with his parents, I confided to his mother what was bothering him. . . . His parents now pressed him to make a clean breast of things, and he left for Amsterdam to reside with his uncle, the vice-admiral. . . .[6]

Upon taking his leave, he presented to me as a souvenir *L'Oiseau* by Michelet, a book he himself passionately admired. Spurgeon was then also one of his favorite writers.[7] Mr. Rijken and his wife were very considerate to him, for they respected his deep earnestness and his gentleness. . . .

[5] Owner of the Blussé and van Braam shop.

[6] Johannes van Gogh, commandant of the naval yard in Amsterdam, who resided on the Grote Kattenburger Street.

[7] C. H. Spurgeon (1834–92), a popular and iconoclastic Baptist preacher, whose *Little Jewels* Görlitz cites (Letter A7) along with the Bible and New Testament as "the only three books he read, as long as I knew him."

VINCENT IN AMSTERDAM (1877-78)

M. B. Mendes da Costa

. . . . It was approximately in 1877 that Reverend J. P. Stricker,[1] a widely admired Amsterdam clergyman, asked me if I were willing to give instruction in Latin and Greek to his nephew, Vincent van Gogh, . . . in order to prepare him for the matriculation examinations connected with university study. I was informed, moreover, that my charge was no ordinary youth, and I thus already had some forewarning of his anything but workaday manner of doing things. . . .

Our first meeting, which is of such great importance for the relationship between teacher and pupil, was quite pleasant. The seemingly reserved young man (we differed only a little in age, since I was then twenty-six and he clearly already older than twenty) felt himself immediately at ease. Despite his lank, reddish-blond hair and many freckles, his outward appearance was by no means unsympathetic. . . .

I quite quickly succeeded in winning his friendship and trust, as was utterly necessary in this case. And because he began his studies inspired by the best intentions, we made rapid progress at the start, so that I was able to assign him the translation of an uncomplicated Latin author. As might have been expected, considering his then so fanatically inspired character, he preferred to use his restricted knowledge of Latin in order to read Thomas a Kempis in the original.

Until this point everything was going well, including the study of mathematics, which in the meantime he had begun under another instructor. However, it was soon apparent that Greek verb forms were

Translated by the editor from Dr. M. B. Mendes da Costa, "Persoonlijke Herinneringen aan Vincent van Gogh," *Het Algemeen Handelsblad*, Dec. 2, 1910. (Letter 122a in *Complete Letters* gives the full text in English.) (Editor's footnotes.)

[1] Vincent's uncle by marriage on his mother's side was the father of Kee Vos, whom Vincent wooed unsuccessfully in 1881.

proving too difficult to master. No matter how I might set about it, whatever means I could employ in order to lessen the tediousness of the task did not avail. "Mendes," he said (we were on a first name basis), "Mendes, do you really believe that these exercises in terror are necessary to someone who wants what I want: to provide peace on earth to needy creatures?" And I, who as his teacher could not agree, but who in the depths of my soul found that he—note well that I said *he, Vincent van Gogh*—was perfectly right, defended myself as best I could. But this didn't affect things at all.

"John Bunyan's *The Pilgrim's Progress* is of much more use to me, as is Thomas a Kempis and a translation of the Bible; I need nothing else." I no longer know how many times he said this to me and how many times I visited the Reverend Stricker in order to discuss the matter. In any case it was invariably decided once again that Vincent would give things yet another try.

But presently one heard again the same old song, and he would arrive in the morning with the well-known report: "Mendes, last night I once more used the cudgel," or "Mendes, I let myself be shut out again last night." This was in reference to a form of self-chastisement, which he practiced upon feeling that he had neglected his duty. In fact, he was residing at the time with his uncle, Vice-Admiral J. van Gogh, director and commandant of the naval base in Amsterdam, whose large house was located on a quay at the naval yards. Should Vincent find that his thoughts had wandered from the right path, then he took a cudgel with him to bed and used it on his back. Should he judge that he had forfeited his right to spend the night in his bed, then he would slip out of the house unnoticed and, upon returning home to find the door locked, would be forced to sleep in a wooden shack on the ground with neither matting nor cover. By preference he did this in the winter time, in order that the punishment—which I presume was for him a form of intellectual or spiritual masochism—was correspondingly more severe. He was well aware that such a report by him was not at all pleasant for me to hear, and, in order to allay my feelings, he was in the habit of presenting me with some snowdrop flowers which he had picked in a near-by graveyard. . . .

It would have been impossible for anyone to become angry under these circumstances, I think, and not merely myself, who had quickly comprehended how consuming during this period was Vincent's need to help people in misery. I had indeed noticed this in my own home, not only did he show great consideration for my deaf and dumb brother, but he always had a friendly word for and about a poor and slightly deformed aunt who lived with us, who was not particularly intelligent and who spoke with difficulty to a degree that many people made fun of her. . . .

Since I was not overly busy in those days, he often remained after

his lesson in order to chat. Naturally we frequently spoke of his earlier association with the art market. He had preserved from this experience a number of prints, lithographs made after paintings, and so forth. Repeatedly he would present me with a print, but invariably it was in a ruined condition, since he literally had filled the margins with scribbled quotations from Thomas a Kempis or the Bible which in some way related to the subject of the picture. Once he even brought me a copy of *De Imitatione Christi*,[2] not at all with the secret idea of converting me,[3] but rather simply to introduce me to its *human* content. . . .

Our acquaintance lasted slightly less than a year. Thereupon I became convinced that, even with the greatest effort on his part, he would never be able to master the required examination. . . . In complete agreement with the wishes of Vincent himself, I advised his uncle to allow him to cease his studies. And so did it happen. . . .

[2] By Thomas a Kempis.
[3] The writer was Jewish.

VINCENT IN CUESMES,
THE BORINAGE (1880)

Gustave Delsaut

He was an intelligent young man who spoke little, always appearing pensive. He lived very soberly. Upon arising in the morning, he breakfasted upon two slices of dry bread and drank a large cup of cold black coffee. Except with his meals, he drank only water. He always ate alone, arranging not to take his meals in the company of others. While eating he either made drawings in his lap or read. All his time was taken up by drawing. He often visited the woods at Ghlin, the cemetery at Mons, or the surrounding countryside.

He liked especially to draw landscapes, castles, shepherds with their flocks, and cows at pasture.

The most striking of his works, as recalled by my sister-in-law at whose home he lodged,[1] was a drawing which represented a family engaged in picking potatoes; some figures are shown digging and others (the women) collecting the potatoes.[2]

He left behind his drawings and his books, but all of these things by now have disappeared through the dispersion of our family.

The following letter, translated in full by the editor, was written by Gustave Delsaut, a Protestant who had known Vincent in the late summer and fall, 1880, at Cuesmes, in the Borinage area of Belgium. Vincent had recently lost his position as lay preacher to the poverty-ridden miners of the area, but he was beginning to draw with professional intentions. The Delsaut account was elicited by Louis Piérard, a Belgian journalist and Socialist politician, for his *La Vie Tragique de Vincent van Gogh* (Paris, 1924; rev. ed., 1939; English tr., 1925). See also Letter 143a. (Editor's footnotes.)

[1] In Letters 134 and 135, Vincent gives his address as "c/o Charles Decrucq, 3 rue du Pavillon, Cuesmes, near Mons." However, in 1880 Elisa, daughter of Charles Decrucq and the future wife of George Delsaut, Gustave's brother, was just thirteen years of age.

[2] Vincent depicted closely related subjects in numerous surviving works; see de la Faille, esp. pp. 45, 59, 74, 87, 320–37, 383, 438, 444–66, 566–67, and 577.

His board and room were paid for by his father, who sent money to him. He expended much money in the purchase of Bibles and New Testaments which he distributed at no charge while on his way to paint.

Once his father was obliged to come to Cuesmes in order to put a stop to his expenditure on books.

He would depart on painting excursions with a folding stool under his arm and a box of paints carried on his back like a peddler.

Whenever he was afflicted with boredom, he would rub his hands without ceasing.

VINCENT IN NUENEN, NORTH BRABANT (1884-85)

Anton C. Kerssemakers

[It was] . . . approximately 1884 when I first met the artist. At the time I was engaged in painting a pair of landscapes on the walls of my office, which I preferred to the use of wallpaper. My house painter and paint supplier was so pleased in his way by this that he brought along van Gogh on one occasion in order to show him my work. Van Gogh was of the opinion that I was a rather good draftsman and was immediately prepared to assist me in learning to paint. . . .

In those days he suffered the poverty of a true Bohemian, and he sometimes went for six weeks without eating any meat. Invariably he ate only dry bread and a piece of cheese, which, as he said, would not spoil during his wanderings. . . . To be sure, he enjoyed taking along on his trips a little cognac in his field canteen, but this was the single luxury which he permitted himself. He had hired a couple of rooms from the church sexton for use as a studio, but these too reflected a Bohemian existence.

One stood amazed at how paintings and drawings in watercolor and crayon were hung and placed about everywhere. . . . [One also noticed] . . . a great pile of ashes near a stove which was never cleaned or polished, a couple of chairs with frayed cane seats, a cupboard with as many as thirty birds' nests, all kinds of mosses and plants found in the heath, several stuffed birds, a spindle, a spinning wheel, a bed-warmer, numerous farm tools, old caps and hats, musty bonnets, wooden shoes, etc. etc.

The tanner and amateur painter from Eindhoven Anton C. Kerssemakers (1846–1926) published this reminiscence of Vincent in Dutch as "Herinneringen aan Vincent van Gogh," *De Amsterdammer: Weekblad voor Nederland* ("De Groene"), April 14 and 21, 1912; excerpted here but translated virtually in full in *Complete Letters* (Letter 435c). (Editor's translation and footnotes.)

He had ordered a painter's box and palette made in Nuenen according to his own instructions, as well as a perspective frame. The latter object was comprised of a sharply pointed iron staff onto which he could screw a frame at any desired height. He explained that earlier artists had used such a device, so why shouldn't we. Some time afterwards I accompanied him to several museums, of which the National Museum [in Amsterdam] was the first. . . . He was easily able to find in this museum the things which most interested him. He led me in particular to the van Goyens, the Bols and above all the Rembrandts. He spent the most time of all in front of *The Jewish Bride* from which he could not be drawn away. . . .

A while later we visited the museums of Antwerp, from which time one striking moment lives above all in my memory. This was when he noticed the fisher boy with the basket on his back (I mean the painting of this subject by Velázquez). Suddenly he left my side and ran up to the painting, with me following behind. As I caught up to him, he stood with folded hands as if in worship of the painting and muttered, "God d" After a pause, he said, "Do you see that, now, that is painting; take a look"; and tracing the direction of some broad brushstrokes with his thumb, "He let it remain just the way he had applied it." And with a broad gesture which encompassed the whole hall, "Almost all the rest is as antiquated as periwigs and pigtails."

He was deeply respectful of Corot, Daubigny, Diaz, Millet and the remainder of the Barbizon school; he was always talking about them, and conversation about his favorite art always came back to this preference. . . .

He regularly compared painting with music. In order to understand better the worth and gradations of tones, he began to take piano lessons from an elderly music teacher who was also an organist in E[indhoven]. However, this did not last long, since, thanks to van Gogh's habit during the lessons of continually comparing musical tones with Prussian blue and dark green, or dark ochre with bright cadmium, the good man began to think that he was dealing with a madman and became so worried that he refused to give further instruction. . . .

Vincent visited me quite frequently at my home in E[indhoven]. Once, while painting in my garden, I suddenly heard a voice behind me say, "Now, there, it is good that you are painting out-of-doors; you must do this often. . . . Yes, do you see the slope of the roof, that must be at least an angle of forty-five degrees, but represented as such it would appear too steep. And I don't know how you should add your colors, but that doesn't matter, just continue as you are, since there is nothing as instructive as painting out-of-doors. You have always to compare things carefully with one another, especially for the tones. Painting is like algebra, one thing relates to another or is equal to another. Above all, study

perspective closely, including aerial perspective; if you already have used green in the background areas, how can you use green effectively in the foreground?"

Whenever he noticed a beautiful evening sky he became, so to say, ecstatic. One evening when we were walking together from Nuenen towards Eindhoven he suddenly stood still before a magnificent sunset. Using his two hands in order somewhat to enframe the view, and with eyes half-closed, he called out, "Damn it all, how does that fellow God, or whatever you wish to call him, do it? Just how does he do it; that's what we must learn to do ourselves!" . . .

Weeks on end he would concentrate exclusively upon the drawing of hands, feet, and wooden shoes. He said that one must have firm control of these things. One of the models which he used in painting his peasant heads was said in the village to be his lady fair; her face reappears frequently among the heads. . . .[1]

He invariably spoke with great respect about Anton Mauve,[2] although the two had not been able to get along very well and had worked together for only a short time. According to Vincent, Mauve had once remonstrated that one should not use his fingers so much in painting, whereupon he himself became angry and retorted, "What on earth does it matter even if I paint with my heels, as long as the result is good and it works?" This latter was a preferred expression of his, and he always spoke of sheep who "work well," a birch sapling which might "work better," or "how well it works" against the evening sky and so on.

He had already spoken on a number of occasions of wishing to leave the vicinity, but I had paid very little attention, thinking that he was not serious. Finally, however, he came to announce his departure for Antwerp and ultimately for Paris. Before departing he visited me in order to say good-bye, bringing as a remembrance a splendid, not yet dry *Autumn Landscape* [F 44/H 49], which had been executed completely in the out-of-doors. . . . As counterremembrance he took along a small canvas executed by myself. . . . When I observed to him that he had not yet signed his work, he said, "Perhaps I shall drop by once again to do that, since I shall probably return again in the future. However, it is actually not necessary, since my work is bound to be recognized one day. Much will be written about my work after I am dead; if time is granted me, I plan to provide for that. . . ."

[1] The author doubtless had in mind such paintings as those illustrated in de la Faille, pp. 64–107.

[2] Anton Mauve (1838–88), a leading painter of the Hague School, had married a niece of Vincent's mother.

VINCENT IN ANTWERP (1886)

Victor Hageman

. . . . I recall very well that rough-featured, nervous, and restless man who fell like a bomb upon the Antwerp Academy, turning upside down the director, the drawing master, and the students. . . . One morning van Gogh came into the painting class [which was taught by Karel Verlat, director of the Antwerp Academy];[1] he was dressed in a blue smock of the kind worn by Flemish livestock merchants and wore a fur cap on his head. In place of the normal palette, he used a board stripped from a case which had contained either sugar or yeast. On this day, the students had been assigned to paint two wrestlers, who were posed on the podium stripped to the waist. Van Gogh began to paint feverishly, furiously, and with a speed which astounded his fellow pupils. He laid on his impasto so heavily that his colors literally dripped from the canvas onto the floor.

When Verlat saw this work and its extraordinary creator, he inquired in Flemish, somewhat dumbfoundedly, "Who are you?"[2] Van Gogh responded quietly, "Well, I am Vincent, a Dutchman." Then the very academic director spoke out contemptuously, while pointing to the canvas once again, "I'll not correct these rotting dogs. My boy, take

Presented episodically in Louis Piérard, "Van Gogh à Anvers," *Les Marges,* 13:45 (January 1914), 47–53 (see also *La Vie Tragique* and Letter 458a), this reminiscence, slightly abbreviated here, was derived from an account given by the minor Belgian painter Victor Hageman (1868–1938). Translation and footnotes are by the editor.

[1] Verlat (1824–90) was a Belgian history painter and miniaturist.

[2] M. E. Tralbaut, in *Vincent van Gogh in zijn Antwerpsche Periode* (Amsterdam, A. J. G. Strengholt's, 1948), 141 ff., rightly questions Hageman's accuracy in terms of detail, particularly here, since the Academy director normally would have interviewed his students before matriculation. However, with about sixty students in class, recognition might have been difficult, and Letter 458a presents evidence in support of Hageman's general trustworthiness.

yourself quickly to the class in drawing." Van Gogh, whose cheeks had turned purple, contained his anger and fled to the course of the good Mr. Sieber,[3] who was also afraid of novelty, but who was of a less irascible temperament than his director. Vincent stayed here several weeks, drawing eagerly, persisting with visible pain in developing his powers, working rapidly without retouchings, most frequently tearing up or throwing behind him the drawings which he had finished. He sketched everything which he found in the classroom, the students, their clothing, the furniture, but forgetting the plaster cast which the professor had assigned for copying. Already at this time, van Gogh was astonishing for the rapidity with which he worked, redoing the same drawing or painting ten to fifteen times over. . . .

One day, by chance, the students of the drawing class at the Antwerp Academy were assigned to copy the *Venus de Milo*.[4] Van Gogh, struck by one of the essential characteristics of his model, strongly accented the breadth of the hips and thus made the Venus submit to the same deformations which he would bring to *The Sower* by Millet and *The Good Samaritan* by Delacroix, other works which he was to copy during the course of his career. The beautiful Grecian had become a robust Flemish matron. When honest Mr. Sieber saw this, he cut van Gogh's sheet of paper to pieces with the impulsive blows of his crayon, correcting him and reminding him of the immutable canons of design. Then the young Dutchman . . . flew into a violent rage and yelled out at the terrified professor, "It's obvious you don't know what a young woman is like, damn it! A woman must have hips, buttocks and a pelvis in which she can carry a child! . . ." This was the final lesson which van Gogh took—or gave—at the Antwerp Academy. . . . With those who understood him, intuiting his nascent genius, he showed himself to be communicative, enthusiastic and fraternal. Very often he spoke to such people about the rough and good-hearted miners of the Borinage, whom he had catechized, cared for, and assisted with so much love. During the tragic strikes of 1886, he even wished to return to that Black Country.

[3] I.e., Eugène Siberdt (1851–1931), a Belgian history, portrait, and genre painter, whose name Vincent and other writers consistently misspelled.

[4] I.e., a plaster cast of the original in the Louvre Museum, Paris.

VINCENT VAN GOGH (1886-87)

A. S. Hartrick

My return to Paris, after the Summer [of 1886] at Pont-Aven,[1] was de-
layed till some time in November. . . . Some time before this, I had
made the acquaintance of J. P. Russell,[2] a big Australian, who . . . had
been working for some time in the Atelier Cormon, which was situated
in the Clichy quarter,[3] where, I learnt, were the homes of the painters
with new ideas. Russell also had his studio in the neighborhood.

Here it was, then, that guided by pure chance I first set eyes on
van Gogh, or "Vincent" as he was generally known and signed himself
in Paris, because the French could not pronounce van Gogh. It so hap-
pened that he, too, had been working *chez* Cormon, up to the summer
of 1886, when that atelier was suddenly closed down by Cormon himself
on account of a disturbance among the pupils there. In spite of certain
quite erroneous theories . . . that van Gogh was of robust appearance
(to fit the fury of his painting, no doubt), I can affirm that to my eye
van Gogh was a rather weedy little man, with pinched features, red
hair and beard, and a light blue eye. He had an extraordinary way of
pouring out sentences, if he got started, in Dutch, English and French,
then glancing back at you over his shoulder, and hissing through his
teeth. In fact, when thus excited, he looked more than a little mad; at
other times he was apt to be morose, as if suspicious. To tell the truth,

Although based upon a private publication of 1916, this account is excerpted from
A Painter's Pilgrimage through Fifty Years (Cambridge, England: Cambridge Univer-
sity Press, 1939). Copyright © 1939 Cambridge University Press. Reprinted by per-
mission of Cambridge University Press.

[1] [Here the author had met Gauguin.—Ed.]

[2] [During the fall of 1886, Hartrick occupied Russell's studio in the Impasse Hélène,
Montmartre.—Ed.]

[3] [The studio of the relatively liberal academician Fernand Piestre, called Cormon
(1845–1924), was located at 104 Boulevard de Clichy.—Ed.]

I fancy the French were civil to him largely because his brother Theodore was employed by Goupil and Company and so bought pictures. . . .

. . . Among those working in the studio was a young man called Bernard, about eighteen years of age, in whom Cormon took an interest. Cormon came round one morning, as usual, to find Bernard painting the old brown sail that served for a background to the model, in alternate streaks of vermilion and vert veronese. On [being asked] what he was doing, Bernard replied, "that he saw it that way." Thereupon Cormon announced that if that was the case he had better go and see things that way somewhere else. . . . Cormon closed down the studio at once[4] for some months, and all the more aggressive students were sent away. During this period, the story goes that Vincent, full of indignation, took this interference with the free expression of the artist so much to heart that he went round with a pistol to shoot Cormon, but, fortunately, did not find him in. . . .

At this time, van Gogh was making his first pictures with the division of tones, painting still life, flowers and landscapes of Montmartre. There is no doubt that this plunge into pure color stimulated him violently, and he piled the oil paint on in a way that was astonishing and decidedly shocking to the innocent eye as well as to that of the more sophisticated, but he had not yet mastered his materials in the way that came to him soon after his arrival in Arles.

Although he was using Impressionist theories of the division of tones, I do not think he was ever a scientific painter in the sense that Seurat and Lautrec became in dealing with complementary colors; but he was particularly pleased with a theory that the eye carried a portion of the last sensation it had enjoyed into the next, so that something of both must be in every picture made. The difficulty was to decide what were the proper sensations so colored to combine together.

An obvious instance of this sort of idea will be found in the fact that the entering of a lamplit room out of the night increases the orange effect of the light, and in the contrary case, the blue. Hence to depict it properly, according to theory, it was necessary in the former case to include some blue in the picture and in the latter some orange. Van Gogh would roll his eyes and hiss through his teeth with gusto, as he brought out the words "blue," "orange"—complementary colors of course. . . .

. . . In some aspects Van Gogh was personally as simple as a child, expressing pleasure and pain loudly in a childlike manner. The direct way he showed his likes and dislikes was sometimes very dis-

[4] [Apparently inaccurate, since, whereas Bernard left the Cormon studio in April, Vincent, who left Antwerp for Paris at the end of February (Letter 459), thereafter spent "three or four months" attending Cormon's classes (Letter 459a).—Ed.]

concerting, but without malice or conscious knowledge that he was giv-
ing offence. When in Paris he did not appear so poverty-stricken to me
as one would suppose from the various tales written of him. He dressed
quite well and in an ordinary way, better than many in the atelier. I
have been to the flat where he was living with his brother Theodore,
54 rue Lepic. It was quite a comfortable one, even rather cluttered up
with all sorts of furniture and works of art. On an easel was the yellow
picture called *Roman Parisiens*,[5] the first of a series of yellow pictures.
Then he drew my attention specially to a number of what he called
"crêpes," that is, Japanese prints printed on crinkled paper like crêpe.
It was clear they interested him greatly, and I am convinced, from the
way he talked, that what he was aiming at in his own painting was to
get a similar effect of little cast shadows in oil paint from roughness of
surface, and this he finally achieved. He showed me some etchings
given him by Matthew Maris (Tyse Maris as he called him), an old
friend evidently,[6] also a bundle of lithographs by himself of Dutch
peasant women working in the fields, and among them a proof of that
terrible litho he called *Sorrow* done from the woman he lived with in Am-
sterdam [who was], naked, pregnant and starving.[7] When I admired some
of these he offered me the bundle, but I, perhaps foolishly, refused to
deprive him, as he was apt to act thus impulsively if anyone praised his
work. . . .

 While I knew him, I don't think anybody in Paris called him mad;
but I frankly confess that neither myself, nor any of those I remember
of his friends, foresaw that van Gogh would be talked of specially and
considered a great genius in the future. . . .

 Theodore van Gogh's gallery was in the Boulevard Montmartre,
quite separate from the main galleries of the house of Goupil, or rather
Boussod, Valadon et Cie, as it was beginning to be known. . . . There,
in his brother's shop, van Gogh at last met and made contact with
artists, whose experiments with pure color were to open his eyes and
[enable him] to create a new art of his own. Though I can not remem-
ber seeing Lautrec in the company of Vincent, I know they foregathered,
and about this time Lautrec made his well-known Pastel Portrait of
Vincent,[8] which is a good likeness and very characteristic of its author
as well. . . .

 All through the early part of 1887, Vincent frequently came to see

[5] [Probably F 359/H 231, which is more monochromatically yellow than the alternate
version, F 358/H 230.—Ed.]

[6] [Although Matthijs Maris (1839–1917) was never a close personal friend (see Letter
332), Vincent did greatly admire his work.—Ed.]

[7] [I.e., F 1655 (see also Fig. 1); the woman was "Sien," with whom circa 1882–83
Vincent lived in The Hague, not Amsterdam.—Ed.]

[8] [Now at the Van Gogh Foundation, Amsterdam; illustrated in color, *Complete
Letters*, 2, p. 520.—Ed.]

me in the Impasse Hélène, to the horror of poor Ryland,[9] who, having hung up a set of weak watercolors of the "La belle dame sans merci" type, found himself unmercifully attacked by the free tongue of van Gogh, who promptly told him that they were anaemic and useless reflections of Pre-Raphaelites—a kind of artist that he mostly despised. . . .

On another occasion I would be in to greet him. Now Vincent had a habit of carrying a thick stick of red and one of blue chalk in each pocket of his coat. With these he used to illustrate his latest impressions or theories of art. As he would start work on the wall or anything that was handy, I immediately placed a newspaper or two on the table, where he would at once begin to set out his latest "motif" in lines a quarter to half an inch thick. I recall the set-out of one such [motif], depicting the scene in a restaurant he favoured at that time.[10] It was a long narrow room, with a narrow table, and seats against the wall, a tall window filling the end. In the foreground he showed some overcoats hanging up, then a line of eaters in perspective. Through the window, as he eagerly informed me, was a dung-heap and on it "un petit bonhomme qui pisse." "Voila!" he said. The design was certainly striking and, again, I wish I had kept it. . . .

[9] [Henry Ryland (1856–1924), British academic figure painter, at the time was also a student of Cormon and shared the Russell studio with Hartrick.—Ed.]

[10] [I.e., the Chez Bataille restaurant in the rue des Abbesses, which is depicted less completely in F 1392 than in the lost drawing described by Hartrick.—Ed.]

VINCENT VAN GOGH (1886-87)

François Gauzi

When Vincent van Gogh entered the studio of Cormon he wished to be known only by his Christian name, and we remained ignorant of his family name for quite some time. He was an excellent companion if one left him in peace. Of northern temperament, he did not appreciate the Parisian spirit. Consequently, the mischievous members of the studio avoided bothering him; they were a bit afraid.

When "art" was being discussed, if one disagreed with him and pursued things to the extreme, he would get worked up in a disquieting fashion. Color drove him mad. Delacroix was his god, and whenever he spoke of this painter his lips trembled with emotion. For a long while van Gogh contented himself with drawing. His drawings were not out of the ordinary or characterized by any particular stylistic tendency. Then, one Monday he placed a canvas on an easel in order to paint for the first time in the studio.

On the modeling platform a woman was posed seated on a stool. Van Gogh quickly sketched his underdrawing on the canvas and took up his palette.

In correcting his students, Cormon demanded that they limit themselves to studying from the model, which is to say that they copy strictly what they had before their eyes, without changing anything. And the students followed rigidly the advice of their master. Van Gogh clearly ignored this advice. Being who he was, he wished to produce a painting rather than a mere study.

He transformed the platform into a couch and situated the woman

The original, slightly more complete version of this reminiscence appeared in François Gauzi, *Lautrec et son Temps* (Paris: David Perret, 1954), pp. 28–32. (Editor's translation and footnotes.) Reprinted by permission of Bibliotheque des Arts, D. Perret.

on a blue drapery.[1] The blue was of an unexpected intensity, which, when juxtaposed with the golden yellow of the woman's skin, resulted in a relationship of unmodified violent tones which were mutually intensifying. He worked with a disorderly fury, throwing colors on his canvas with febrile haste. He worked his colors as if mixing pastry, covering the length of his brush with the marks of his sticky fingers. He would continue painting even during the rest periods for the model. The violence of his study surprised the studio; the classically minded remained bewildered. . . .

When Cormon visited the studio on Wednesday, conversation ceased and, as was usual, a relative silence was observed. . . .

When Cormon moved in front of the study by van Gogh the silence became absolute, impressive. Everyone looked at his own drawing and listened intently. What would the master say?

Placed not far from Vincent, I could observe Cormon from the corner of my eye. He perused the painting by van Gogh impassively, without saying a word. Finally he spoke, and his correction failed to take note of the color, being concerned exclusively with the drawing.

Then each student returned to his work without further concern for either Cormon or Vincent.

During a visit which Vincent made one day to my residence, he noticed at the moment of his departure a book by Balzac, *César Birotteau,* lying on the table.

"You read Balzac," he said; "you are well advised; what an astonishing author, everyone should be obliged to know him by heart." . . .

I went to return his visit. He lived in a spacious, well-lighted room which also served as his studio. Just then he was finishing a still life which he showed to me. He had purchased at the flea market a pair of old, worn-out shoes, shoes of a street peddler which nonetheless were clean and freshly polished. They were sturdy footwear lacking in fantasy. He put on these shoes one rainy afternoon and took a walk along the fortifications.[2] Covered with mud, they appeared more interesting. A study is not necessarily a painting; army boots or roses might have served just as well.

Vincent copied his pair of shoes faithfully. This idea, which was hardly revolutionary, appeared bizarre to some of us, his studio comrades, who could not imagine a plate of apples hanging in a dining room as a companion piece to a pair of hobnailed boots.

[1] The painting is perhaps one among F 328/H 236, F 329/H 111, and F 330/H 235, none of which, however, quite manifests the striking color usage described by Gauzi.

[2] I.e., the ramparts surrounding Paris depicted in such watercolors as F 1400–F 1403. The painting of a pair of shoes almost certainly was one among Fig. 4, F 332a, and F 333/H 251.

ARTISTS' IMPRESSIONS OF VINCENT IN PARIS (1886-87)

SUZANNE VALADON:[1]

I recall van Gogh coming to our weekly gatherings at the residence of Lautrec.[2] He would arrive carrying a heavy canvas under his arm, which he would place in a well-lighted corner, and wait for someone to take notice of him. No one was the least concerned. He would sit down opposite his work, surveying the others' glances and sharing little in the conversation. Finally wearying, he would depart carrying this latest example of his work. Nevertheless, the following week he would return and commence the same stratagem yet again.

LUCIEN PISSARRO:[3]

It is quite difficult to describe van Gogh in physical terms, but I am able to relate a little incident. One day my father[4] and I happened to meet him along the rue Lepic. He was returning from Asnières carrying some canvases based upon motifs found there. He was wearing clothes of blue, the garment of a zinc-worker. Moreover, he insisted upon showing his studies to my father, arranging them side by side along a wall in the street, to the amazement of those passing by.

[1] Valadon (1867–1938), an artist's model, friend of Toulouse-Lautrec, mother of Maurice Utrillo and painter of genuine talent herself, provided this brief recollection for Florent Fels, *Vincent van Gogh* (Paris: H. Floury, 1928), p. 136. (Editor's translation and footnote.)

[2] From 1886 to 1888 Toulouse-Lautrec's successive studio-residences were at 7 rue Tourlacque and 27 rue Caulaincourt, or virtually around the corner from Vincent's 54 rue Lepic address.

[3] From a letter of May 27, 1928, written by Lucien Pissarro (1863–1944) to Dr. Paul Gachet, whose eponymous son published it in *Lettres Impressionnistes au Dr. Gachet et à Murer* (Paris: B. Grasset, 1957), pp. 54–56. (Editor's translation and footnote.) Reprinted by permission of Editions Bernard Grasset.

[4] I.e., Camille Pissarro (1831–1903), whose work Theo van Gogh was instrumental in selling and who later suggested that Vincent reside in Auvers near Dr. Gachet (see Letters T18 and T31).

Oh yes, I once attended an evening gathering at the rue Lepic, a gathering where we experimented with exercises in autosuggestion—a not uncommon practice. This was approximately during the years 1886–87.

PAUL SIGNAC:[5]

Yes, I knew van Gogh from meetings at the shop of Père Tanguy. On other occasions I would encounter him at Asnières and at Saint-Ouen. We painted together on the river banks, we lunched at roadside cafés and we returned by foot to Paris via the Avenues of Saint-Ouen and Clichy. Van Gogh, wearing the blue overalls of a zinc-worker, would have little dots of color painted on his shirt sleeves. Sticking quite close to me, he would be yelling, gesticulating and brandishing a large, size-thirty,[6] freshly painted canvas; in this fashion he would manage to polychrome both himself and the passers-by.

[5] This brief recollection by the neo-Impressionist painter was provided for G. Coquiot, *Vincent van Gogh* (Paris: Ollendorff, 1923), p. 140; see Letter 590a for a later reminiscence by Signac of Vincent in Arles. (Editor's translation and footnotes.)

[6] I.e., a painting approximately 21″ x 36″ in size.

EMILE BERNARD ON VINCENT (1886-87)

Emile Bernard

VINCENT VAN GOGH[1]

With reddish hair (a goatee, untrimmed moustache, closely cut on top), a sharp glance, and a mouth incisively set as if to speak; of medium build, stocky but not to an excess, quick of gesture, abrupt in gait— such was van Gogh, who was never without either his pipe, a canvas, an engraving, or a portfolio. Passionate in discourse, interminably expansive in developing his ideas, little prepared for controversy, yet always therein engaged. And his dreams, oh, what dreams! Gigantic exhibitions, philanthropic communities of artists, founding of colonies in the south of France; moreover, a progressive invasion of the public domain in order to reeducate the masses to the love of art which they knew in the past.

A Dutchman, a Protestant, the son of a pastor, van Gogh at first seemed destined for the cloth; but, although he made an attempt at this, he finally turned to painting. Excessive in everything, he doubtless chafed at the narrow-mindedness of his teachers! Converted to art, he studied Israels, whom he took as his first model. Rembrandt was next. Then he came to France, to the place where his brother, Theodore van Gogh, was established with the art firm of Goupil. Thanks to this brother, he was able to devote himself to painting. He hastened to study under Cormon, but was soon disillusioned. He experimented with the complementary colors of the Pointillists, with which he became annoyed. Finally, after studying the work of Monticelli, Manet, Gauguin, and others, his own style began to take flight. He definitely no longer was subject to the influence of another; van Gogh's work is more personal than that of anyone else. Enamored of the arts of Japan, of India, of China, of

[1] Bernard's commemorative tribute "Vincent van Gogh," here translated in full into English for the first time, appeared in *La Plume*, 3:57 (September 1, 1891), 300–301. (Editor's translation.)

all that which sings, smiles, and vibrates, he found among these innate [oriental] artists his astonishing technique for achieving harmony, the extraordinary flight of his draftsmanship. In the depths of his own being circulated the frenzied nightmares which weigh upon us so heavily and without respite.

PEOPLE OF TODAY:
VINCENT VAN GOGH[2]

I met Vincent van Gogh for the first time at Cormon's studio, where he did not condescend to notice those who were laughing behind his back, and later at the shop of Père Tanguy, that smiling and honest old priest in his tiny chapel of art. When Vincent emerged from the back room with his high and broad forehead, I was almost afraid that he would burst into flame.[3] However, we fast became friends, and he opened for me cartons of things from Holland and his portfolio of studies. What surprising sketches! Lugubrious processions viewed under gray skies, the "common grave";[4] views of the Paris fortifications in rectilinear perspective; the windmills of Montmartre with their sinister arms (over which still hovered a hazy northern fog); then, too, there were barren gardens, roadways in the light of evening, and faces of peasants with African eyes and mouths.[5] Upon the table, among some Japanese prints, were balls of yarn of which the threads were interlaced in an unexpected play of tonalities.[6]

I was bewildered to find within this chaos a mealtime of the poor in a darkened hut with a dim lamp. He called this *The Potato Eaters* [Fig. 2]; it was of a singular ugliness and expressed a feeling of inquietude.

Next he put away his works of art and we spoke of literature. He had a limitless admiration for Huysmans; he especially liked *En Ménage* and after that *A Rebours*. He was also strongly taken with Zola; it was while reading this author that Vincent thought of painting the humble shanties of Montmartre where the lower middle classes come to cultivate their tiny pieces of sand in the early morning sun.[7]

[2] This second essay by Bernard, "Vincent van Gogh," of which the present translation (by the editor) comprises approximately the first half, appeared in the pamphlet series *Les Hommes d'Aujourd'hui* (Paris: Vanier, 1891), 8, no. 390 (also included in the Vollard edition of Vincent's letters to Bernard, pp. 65–69). (Editor's footnotes.)

[3] Either Vincent's reddish hair or his explosive temperament could have been meant.

[4] See F 1399 and F 1399a for representations of the no longer extant *la fosse commune* of Paris.

[5] I.e., the Brabant studies of heads.

[6] These balls of yarn are preserved at the Van Gogh Foundation, Amsterdam.

[7] Apparently intended are, e.g., F 264a/H 394, F 316/H 364, F 346/H 265, and F 388verso/H 282.

As for painting, he loved above all others Monticelli and Delacroix, spoke of Millet with adoration, and despised profoundly the self-styled modern classicists. However, being as single-minded as he was, he had the unswerving faith of those who love art above all else, and he studied all types of art with equal interest.

Somewhat later, after we had become friends, he initiated me to all his projects—and how many there were! He was most discouraged not by the lack of appreciation for his own work, but by the fact that Pissarro, Guillaumin and Gauguin were in difficult financial circumstances which hindered their efforts at work. It was then that he undertook with his brother Theodore . . . a campaign which consisted in making these painters acceptable in the salons which are devoted to known, but inept artists. In this plan, aided by fraternal devotion, he succeeded fully.

Nonetheless, following an attempt at exhibition in a large working-class restaurant on the Avenue de Clichy,[8] he was attracted to the south of France (where his master Monticelli had primarily lived), and he departed for Arles.

. . . From Arles [date] the first canvases executed in a decisive manner. He already had painted at Asnières in an indecisive, Pointillist style and, then, some still life subjects realized with bars of *complementary colors,* among others the *Yellow Books,* which he exhibited at the Indépendants in 1888.[9] But only at Arles did he affirm himself in a very pictorial and personal technique. One thinks of *The Rhône, The Sower, The Berceuse, The Olive Trees, The Vines of Grapes.*[10] Oh, how much he loved those olive trees, and even then he already was tormented by a nascent symbolism! "In reference to the Christ at Gethsemane, I labor upon my olive trees," he wrote me.[11] In addition each of his works has a story, such as that for *The Berceuse* [Fig. 11]: "At night on the sea the fishermen see at the bow of their ship a supernatural woman, the sight of which does not frighten them at all, for it is the *berceuse,* she who pulls the cord to rock the basket of the baby when it whines; and it is she who returns to sing to the rolling of the *great wooden cradle* the hymns of childhood, hymns which bring rest and consolation to a hard life. . . ."

He consequently painted *The Berceuse* with the intention of offering it either to Marseille or to Saintes-Maries for placement in a tavern

[8] I.e., an exhibition at the Restaurant Du Chalet organized by Vincent late in 1887 and containing many works by himself and also contributions from Bernard, L. Anquetin, H. Toulouse-Lautrec, and the minor Dutch painter A. Koning.

[9] Either F 358/H 230 or F 359/H 231.

[10] All well-known Arles period subjects except The Olive Trees, executed at St. Rémy; see, e.g., Figs. 13, 19, 11, 21 and F 495/H 512.

[11] In Letter B21, which Bernard interprets somewhat arbitrarily; cf., Letters B19, 505, 540, 614, 615, and 643.

frequented by sailors. Two great sunflower paintings were to serve as companion pieces, because he saw in their intense yellow the supreme clarity of love.[12]

FROM *PREFACE TO THE LETTERS TO BERNARD*[13]

I can recall seeing him [Vincent] at Cormon's where he remained to work, as if incarcerated, after the other students had left in the afternoon. Seated before an antique plaster cast, he would copy the classic forms with angelic patience. He sought to take possession of the contours, the volumes, the surface relief. He would correct himself, recommence with passion, and end up by erasing until he had rubbed a number of holes in his sheet of paper. . . .

Carrying a large-sized canvas on his back, he would take to the roads; then he would cut up the canvas in pieces according to the demands of the subject which he chose to depict. In the evening he would return fully loaded. It was as if he had brought back a tiny travelling exhibition in which were displayed all of the day's emotional experiences. . . . Vincent often came to visit me in the studio made of wood which I had constructed in the garden of my parents' home in Asnières. It was here that we both commenced to make portraits of Père Tanguy,[14] and that he began one of me as well. However, having quarreled with my father, who rejected his advice about my own future, he became so angry that he abandoned making my portrait altogether and carried off that of Tanguy, unfinished and still wet, under his arm. He was gone for good and never set foot in our house again. Thereafter I was obliged to see him at the apartment which he shared with his brother at 54 rue Lepic.

One evening Vincent confided to me, "I am leaving tomorrow; we must arrange the apartment so that my brother will feel that I am still with him." He pinned some Japanese prints on the walls and placed his own canvases on easels, while leaving others piled up in heaps. He had prepared for me a roll of things which I untied; these were Chinese paintings, one of his discoveries, which he had rescued from the hands of a merchant of secondhand goods who used them for wrapping his customers' purchases. After this he announced that he was leaving for the south of France, for Arles, and that he hoped I would be able to join him there. "For," he said, "it is in the south of France that it is now

[12] Bernard's interpretation of *La Berceuse* apparently was drawn from Letters 574 and 592, where, however, there is no mention of a sailors' tavern.

[13] I.e., the Vollard edition; see Introduction, n. 5, above.

[14] The painting by Vincent was probably either Fig. 5, F 364/H 305, or less likely F 263/H 416.

necessary to found the artists' workshop of the future." I left and was accompanied by him until we reached the Avenue de Clichy—so justly called by him the "little boulevard"—where we shook hands. And that was our final good-bye; I was never to see him again, and I shall never again be so close to him until we are united in death. . . .

GAUGUIN ON VINCENT (1888)

Paul Gauguin

STILL LIFE PAINTINGS[1]

In my yellow chamber—sunflowers with purple orbs stand out upon a yellow background; the stems are immersed in the water of a yellow pot which stands upon a yellow table. In a corner of the painting, the painter's signature: Vincent. And the yellow sun which passes through the yellow curtains of my room, all this florescence is bathed in gold. In the morning upon awaking in my bed I imagine that all this must smell quite pleasant.

Oh! To be sure, he loved the color yellow, the good Vincent, this painter from Holland; flashes of sunlight refreshed his soul. Abhorring mists, he felt a need for warmth.

While we were together in Arles, both of us mad and constantly struggling to unravel the secrets of color, I myself adored the color red (where could one find the perfect vermilion?). He traced with his pure yellow brush upon a wall, suddenly turned violet:

> I am sound in Spirit.
> I am the Holy Spirit.[2]

In my yellow room was a small still life painting. It was in violet: two enormous, worn, and misshapened walking shoes, the shoes of Vin-

[1] A complete translation by the editor of "Natures Mortes," *Essais d'Art Libre,* 4 (January 1894), 273–75. A somewhat modified version of this recollection occurs in the "Diverse Choses" manuscript (p. 261), which Gauguin added to his manuscript for *Noa Noa* apparently in Tahiti circa 1896–97 (see R. Huyghe, "La Clef de Noa-Noa," in Paul Gauguin, *L'Ancien Culte Mahorie* [Paris: Pierre Berès, 1951], pp. 5–11). This latter version was published in Jean de Rotonchamp, *Paul Gauguin* (Paris: Edouard Druet, 1906; 2d ed., G. Crès, 1925). All footnotes are by the editor.

[2] The original couplet in French ("Je suis sain d'Esprit. Je suis Saint-Esprit.") sounds an ironic liturgical tone, in keeping with the double meaning of "natures mortes."

cent, those which, when still new, he put on one fine morning in Holland before departing by foot for Belgium.[3] The young preacher (he had just finished his theological studies in order to become, like his father, a pastor) was on his way to visit, in the mines, those whom he called his brothers. He had read of such simple workers in the Bible, oppressed for the luxury of the powerful.

Contrary to the teachings of his instructors, the wise men of Holland, Vincent believed in a Jesus who loved the poor. His soul was filled with charity and he wished, by means of consoling words and self-sacrifice, to help the weak combat the strong. Very decidedly, Vincent already was mad.

His teaching of the Bible in the mines was profitable, I believe, for the miners below, but disagreeable for the authorities above the ground. He was quickly recalled and dismissed, and a family council was held, which judged him insane and advised a retreat for reasons of health. However, he was not confined, thanks to the intervention of his brother Theo.

One day the somber, dark mine was inundated by a chrome yellow light; it was the terrifying flash of pit-gas fire, a powerful dynamite which never misfires. The beings who were crawling and swarming about in the filthy carbon when this occurred departed from life and from humanity that day without uttering the least blasphemy. One of them, frightfully mutilated and scorched on the face, was taken in by Vincent. In the meantime the company doctor classified this man a hopeless case, to be salvaged only by a miracle or by motherly attention which would be very costly to provide. No, it would be foolish to waste one's efforts.

But Vincent believed in miracles, in maternity. This madman (decidedly he was mad) watched over the bed of the moribund victim. He effectively prevented any contaminating air from reaching the wounds[4] and he paid for the needed medicaments. He spoke the words of a consoling priest (decidedly he was mad). This work of a madman succeeded in reviving a Christian from the dead.

When the injured miner, finally healed, descended into the earth to return to his toils, you could observe, said Vincent, the head of Jesus Martyr, surmounted on the brow by an aureole and carrying the jagged marks of the crown of thorns, red scars on the muddy yellow forehead of a miner.

And myself . . . I painted him, Vincent,[5] who with his yellow brush traced upon a wall suddenly turned violet:

[3] Possibly the painting of 1887 in blue and purple, *A Pair of Shoes*, F 333/H 251; see also Figure 4.

[4] By applying compresses soaked in olive oil; see Letter 143a.

[5] The portrait, *Vincent Painting Sunflowers*, is now at the Van Gogh Foundation, Amsterdam.

I am the Holy Spirit,
. . . sound in Spirit.

Decidedly, this man was mad.

THE INTIMATE JOURNALS [6]
(AVANT ET APRÈS)

For quite some time I have wished to write about van Gogh, and I shall certainly do so one fine day when I am feeling up to it! For the present I intend to recount about him, or, to put it better, about us, certain things which are likely to correct an error which has been circulated in certain quarters.

It was surely chance which dictated that in the course of my life several men who sought my company and an opportunity for discussion have gone mad.

The two van Gogh brothers fall into this category, and either through evil intention or naïveté their madness has been attributed to my doing. Of course, some persons exercise a relatively great influence over their friends. Quite a long time after the catastrophe, Vincent wrote me from the rest home where he was being treated. He said, "How fortunate you are to be in Paris. It's still there that one can find the top authorities. Certainly you need to consult a specialist in order to be cured of madness. Aren't we all mad?" It was good advice, which is why I did not follow it—doubtless as a gesture of contradiction.

The readers of the *Mercure* could have seen from a letter by Vincent, which was published several years ago,[7] how insistent he was that I come to Arles and be the director of the artists' studio which he wished to found.

I was working at the time in Pont-Aven in Brittany, and, either because I wished to finish some studies begun in this area or because my instincts vaguely forewarned me of something abnormal, I resisted a long while, until, vanquished by the impetus of Vincent's sincerity, I made up my mind to go.[8]

I arrived at Arles late in the night and was awaiting daybreak in

[6] Known in English from the Van Wyck Brooks translation of 1921 as *Intimate Journals*, Gauguin's original manuscript was called *Avant et Après* and was datelined "Atuana, Marquesas, January–February, 1903." The textual portion devoted to Vincent first appeared in Charles Morice, "Paul Gauguin," *Mercure de France*, 48: 166 (October 1903) and in Rotonchamp, *Paul Gauguin*. The present translation was made by the editor from the G. Crès edition of *Avant et Après* (Paris, 1923) and is slightly abbreviated.

[7] I.e., by E. Bernard in *Mercure de France* (see Introduction) during the period when Gauguin was visiting France (circa 1893–95).

[8] Compare this explanation with Letters B7, B14, B17, and 493–507 (excepting 498a, 499, and 502).

an all-night café. The proprietor took a look at me and exclaimed, "It's you, his pal, I recognize you."

The portrait of myself which I had sent to Vincent suffices to explain the exclamation of the proprietor.[9] While showing him my portrait, Vincent explained that it represented a pal who was expected to arrive shortly.

Neither too early nor too late, I went to awaken Vincent. The day was devoted to getting me installed, to exchanging gossip, and to walking about in order that I might admire the beauty of both Arles and the Arlesian women, about whom, incidentally, I could not work up much enthusiasm.

Beginning the following day, we set to work, he continuing where he had left off and I starting from scratch. . . .

It was . . . several weeks before I sensed clearly the tart flavor of Arles and its surroundings. This did not prevent us from working steadily, especially Vincent. Between the two beings, he and I, the one a ripe volcano, the other seething too, albeit inwardly, some sort of conflict was bound to occur.

From the first, everywhere and in every respect I discovered a shocking disorder. His box of colors scarcely sufficed to contain all of his squeezed-out paint tubes, which he never recapped. In spite of all this disorder, this mess, everything glowed warmly in his canvases, and in his speech as well. Daudet, de Goncourt, the Bible fueled the brain of this Dutchman. The quays, bridges and boats of Arles, the whole south of France had become for him another Holland. He even forgot how to write in Dutch;[10] as one can judge from the publication of his letters to his brother, he wrote only in French and this he did admirably with a full complement of elegant adverbial forms.

Despite my best efforts at disentangling from this disorderly brain a logical train of critical opinion, I was not able to fathom the complete contradiction between his painting and his judgments. Thus, for example, he had an unlimited admiration for Meissonier and a profound hatred for Ingres. Degas was his despair and Cézanne was nothing but a crackpot.[11] He wept when thinking about Monticelli.

It angered him to have to recognize in me a substantial intelligence, although my forehead was too small, a sign of imbecility. In the midst of all this, he could display great affection or, rather, the altruism of the Gospel. . . .

How long did we remain together? I could not say, having entirely

[9] I.e., *Self Portrait: Les Misérables* (illustrated in Rewald, p. 211) now at the Van Gogh Foundation, Amsterdam; see Letters 545, B19.

[10] Clearly untrue; Vincent was, in fact, trilingual (Dutch, French, and, less fluently, English) and occasionally wrote letters in Dutch through 1890.

[11] Quite dubious; Vincent's correspondence consistently reflects admiration for Degas and Cézanne, and a lesser respect, but scarcely "hatred," for Ingres.

forgotten. In spite of the rapidity with which the catastrophe arrived, in spite of the fever to work which had come over me, it seemed like a century.

Without the public having any suspicion, two men were accomplishing work of tremendous usefulness to them both. Perhaps to others? Certain things bear fruit.

At the moment when I arrived at Arles, Vincent was fully committed to the neo-Impressionist school, and he was floundering about considerably, which caused him to suffer. It matters little that this school, like all schools, was bad; [it matters] only that it did not accord with his constitution, which was so lacking in patience and so independent.

With all these yellows on violet, all this work with complementary colors, which was undertaken haphazardly by him, he produced merely subdued harmonies which were incomplete and monotonous; the sound of the clarion was missing.

I undertook the task of enlightening him, which was easy for me, since I found rich and fertile soil. Like all natures which are original and marked with the stamp of personality, Vincent had no fear of his neighbor and was not stubborn.

Beginning that day, our Vincent made astonishing progress; he seemed to sense all that he had within himself, and this resulted in that whole endless series of sun paintings executed in full sunlight.

Have you seen the portrait of the poet? [12]

The face and the hair are chrome yellow.

Second, the clothing is chrome yellow.

Third, the necktie is chrome yellow with a tiepin of emerald, green emerald, on a background of chrome yellow (the fourth instance [of this color usage]).

This is what an Italian painter observed to me, and he added, "*Merde, merde,* everything is yellow; I don't know what painting is any more."

It would be idle to discuss here details of technique. I mention this only to inform you that, without sacrificing a thumbnail of his own originality, van Gogh gained from me some fertile instruction. Each day he would express his gratitude for this. And this is what he wished to say in writing to Mr. Aurier, that he owed much to Paul Gauguin.[13]

When I arrived at Arles, Vincent was trying to find his way, whereas I, being considerably older, already had reached maturity.[14] To Vincent I do owe something; namely, in the awareness of having been useful to him, the strengthening of my own previous ideas about

[12] I.e., F 462/H 490, *Portrait of Eugène Boch, A Belgian Painter,* executed September, 1888.

[13] See Letter 626a.

[14] Vincent was then thirty-five, Gauguin just forty years of age.

painting. Moreover, in difficult moments, I am reminded that one can find others less fortunate than oneself.

In reading the passage, "The drawing of Gauguin somewhat recalls that of van Gogh," [15] I smile.

During the latter part of my stay, Vincent became excessively brusque and boisterous, then silent. Several nights I surprised Vincent after he had gotten up and was coming over toward my bed. To what should I attribute my awakening just at that moment? Invariably it sufficed for me to say to him very soberly, "What's the matter, Vincent?" and he would return to his bed without speaking a word and fall into a deep slumber.

I hit upon the idea of making his portrait while he was working upon the still life subject which he loved so much, some sunflowers. When the portrait was finished, he said to me, "It is indeed I, but I having gone mad."

That same evening we went to a café where he ordered a light absinthe. Suddenly he threw the glass and its contents at my head. I dodged the blow and, taking him bodily in my arms, I left the café and crossed over the Victor Hugo Square. Some minutes later Vincent found himself in bed, where he fell asleep in a few seconds and did not awake until the morning.

Upon awaking he said to me very calmly, "My dear Gauguin, I have a vague memory of having offended you last evening."

I responded, "I gladly forgive you with all my heart, but yesterday's scene could be repeated, and, if I were struck, I might lose control of myself and strangle you. Therefore, permit me to write to your brother and announce my return."

My God, what a day!

The evening having come, after quickly finishing my dinner, I felt a need to go walking alone and to enjoy the scent of the laurel flowers. I had already almost crossed over Victor Hugo Square when I heard behind me a familiar short footstep, rapid but irregular. I turned around just as Vincent rushed towards me, an open razor in his hand. My gaze at this moment must have been quite formidable, since he stopped and, lowering his head, ran in the direction of the house.

Was I lax in my behavior at this moment and was I not obliged to disarm and to seek to pacify him? I have often tested my conscience with this question, but I have never found anything to reproach myself with. Whoever desires may throw the first stone.

It was only a short stretch to a decent hotel in Arles, where, after asking the hour of day, I engaged a room and went to bed. I was very agitated and could not get to sleep before about three in the morning, and I awoke rather late—at about 7:30.

[15] A reference to A. Fontainas, *Mercure de France*, 29:109 (January 1899), 236; see discussion by Roskill, *Van Gogh, Gauguin*, pp. 279–81.

Upon arriving at the square, I saw that a large crowd was gathered. Standing near our house were some policemen along with a short gentle-man wearing a melon-shaped hat who was the commissioner of police.

This is what had happened. Van Gogh returned to the house and immediately cut off his ear close to the head.[16] He must have taken a fair amount of time in stopping the hemorrhaging, since the following day many sodden towels were still scattered about on the floor tiles of the two lower rooms. The blood had stained these two rooms and the staircase which led to our bedroom above.

When he was in good enough condition to go out, his head covered by a Basque beret pulled far down, he went straight to an establishment where for want of a fellow countrywoman one can find a chance ac-quaintance and gave the door sentry his ear, carefully washed and con-tained in an envelope. "Here is," he said, "a remembrance of me," [17] and then he fled and returned home where he went to bed and slept. He took the trouble, however, to close the shutters and to place a lighted lamp on a table near the window. . . .

Vincent lay in his bed completely enveloped by his bedsheets, curled up like the cock of a gun; he appeared lifeless. Gently, very gently, I felt the body, the heat of which assured me that it was still alive. This was for me like a reprieve from the suspension of all my powers of thought and of my energy.

Nearly in a whisper I said to the commissioner of police, "Could you, sir, awaken this man with great care, and, if he asks after me, say that I have left for Paris; the sight of me might prove fatal to him." . . .

. . . Vincent was conducted to the hospital, where, upon arrival, his brain began to wander about again.

The rest of the story is well known to those who are interested. It would be useless to speak about this, except for the great suffering of a man who, cared for in a madhouse, at monthly intervals sufficiently regained his reason so that he was able to understand his condition and in a frenzy paint those admirable pictures for which he is known.[18]

The last letter which I received from him was dated from Auvers, near Pontoise. He announced that he had hoped to be recovered enough to come and visit me in Brittany, but that now he was obliged to recog-nize the impossibility of a cure. "Dear Master" (the only time he used this word), "after having known you and caused you to suffer, it is more dignified to die in a good state of mind than in a degraded state." Ac-

[16] On Vincent's mutilation, see Rewald, p. 270, n. 42.

[17] Possibly another intentionally ambiguous reference (see n. 2, above), since, apart from Christ's institution of the Eucharist (see Luke 22:19–20), the words and ges-ture might imply a matador saluting the lady of his choice with the ear of a slain bull (and Vincent intended his gift for a certain Rachel).

[18] An exaggerated account, since Vincent remained productive, except for intervals of crisis, throughout the St. Rémy and Auvers periods.

cordingly, he put a pistol shot in his abdomen, and it was only some hours later that, lying in his bed and smoking his pipe, he died, having all his presence of mind, with love for his art and without hatred for others.

In *Les Monstres,* Jean Dolent writes, "Whenever Gauguin says 'Vincent' his voice is gentle." [19] Without any true knowledge, Jean Dolent guessed correctly. One knows why.

[19] Antoine Fournier (pseud. Jean Dolent, 1835–1909) in *Les Monstres* (Paris, 1896), p. 40, had described Gauguin as "lowering his voice for Vincent, Gustave Moreau, Puvis de Chavannes and the old masters of the museums."

A REMINISCENCE BY VINCENT'S SISTER-IN-LAW (1890)

Johanna van Gogh-Bonger

Vincent returned from the South on May 17, 1890. First he was going to spend a few days with us in Paris. A telegram from Tarascon informed us that he was going to travel that night and would arrive at ten in the morning. That night Theo could not sleep for anxiety lest something happen to Vincent on the way; he had only just recovered from a long and serious attack, and had refused to be accompanied by anyone. How thankful we were when it was at last time for Theo to go to the station!

From the Cité Pigalle to the Gare de Lyon was a long distance; it seemed an eternity before they came back. I was beginning to be afraid that something had happened when at last I saw an open fiacre enter the Cité; two merry faces nodded to me, two hands waved—a moment later Vincent stood before me.

I had expected a sick man, but here was a sturdy, broad-shouldered man, with a healthy color, a smile on his face, and a very resolute appearance. . . .

"He seems perfectly well; he looks much stronger than Theo," was my first thought.

Then Theo drew him into the room where our little boy's cradle was; he [Vincent W. van Gogh, born February 1, 1890.] had been named after Vincent. Silently the two brothers looked at the quietly sleeping baby—both had tears in their eyes. Then Vincent turned smilingly to me and said, pointing to the simple crocheted cover on the cradle, "Do not cover him too much with lace, little sister."

Theo's bride, Johanna van Gogh-Bonger, recorded her memories of three meetings with Vincent during the summer of 1890 in the introduction to the first edition of the *Brieven aan zijn Broeder* (see Introduction, n. 7 in this volume). This introduction has been maintained in the *Complete Letters*, from which the present translation by Mrs. Van Gogh-Bonger herself has been borrowed. Reprinted with permission of New York Graphic Society from *The Complete Letters of Vincent van Gogh* by Vincent van Gogh. © 1958.

He stayed with us three days, and was cheerful and lively all the time. St. Rémy was not mentioned. He went out by himself to buy olives, which he used to eat every day and which he insisted on our eating too. The first morning he was up very early and was standing in his shirt sleeves looking at his pictures, of which our apartment was full. The walls were covered with them. . . . Besides, to the great despair of our *femme de ménage*, there were under the bed, under the sofa, under the cupboards in the little spare room, huge piles of unframed canvases; they were now spread out on the ground and studied with great attention.

We also had many visitors, but Vincent soon perceived that the bustle of Paris did him no good, and he longed to set to work again. So he started on May 21 for Auvers, with an introduction to Dr. Gachet, whose faithful friendship was to become his greatest support during the short time he spent at Auvers. We promised to come and see him soon, and he also wanted to come back to us in a few weeks to paint our portraits. In Auvers he lodged at an inn and went to work immediately. . . .

Soon after, on June 10, we received an invitation from him to spend a whole day in Auvers and bring the baby. Vincent came to meet us at the train, and he brought a bird's nest as a plaything for his little nephew and namesake. He insisted upon carrying the baby himself and had no rest until he had shown him all the animals in the yard. . . . Early in July, Vincent visited us once more in Paris. We were exhausted by a serious illness of the baby; Theo was again considering the old plan of leaving Goupil and setting up in business for himself; Vincent was not satisfied with the place where the pictures were kept, and our removal to a larger apartment was talked of—so those were days of much worry and anxiety. Many friends came to visit Vincent—among others Aurier, who had recently written his famous article about Vincent [included in this volume] and now came again to look at the pictures with the painter himself. Toulouse-Lautrec stayed for lunch and made many jokes with Vincent about an undertaker's man they had met on the stairs. Guillaumin was also expected, but it became too much for Vincent, so he did not wait for this visit but hurried back to Auvers—overtired and excited, as his last letters and pictures show, in which the threatening catastrophe seems approaching like the ominous black birds that dart through the storm over the wheat fields [Fig. 25]. . . .

EARLY REVIEW NOTICES (1888-91)

GUSTAVE KAHN: SALON DES INDÉPENDANTS, PARIS, 1888.[1]

Mr. van Gogh has a vigorous brushstroke in his large landscapes and cares very little for the value and the exactitude of his tones. A polychromatic multitude of books is represented in the manner of a tapestry;[2] while this motif is satisfactory as a study, it can not serve as the pretext for a painting. . . .

FÉLIX FÉNÉON: SALON DES INDÉPENDANTS, PARIS, 1889.[3]

The *Irises* [F 608/H 606] violently slash their petals to pieces upon swordlike leaves. Mr. van Gogh is an entertaining colorist even in such extravagances as his *Starry Night* [Fig. 13], in which the sky is rendered as a crude matwork pattern of flat strokes of the brush and the stars appear as swirls of white, pink, and yellow which have been pressed directly from the tube. Triangles of orange are engulfed in the river waters, and oddly sinister figures move in haste near the moored boats.

ERNEST CLOSSON: LES VINGT, BRUSSELS, 1890.[4]

We return to *The Red Vineyard* [F 495/H 512] by the recently deceased Vincent van Gogh. If one assumes an ordinary point of view

[1] In this earliest known review notice of Vincent ("Peinture: Exposition des Indépendants," *La Revue Indépendante*, no. 18 [April 1888], p. 163), the writer reflects his bias for the disciplined style of neo-Impressionism; for Vincent's calm and thoughtful reaction see Letter 474. (Translated by the editor.)

[2] [Probably *Still Life: Romans Parisiens with a Rose*, F 359/H 231—Ed.] (See Hartrick's article included in this volume.)

[3] Fénéon (1861–1944), another supporter of Seurat, published this notice in *La Vogue*, September, 1889; it is included in the excellent two-volume edition of Fénéon's writings, *Oeuvres Plus Que Complètes*, ed. Joan U. Halperin (Genève-Paris: Droz, 1970), 1:168. (Translated by the editor.)

[4] This delayed appraisal of the 1890 Les Vingt exhibition appeared only after Vincent's death as "Peinture Symbolique," *Impartial Bruxellois*, March 22, 1891. It was translated by the editor.

in judging this painting, what does one say of the irradiating light, the diffusion of flaming rays, the vineyard in blood-drenched colors, and the orgy of warm and intense tonalities in which blood and fire appear to have usurped the place of color? It is madness, one will say, and not without reason. And one would not have made a mistake. But if one assumes the more particularized point of view of the artist and if one enters more deeply into his thinking, the canvas has a compelling attraction. Van Gogh has wished in his *Vineyard* to show us the ferment and the intoxication, the maddening warmth and effervescence of wine. And the abandonment in his color suggests the senseless orgies of which the vineyard can be considered the singular promoter and primary source.

GEORGE LECOMTE: SALON DES INDÉPENDANTS, PARIS, 1890.[5]

Mr. Vincent van Gogh's ferocious impasto and his exclusive use of colors which harmonize easily result in powerful effects: the violet background of *Cypresses* and the symphony of green in a landscape make a vivid impression.[6]

EMILE VERHAEREN: LES VINGT, BRUSSELS, 1891.[7]

By interposing Gauguin as an intermediary, one comprehends what is owed to Cézanne and Guillaumin by the Cloisonist, Vincent van Gogh. One could say that the latter paints as if with flaming matchsticks. His broad patches of vivid color, so to speak, are deployed like rows of upright little batons. The yellows are denied the slightest nuance, the blues cry out, and the blacks encircle the objects in order to produce a crude and barbarous ensemble. The skys appear stirred up by cyclones, the trees are bent in supplication, and the rustic, primitive human figures are defined in terms of ponderous poses and rhythms. Mr. van Gogh is, above all, decorative. In order to be most advantageously seen, his works ought to be viewed at a very great distance by the spectator. The technique is rudimentary and appears infantile, but how great is the simplicity of his gifts, so invaluable and peremptory. The drawings are no less powerful. They are of a mad and intemperate impetuosity; the manner of rendering is Japanese. His hand is sure but at the same time astonishing in its impatience. The strokes are large and vigorous, the ensemble majestic! But, alas, all this was executed by fingers which are now dead!

[5] As translated from *Art et Critique*, March 29, 1890, p. 203, by A. M. Hammacher in "Van Gogh," p. 13. Lecomte (1867–1958) was a well-known French playwright, anarchist sympathizer, and editor of the Symbolist weekly *La Cravache*.

[6] [Although these works remain unidentified, here Vincent exhibited principally landscapes from St. Rémy.—Ed.]

[7] Verhaeren (1855–1917), the noted Belgian critic and writer, published his review in *Nation*, February 14, 1891. The eight paintings and seven drawings exhibited here were selected with the aid of Theo's widow and Paul Signac, and most, if not all, represented subjects from Provence or Auvers. (Editor's translation.)

EUGÈNE TARDIEU: SALON DES INDÉPENDANTS, PARIS, 1891.[8]

A crepe of mourning marks the place reserved for Vincent van Gogh, that so curious artist who unfortunately died sometime last summer. Vincent van Gogh was a Dutchman; he admired Delacroix, Courbet, Millet, and Rembrandt. His life was one of the most curious psychological novels one could dream of. It is said that he was a relentless worker, a celibate, and a mystic. He had a powerful imagination, all the gifts of a painter, and doubtless very little of what one vulgarly calls "good sense." He pushed the theories which he embraced to an extreme until they became perfectly incomprehensible. Of the ten canvases which are exhibited at the Indépendants, I can claim to understand only two or three: a field executed in a beautiful delicate green which stretches out to infinity under an impeccable azure sky, a *Lane in Arles* of surprising coloration which nonetheless makes a striking impression,[9] and a *Resurrection of Lazarus* [Fig. 24], which is a strange interpretation of a well-known work [by Rembrandt]. The name of van Gogh doubtless serves as a pretext for interesting discussions on art from which might emerge some new truths. This strange painter has some passionate admirers, and his character attracted some strong friendships. . . .

[8] This review by a minor French critic appeared in *Le Magazine Français Illustré*, April 25, 1891. (Editor's translation and footnote.)
[9] The Field most probably represents an Auvers landscape (e.g., F 778/H 806 or F 782/H 759), while the *Lane* quite likely refers to the "Alyscamps" paintings (i.e., F 486/H 513, F 487/H 514, F 568/H 551, and F 569/H 552).

VINCENT, AN ISOLATED ARTIST (1890)

Albert Aurier

And so it happened that, all at once, immediately upon returning to the base and muddy confusion of the filthy streets and to the ugly world of a dissipated reality, in spite of myself, these bits of verse resounded in my memory:

> The intoxicating monotony
> Of metal, of marble and of water . . .
> And everything, even the color black,
> Appeared polished, transparent, iridescent;
> Liquid enshrined its glory
> In crystallized rays . . .
> And ponderous waterfalls
> Suspended their movement, dazzling,
> Like curtains of crystal,
> They became walls of metal . . .[1]

Under skies at times cut into dazzling fragments of sapphire and turquoise, at times moulded from some unknown kind of infernal sul-

Aurier's pioneering critical study first appeared as "Les Isolés: Vincent van Gogh," *Mercure de France,* 1:1 (January 1890), 24–29, and was reprinted in *Oeuvres Posthumes* (Paris, 1893), pp. 257–65. The segments translated here, by the editor, comprise chiefly the "literary appreciation" which opens the article, whereas a translation of the slightly longer historical analysis which follows can be found in Linda Nochlin, *Impressionism and Post-Impressionism, 1874–1904: Sources and Documents* (Englewood Cliffs, N.J.: Prentice-Hall, Inc., 1966), pp. 152–56. (Editor's footnotes.) Reprinted by permission of *Mercure de France.*

[1] This poem is a pastiche of the "Rêve Parisien" from Baudelaire's *Les Fleurs du Mal* (kindly identified for me by Prof. L. J. Austin, Cambridge University). Possibly Aurier's quotation and subsequent analysis was inspired by Letter 499, which he could have read at Theo's; see also Letters B7, B12, B13, and B21 for Vincent's comments on Baudelaire.

phur, so warm, poisonous, and blinding; under skys resembling molten outpourings of metal and crystal, which every so often are irradiated by torrid solar disks; under an incessant and awesome shimmering of every imaginable effect of light; heavy, flaming, pungent mixtures of air, seemingly exhaled by fantastic furnaces in which gold, diamonds, and [other] singular gems are volatilized—here is a disquieting and disturbing display of a quixotic nature, simultaneously true to life, yet quasi-supernatural; of an excessive nature, in which everything, being and appearance, shadow and light, form and color, rises and rears up in a willful rage to howl its own essential song—at full pitch and as fiercely shrill as possible. We find trees twisted like battling giants, proclaiming with the gestures of their gnarled, menacing arms and with the tragic soaring of their green manes, an untamable power, the pride of their musculature, their blood-warm sap, their eternal defiance of the hurricane, of lightning, of malevolent nature. There are cypresses which show off their nightmarish silhouettes of black flame; mountains which rear their backs like mammoths or rhinoceroses; white, pink, and honey-colored orchards, like the idealizing dreams of virgins; squatting, passionately contorted cottages along with beings who feel pleasure, suffer, and think; rocks, pieces of land, undergrowths, plots of grass, gardens, and rivers which one may describe as sculpted from unknown minerals which have been polished to a brilliant and enchanting iridescence. Flaming landscapes appear as the effervescence of multicolored glazes emerging from some diabolical crucible of an alchemist; frondescences like the patinas of ancient bronze, new copper and spun glass; gardens of flowers which appear less like flowers than like the most luxurious jewelry made from rubies, agates, onyxes, emeralds, corundums, chrysoberyls, amethysts, and chalcedonies. It is the universal, frantic, and blinding coruscation of objects; it is material reality or nature frenetically distorted into a paroxysm of extreme exacerbation; forms are seen as in nightmares, color has turned into flame and, once purified, becomes jewellike, light sets fire to itself, and life is lived at a fever pitch.

Such was, without exaggerating, as one might suppose, the impression which is left upon the retina when it first views the strange, intense, and feverish work of Vincent van Gogh, that compatriot and not unworthy descendant of the old Dutch masters.

Oh! how far we are—is it not so?—from the beautiful, great traditional art, so wholesome and well-balanced, of the Dutch past! . . . How distant from the delicate and always somewhat cloudy and hazy colors of northern countries and from the untiring picking and choosing among these well-mannered artists from former times over there who painted "in their manner" with a calm spirit, warmly clad feet, and a belly full of beer. . . .

It is . . . permissible to relate the work itself of Vincent van Gogh to his temperament as a person, or rather as an artist. This process of

induction is corroborated, if I wish to use them, by certain biographical considerations. What characterizes his work as a whole is its excess of strength, of nervousness, its violence of expression. In his categorical affirmation of the character of things, in his often daring simplification of forms, in his insolence in confronting the sun directly, in the vehement passion of his drawing and color, right down to the smallest details of his technique, a powerful figure is revealed—masculine, daring, very often brutal, yet at times ingenuously delicate. This is revealed in the almost orgiastic exaggerations of everything he has painted; he is a fanatic, an enemy of bourgeois sobriety and of pettiness, a kind of drunken giant, better at shaking up mountains than handling delicate nicknacks, a brain at the boiling point, pouring down its lava unchecked into all the ravines of art, a terrible, saddened genius, often sublime, sometimes grotesque, always near the brink of the pathological. Last, and most important, he is a hyperaesthete with clear symptoms who, with abnormal, perhaps even painful, intensity perceives the imperceptible and secret characteristics of line and form, and still more, those colors, lights, and nuances which are invisible to healthy eyes, the magic iridescence of shadows. And this is why the realism of this neurotic, as well as his sincerity and his truth, are so different from the realism, the sincerity, and the truth of those great petty bourgeois of Holland, who were so healthy physically and well-balanced mentally, who were his ancestors and his masters. . . .

Nevertheless, one should not deceive oneself into thinking that Vincent van Gogh was not a product of this same ancestry. More than many another, he underwent the influence of those ineluctable, atavistic laws of which Mr. Taine deliberately makes a mystery.[2] He is good and properly a Dutchman of the sublime lineage of Frans Hals.

Moreover, like all his illustrious compatriots, he is, in effect, a realist, a realist in the most basic sense of the term.

Ars est homo, additus naturae said Chancellor Bacon,[3] and Mr. Emile Zola has defined naturalism as "nature viewed through the medium of a temperament."[4] Now, it is this "*homo additus*," this "through the medium of a temperament," this variable deformation according to one's temperament, or this moulding of that which is hypothetically believed to be objectively true and always the same into that which is subjective and diverse which complicates the issue and obviates any possibility of [arriving at] absolute criteria for judging the degree of passive sincerity of an artist before [the world of] nature. . . .

[2] Hippolyte Taine (1828–93), in his *Philosophie de l'Art* (Paris, 1865), codified a positivist, sociological art theory antithetical to the emergent Symbolism of Aurier.

[3] The phrase of Francis Bacon (1561–1626), the English philosopher, may be translated as "art depends upon men who are dedicated to nature."

[4] Zola's own wording was "Une oeuvre d'art est un coin de la création vu à travers un tempérament."

VINCENT AS COLORIST (1890)

Frederik van Eeden

[The following is] not art criticism, a critical opinion, but only an impression, a personal observation. Possibly it is important, because it concerns the work of a brilliant, but virtually unknown Dutch artist who died a few months ago.

I permit myself to write about van Gogh because I believe that even someone who is not a painter can [nonetheless] experience his art in a pure manner. Perhaps [such a person can react] even more purely and forcefully than other painters, since the latter are more likely than non-artists to be angered by his neglect of many things which they themselves take seriously. . . .

I don't understand fully how it now happens that the work of Vincent van Gogh affects me so directly and with such unexpected immediacy and intensity. I am scarcely able to clear from my mind the memory of his pictures. I see his colors in the objects of my everyday environment and am surprisingly able to see beauty in things which formerly did not appeal to me. He is certainly not less modern, albeit less Dutch, than other contemporaries. Perhaps he is indeed less refined and less subtle than others. One of our best Dutch critics assured me that van Gogh is rhetorical. Perhaps therefore I am like the second-rate reader of verses, who is not strongly affected by poetry which is without a little bit of rhetoric and who for this reason prefers Byron to Shelley.

Vincent—for it is with this name only that he signed his work—employed strong, vivid coloring, not the subdued, finely nuanced tonal colors of the best contemporary Dutch painters.[1] [He avoids their]

Approximately half of this eulogistic, earliest tribute of any length in Dutch, "Kunst: Vincent van Gogh," *De Nieuwe Gids*," December 1, 1890, pp. 263–70, has been included in the present translation, which is the editor's. (Editor's footnotes.)

[1] An almost certain reference to the Hague School, including Anton Mauve.

delicate greys, toned-down ultramarine, and soft yellowish ochers [and favors] only violently sparkling [hues:] glaring green, pure vermilion, intense violet purple, strong cobalt blue, and above all yellow, a fierce yellow, a brutal chrome yellow. Some canvases are filled with a single, gleaming, powerful, and merciless yellow.

I am partial to such usages, but I didn't know until I saw Vincent's work that I was as strongly attached as I now realize. This inclination towards bright colors is a primitive inclination, but perhaps at the same time an expression of refinement. All southern and Asiatic peoples employ more vivid colors than do we Dutch. However, the Flemish and North-Netherlands primitives from the fourteenth and fifteenth centuries produced brightly colored paintings, and in earlier times the Dutch people knew how to select and harmonize splendidly the bright colors of their clothing and household effects.

It is generally thought, I believe, that bright colors can never be as beautiful as toned-down or mixed colors; it is felt that a refined and highly developed taste will scorn such brightness as crude and childlike. Yet the colorfulness of van Eyck was by no means crude and the brightness of Japanese drawings and watercolors is hardly childlike. At the Paris exhibition[2] there was nothing produced by the modern European art industry which compared with the colorful ornaments, vases, and clothing from Tunis, Morocco, Algeria, Persia, India, Indo-China, and Japan.

"The Dutch painters lack courage," said Vincent, "they don't dare use genuine color in their canvases." [3]

But courage is not enough in my opinion. Dutch farm women still are to be seen wearing green and purple dresses. These are usually described as "screeching colors," and to be sure they produce a mighty ugly scream. Our people have lost the ability to clothe themselves with pure colors.

That it takes courage to use such colors is proven by the difficulty and danger inherent in their use. Whoever uses them poorly produces something quite ugly, something much worse than a badly executed painting in mixed, subdued tonalities.

I discovered that van Gogh was both brutal and beautiful in his manner. This was an additional, incidental pleasure, like hearing someone who is able to sing loudly without hitting any false notes. One is always inclined to be a bit timid at first, since one imagines that loud singing must always be either ugly or affected. But, if it goes well and the timidity is overcome, then one takes pleasure in a strong voice. Likewise, I take pleasure in these bright, vivid colors.

Van Gogh exaggerates quite strongly. He sometimes paints blood-red trees, grass green skies and saffron yellow faces. I had never seen

[2] I.e., the Exposition Universelle de 1889.
[3] See Letter 476, which van Eeden could have read thanks to Theo's widow.

such things, but yet I could understand him. Later, having viewed his paintings, I began to see his colors in actual objects, just as he had seen in things the essential colors which he was able to extract. In an evening sky there is green, while in the tilled fields beneath there is purple; he painted these two things in strong contrasting greens and purples, and it was beautiful. It was beautiful because it was just right. That is to say, he had chosen the right color combination, which had been responsible for the beauty found in nature, and he had extracted this in all its purity and set it down as a beautiful contrast. He was able to enhance the harmony of the colors while holding them in balance./Must everyone always demand from an artist that his work reproduce as closely as possible the real appearance of things? Rather, one should merely demand that he express as strongly as possible what is beautiful in natural appearance or, to put it better, in *his* vision of reality, in his spiritual or emotional life. And for myself, who am less directly sensitive to the beauty of subtle nuances, this crude, strongly accentuated, and raw expression of color produced a very powerful and direct sensation of beauty. . . .

THE MAN TRANSCENDS THE ARTIST (1891)

Johan de Meester

It was in his flower paintings, I believe, that Vincent was at his purest and was most exclusively a painter. Whenever he produced landscapes, the thinker, the poet, and the symbolist too readily came to the fore, whereas with flowers he often was able to limit himself to the visual attractiveness of the subject and to attempt to reproduce the colorful splendor of flowers in a lifelike manner on canvas. Flowers glitter and sparkle, and van Gogh was enraptured with strong colors. Golden yellow crowfoots and sunflowers and dark fiery irises were placed before a golden yellow backdrop, and he produced from this a painting more than a yard in height. Alternatively, he selected from a landscape setting a detail of an orchard. Here one sees, against the green ground-plane and set along dark branches, heavy, provocatively bursting blossoms which gleam iridescently in their beautiful, maidenly colors and are magnificently luxurious in their youthful nakedness. Or yet in another way—since the flowers seduced this man of violence into courtliness—he used them to decorate his female figures or painted them in the decorative manner of the Japanese, whose art he passionately admired.

The art of Japan also occasionally influenced his landscapes, for instance, when he painted rolling fields or orchards. Apart from this love, one can readily see in his work admiration for the sentiment of Holbein[1]

This leading Dutch journalist had known Theo in Paris since 1886. Although various segments of text, excluded here, contain incorrect biographical data and a dubious theory of "faulty technique," de Meester's "Vincent van Gogh," *Nederland*, March, 1891 (datelined January), pp. 312–19, remains an impressive early analysis of the color usages and the Realist-Symbolist content in Vincent's art. (Translation and footnotes by the editor.)

[1] See F 847–48.

and in particular for that of Millet. He wished to be simple and naive—
I shall very shortly explain that this had a special meaning for him—
and several heads of young girls and children possess the pure tautness
of a Holbein portrait. Like Millet, he attempted to live as a man of the
land—first in his native Brabant, later in various regions of France,
chiefly in Provence—in order to penetrate spiritually into that kind of
life and, by experiencing everything therein which was beautiful, deeply
poetic, and of artistic value, to reproduce it [as art]. . . .

Especially among Dutch artists who favor delicately tonal painting,
there could be found critics who, through an idealized love of harmonized
color, would deny Vincent the title of colorist. Very definitely he does
not idealize. Yet, just as little was he satisfied with the ugly, screaming,
and in part quite conventional colors of so many modern French artists.
He found Provence beautiful and attempted to reproduce that which he
saw as sharply and exactly as possible. He accomplished this by employ-
ing very strong hues in a search for a balance of values which was based
not upon some ideal harmony, but upon—as far as this is possible to
realize in the medium of paint—the harmony which he found in nature.

Simultaneously, he sought the power of nature, her violent king-
dom. A sunlit path, a pedestrian lane somewhere in the south of France,
was pictured thus: the sandy path is orange, the trees lining it are blue,
alongside [there is] a strip of bright green grass and finally another side
path in pink shadow. Certainly, it will be a long time before the general
public believes in blue trees. Yet, in the course of time the public will
almost surely learn to use its eyes and also learn to understand that an
object may be green in nature and yet appear blue through the effects
of its surroundings, through the effect of light and atmosphere. . . .

Another painting, which is just as bright in color and characteristic
as the path just mentioned, represents the room which he rented from a
farmer in Provence [Fig. 9].[2] The bedstead is orange, the chairs are
golden yellow, the wallpaper is bright blue, the chimney place purple
violet, the table green, and the floor brick red. One must have something
in order to use such colors and to make something good and harmonious
out of them!

This is also a singular canvas because of the extraordinary naive
and very distinct outlines found in the composition. It is as if he were
attempting to teach children to learn to use their eyes! And there was
something intentional in this. Vincent van Gogh—I already have referred
to this tendency—wished to make art something popular; convinced that
art could have great meaning for the average person, he believed that
one was obliged to popularize art by making it easier to understand.
This explains [why he produced] so many commonplace subjects, the
linearly simplified compositions and color combinations such as those

[2] In fact, the Yellow House in Arles had been rented from a hotel proprietor; see
Letter 480.

found in the cheapest types of popular prints.[3] This painter remained the same student of divinity who, of necessity (to some extent) self-taught, departed for the Borinage.

In this respect, van Gogh practiced painting for its own sake just as little as he had theology. He was no artist by instinct, but rather, thanks to a particularly rich temperament, he found in painting the most appropriate opportunity to express his own conceptions of nature and of life. . . .

He wished to express, in whatever manner possible, the many things which seemed important to his rich intelligence. Time and again in his paintings he lapsed into the use of symbols. With great enthusiasm he attempted to express the titanic and chaotic aspect of nature. Trees, their trunks or, in other examples, the top parts, become giants which, although forcefully wedged into the ground, simultaneously appear quite broad, quite heavy, and quite tall. Behind these forms the sun is seen to set against an aurora borealis. In the foreground lie stretches of heath or piles of hay which take on the outlines of a hunchback. Now and then there is a human being in the fields, and occasionally such figures constitute the primary subject matter, as in the many sowers which he painted, those peasants with their inspired animallike behavior. Clearly the silhouettes, the movements of the hands, and the work itself of these peasants made a very deep impression on the artist. He penetrated so readily into their natures that in numerous instances one can discover Vincent's own traits in the image of an energetic farmer.

Nowhere was he more a symbolist than in *La Désolation des Champs*,[4] a canvas of considerable width in which golden yellow, heavily convoluted and bristly grain stalks wave about. A slate pink path leads to the crest of an incline which culminates in the dark blue of the stormy horizon and, above the grain, black birds sweep past, which appear like fluttering claws. This canvas made me think of a drawing made by Victor Hugo in his youth and representing a tossing sea.[5] Both the painting and the drawing express powerfully a Romantic sense of the chaotic. Indeed, this painter, who wished to be as realistic as possible in his use of color, was a Romantic in his use of symbols. Titanic feelings must have coursed and surged throughout his being, and it is very much in question whether or not the art of painting was a sufficient medium for their expression.

I had an occasion to see a *Sous Bois*, which was said to be his final painting.[6] It was full of sun and life, a marvelously opulent piece drawn from a sumptuous and joyous [conception of] nature, and a very good

[3] Literally, "penny-prints," meaning brightly colored prints of the type then popular in Paris.

[4] I.e., *Crows in the Wheatfields*, Figure 25.

[5] The French Romantic writer had produced many marine watercolors during the 1860s; for Vincent's admiration of Hugo see Letters 136 and 621.

[6] Probably F 816/H 801 or, less likely, F 773/H 764.

painting. I looked at this work for a long while, but it was impossible for me to see in it the supreme expression, the final testament of van Gogh's temperament. That temperament was more impetuous in its richness, just as it was more vehement with every complete revelation. Moreover, however important it is to recognize the talent of this artist of only ten years' productivity, his image takes on unusual proportions only if we see him struggling and agonizing with the nervous energy of a modern Byron about those puzzles which, as a painter, he was as little able to find solved in nature as he was, as a student of theology, to find them solved in the realm of doctrine. . . .

STYLE AS AFFIRMATION OF A PERSONALITY (1891)

Octave Mirbeau

At the exhibition of the Indépendants,[1] among some successful experiments and especially among much banality, not to mention the frauds, the canvases of the much regretted Vincent van Gogh stand out clearly. In front of the black crepe of mourning which attracts the attention of the crowd of [otherwise] indifferent passers-by, one is overcome by a great sense of sadness to think that this magnificently gifted painter, this so overwrought, so instinctive, and so visionary artist, no longer lives. It is a cruel loss, far more sorrowful and irreparable for art than that of Mr. Meissonier, even if the public was not treated to the pompous obsequies [which were granted the latter artist].[2] In the case of the unfortunate Vincent, with whom expired a true flame of genius, he entered into a death which was as obscure and little noticed as had been a life [beset by] injustice.

Moreover, it is not necessary to make a judgment based only upon the several works which are exhibited at present in the Pavillon of the City of Paris,[3] where they appear very superior in intensity of vision, in richness of expression, and in power of style to all the surrounding works. To be sure, I am not insensitive to the research on light by Mr. Georges

Although never fully translated into English, Mirbeau's commemorative tribute "Vincent van Gogh," *Echo de Paris*, March 31, 1891, exercised a decided influence upon much early writing about the Dutch artist. The present translation, made by the editor, is complete except for a romanticized and factually inaccurate biographical account. (Editor's footnotes.)

[1] I.e., the Salon des Indépendants, Paris, 1891.

[2] E. J. Meissonier (1815–91), the painter of minutely executed, often miniature-sized, academic, historical and genre scenes, had been granted an extravagant public funeral as a national hero.

[3] The location of the Indépendants exhibition on the Champs Elysée.

Seurat, whose seascapes I deeply admire for their exquisite and penetrating luminosity. But none among these incontestable artists[4] retains my attention as does Mr. Vincent van Gogh. With him I sense myself in the presence of someone more elevated, a greater master, who makes one restless to the point of turmoil through the imposition of his talent. . . .

Van Gogh was of Dutch origin, from the country of Rembrandt, which artist he seems to have loved and admired greatly. His temperament was of such abundant originality, of such fire, and of such hyperaesthetic sensibility that he used personal impressions as his only guide. If one wishes to cite an artistic patrimony, one might perhaps say that Rembrandt was his chosen ancestor, the one whom he wished to see reborn. In the artist's numerous drawings, one does not discover specific resemblances [to Rembrandt], but rather a similar cult of the exasperated and a parallel richness of invention. Van Gogh does not always adhere to the discipline and the sobriety of the great Dutch master, but he frequently equals him in eloquence and a prodigious faculty for rendering life. Van Gogh's manner of feeling is provided to us very exactly and affectingly in the copies which he executed after various works by Rembrandt, Delacroix, and Millet. These are admirable. However, one should not really speak of copies in reference to these imposing re-creations. They are, instead, interpretations through which the painter is able to re-create the work of others and to make it his own without abandoning the original spirit and special character of his model. In the *Sower*,[5] a work based on Millet but rendered with superhuman beauty by van Gogh, the sense of movement is accentuated, the vision is expanded, and the line is amplified to symbolic significance. That which was Millet still lives in the copy, but Vincent has introduced something of his own through which the painting immediately gains a novel quality of splendor. It is quite certain that his observation of nature is characterized by the same mental habits and superior creative gifts which he brings to the study of earlier masterpieces of art. It is not possible to forget his personality, whether it be directed towards some scene from reality or towards an internal vision. It overflows his being, giving intense illumination to all that he sees, touches, and feels. It is not, however, that he has become absorbed in the natural world. Rather, he has absorbed nature within himself; he has forced nature to become tractable, to be moulded by the forms of his thoughts, to follow his flights of imagination, and

[4] Along with Seurat, Mirbeau had praised Theo van Rysselberghe, Maurice Denis, Armand Guillaumin, Toulouse-Lautrec, Lucien Pissarro, Louis Anquetin, and, with greater reservation, Paul Signac.

[5] For the three types of late Sower painting by Vincent, see Figure 19, F 450/H 481, and F 689/H 660.

even to submit to his so characteristic deformations. Van Gogh possessed, to a rare degree, that which distinguishes one person from another—style. Among a throng of unsorted canvases, it takes only a quick glance to recognize those of van Gogh, just as it is possible to recognize those of Corot, Manet, Degas, Monet, or Monticelli. All these artists have their own genius, which could not be otherwise and which represents a style, or, in other words, the affirmation of a personality. In everything which is depicted by the brush of this strange and powerful creator there lives something unusual which is independent of the objects he paints and which is in himself—is himself. He exerts himself completely on behalf of the trees, skies, flowers, and fields which he disgorges from the astonishing torrent of his being. These forms multiply, follow their wild courses and writhe about, culminating in the imposing madness of his skies, where the heavenly bodies swirl and stagger about as if intoxicated and where the stars spread out in untidy rows of comets. Yet, even in the abandonment of fantastic flowers, which rear up and ruffle their feathers like demented birds, van Gogh invariably maintains his admirable qualities as a painter, a moving nobility and a tragic grandeur which is terrifying. And in his moments of calm, what serenity there is in his vast sunlit plains, his orchards in bloom, where the plum trees and apple trees appear in joyous snowlike white and where the goodness of life ascends from the earth in gentle vibrations and expands into the soft pallor of peaceful skys bathed by refreshing breezes. Oh, how he has understood the exquisite soul of flowers. How his hand, which can set such terrifying torches into the black firmament, becomes so delicate in binding these perfumed and fragile bouquets. And yet even such caresses as these do not explain how he can express their inexpressible fragrance and infinite grace.

And how well he also has understood the sadness, the unknown and divine in the eyes of the poor, mad and sick men who were his brothers.[6]

[6] E.g., F 533/H 558 and F 703/H 653.

VINCENT'S PAINTINGS AT THE
BERNHEIM JEUNE GALLERY (1901)

Julien Leclercq

The numerous exhibitions and great public sales which have occurred during the last five or six years have finally assured the victory of the Impressionist movement, which was preeminently a French movement in art. From its beginnings it was to have very great repercussions, and it already figures as an important chapter in the history of painting. A process of classification and selection has been taking place among the works of the early masters of this movement; each is now attributed a role for the originality and influence which he exerted in the common effort.

Monet, Degas, Renoir, Pissarro, and Sisley are today incontestably glorious names. Cézanne is in the process of being accepted, following a long period of unobtrusive labor. There remain two or three among those who threw themselves from the first into this heroic battle whose work is too little known and whose contribution is imperfectly delineated. These are Armand Guillaumin, Paul Gauguin, and Vincent van Gogh.[1] For them, too, the time will come. The time has come, in fact. The present exhibition will permit those who are unfamiliar with the

Leclercq met Vincent in 1890 in the company of A. Aurier. He survived both just long enough to produce the catalogue essay for the first broadly appreciated exhibition of Vincent's work held in France. (That of 1897 at the Vollard Gallery received little public or critical attention.) The overwhelming majority of the seventy-one works displayed at the Bernheim Jeune Gallery, Paris, in March, 1901, were from the French periods, and Leclercq's essay, translated here in somewhat abbreviated form, further witnesses a belated acceptance of Vincent as an artist within the mainstream of French tradition. (Editor's translation and footnotes.) Reprinted by permission of Galerie Bernheim Jeune.

[1] Only Armand Guillaumin (1841–1927), of course, was from the first a genuine Impressionist.

work of Vincent a chance to render him justice. Alas, this reparation can be granted only posthumously. . . .

At The Hague, in Drenthe, and at Nuenen, Vincent painted in a black manner; he worked with vigor, producing some landscapes, a great number of portraits and studies of peasants and rustic scenes.[2] The *Potato Eaters* [Fig. 2] from Nuenen is the most important characteristic work of this period. Upon his arrival in Paris, Vincent did not immediately adopt a lighter palette. . . .

Yet, the Impressionists and especially the most brilliant among them, Claude Monet, soon had an influence upon him. [The canvases of] his compatriot Jongkind, whose work was disdained for a long time, began to appear frequently in the shop windows of the merchants of the rue Lafitte,[3] and Raffaëlli, with his Parisian character, began to have an influence as well.[4] And that was not all. The long-standing admiration which Vincent had had for Delacroix became even more ardent. At the same time, he discovered [works by] Monticelli in the store belonging to Delarbeyette.[5] The works from 1886 and the beginning of 1887 do not have a well-defined character. One thinks here of such studies as the *Impression of July 14th*,[6] already Impressionist in appearance, and of the bouquet of flowers, in which one senses [the influence of] Delacroix and Monticelli.[7]

It was in the course of 1887 that he adopted Impressionism openly and passed it on in such landscapes as the *Bridge at Asnières* [F 301/ H 380], in which one sees that the technical question of a minute division among colors, inspired by Seurat, did not leave him indifferent, even if this patient methodology did not suit his lively talent. In the midst of all these influences Vincent developed quickly. The Japanese also provoked some hasty meditation in this painter who had so prodigious a capacity for assimilation. A great shock, sudden isolation, and the observation of vibrant natural surroundings, all this blending with a rich

[2] Actually, very few figural works from the Dutch periods were executed as portraits.

[3] Where both the Bernheim Jeune and the Durand-Ruel galleries were located.

[4] Vincent's admiration for J. F. Raffaëlli (1850–1924), the minor Impressionist painter of various character types and settings in Paris and environs, dates from the summer of 1885 when he received, in Brabant, an illustrated catalogue sent by Theo of an exhibition of Raphaëlli's works (almost certainly that of March–April, 1884, at 28 bis avenue de l'Opéra); see Letter 416.

[5] The shop of Joseph Delarbeyette, rue de Provence, exhibited the work of Adolphe Monticelli (1824–86) beginning circa 1882.

[6] I.e., F 222/H 387 (no. 22 in the Bernheim Jeune catalogue), the attribution of which to Vincent has sometimes been doubted.

[7] The Bernheim Jeune catalogue lists two flower paintings from 1886 (nos. 8 and 23); as examples of such works influenced by Delacroix and Monticelli, see F 241/H 294, F 249/H 288, F 250/H 289, F 251/H 295, and F 252/H 293.

body of acquisitions would soon bring about a bursting forth of his personality.

It was in February, 1888, that he left Paris for Provence. In spite of a weak state of health against which he was fighting, and naturally gifted, moreover, with a lively and gay habit of mind, he experienced joy, a dazzling sight, a surprise. . . . In three years (1888–90) he completed a career so prodigious and so personal that he assumes a place of distinction among those masters who had given him his start. Vincent differed from the Impressionists in that the sentiment of the latter, in reference to landscape, derives more or less from Corot, whereas his sentiment derives from Delacroix. With the Impressionists there is fluidity, an enveloping atmosphere, a haze in the air, and a certain atticism, whereas with Vincent there is sonority, imagination, and passion.

He was also preoccupied with giving style to his landscapes by rendering the lines visible and by treating his general color tones as totalities. The others had sought effects of atmosphere.

Few artists have spoken of their art with more knowledge or were more clear-sighted than Vincent. One might, with the aid of his works and his correspondence, produce a complete and significant study. . . . He had a profound understanding of painting, a sensibility of rare power, and an imaginative and, at the same time, positive character, which is a Dutch trait. He was able to raise himself deliberately above particular considerations after having penetrated to the core of things, but without forgetting the issue at hand. His physical sufferings, which were real and led to passing difficulties, never compromised the conscience of this artist. In fact, they exalted this quality, even as he developed other qualities which have the essence of genius in them; such sufferings redirected his faculties by wearing down his physical apparatus, certainly, but they also made of him a visionary. It is necessary to consider his work as an exceptional case and to avoid applying to him the ordinary standards of criticism, that deplorable set of principles handed on from one generation to the next. . . .

. . . I have retained the memory of a small, light-haired, and nervous person with lively eyes, a large forehead, and a chilly air about him, which made me think vaguely of the demeanor of a Spinoza, concealing beneath a timid exterior a vehement activity of thought. . . .

Vincent van Gogh rarely signed his works, especially those from the three final years. He considered this a vain habit and thought that an artist ought to work in humility. Whenever he did by chance sign a painting, this was rather to add a note of color in one of the corners. Then, he would inscribe merely "Vincent." With reason he believed that in France no one could pronounce the name "van Gogh," and I presume, too, that, as an Impressionist, he did not especially wish to appear a foreigner. It is with this single Christian name "Vincent" that he sur-

vives and ought to survive. It is with this designation that he entered into our French school of painting, of which he wished to be and truly was a member. His name [forever] will evoke the idea of a magnificent conception of color. . . .

VINCENT AND SOCIALISM (1906)

Julius Meier-Graefe

Van Gogh has conquered Germany more quickly than he did France. . . . For Germany's young people, who are finding it difficult to choose between art and applied art, van Gogh arrives at the right moment. If one sees nothing else, one can at least understand his love for ornamental design and hastily identify his ideals with one's own.[1] Yet, van Gogh can also be of lasting value to us. His work betrays extraordinary depth, and behind the uncommon character of his fate something more is contained than a single instance of tense drama. He represents, like every great artist, a well-organized world through which our own thoughts and perceptions become enlarged and which promises an unexpected and growing richness [of experience]. . . .

Delacroix revealed himself to van Gogh at the correct moment. . . . The preferred medium of the painter of *Medea*[2] was color, which inspired the most impulsive aspect of his genius. Red, green, and blue trickle across the canvases of Delacroix like fiery brooks, apparent emanations of some elemental power, a momentary outflow of terror and enthrallment. . . . It was this color usage rather than the solution of technical problems which van Gogh learned from this master whom he,

Meier-Graefe first wrote about Vincent in his "Beiträge zu einer Modernen Aesthetik," *Die Insel* (May 1900), pp. 207–16, and it is difficult to overestimate the influence of the chapter on Vincent in his three-volume *Entwicklungsgeschichte der Moderne Kunst* (Stuttgart: Hoffmann, 1904). However, here the editor has translated the less well known Über Vincent van Gogh," *Sozialistischen Monatshefte*, 10:2 (February 1906), 145–57, because, although reduced by half, it nonetheless constitutes a pioneering and still valuable, if somewhat romanticized, attempt to explain Vincent's art in terms of a combination of psychological, environmental, and stylistic influences. (Editor's footnotes.) Reprinted by permission of Mrs. Meier-Graefe-Broch.

[1] A reference to the *Art Nouveau* movement, which Meier-Graefe esteemed highly.
[2] The painting of 1838 by Delacroix in the Lille Museum.

along with Millet, most honored. In the sober nomenclature of the painting profession, van Gogh did nothing more than replace a reliance upon tonalities with the use of pure hues. . . . This insight into the benefits to be derived from the syntax of such a form of expression supplied the most noteworthy element in the development of modern art forms. It is a purely physiological phenomenon, insofar as without further elucidation, and presuming a common artistic approach, a painting conceived in bright colors has a stronger effect and greater carrying power than does one based upon the use of tonalities. It has a psychological character, insofar as the methods of the colorists correspond better than those of other painters to the necessarily rapid process of creation which characterizes modern painting. . . . The same development which allowed Rembrandt to reach his peak is responsible for the progress made in modern painting. For an artist as prone as was van Gogh to think in terms of synthesis and to consider as *healthy* in art that which was simple, this fresh approach was indispensable. . . .

All great works of art are trophies of victorious struggle, even those restrained and tranquil pieces before which one bows down as before the clandestine splendor of gentle flowers. In every flower glimmers a mysterious quality of soul, which, despite all filth and a thousand natural dangers, unfurls from the fruitful earth in the form of a blossom. In van Gogh's work of the Arles period, the struggle rages more fiercely, occasionally with deafening clamor. Beneath the scorching heavens his pictures erupt into flames. The passion of a human being, who during his whole life knew nothing nobler than to sacrifice himself, here conceived beauty as a tangible object which one had only to snatch up. He felt himself to be like the reaper in the fairy tale, for whom as many new stalks of grain grew up as he was able to cut down, but who remained harvesting as long as he could stand on his feet. He did not paint his pictures; he spewed them out. One may presume that during the period which he spent in Arles, from February, 1888, until May, 1889, several hundred works were produced. What Gautier said of Delacroix, that he carried the sun in his head and a hurricane in his heart,[3] is valid for van Gogh in a literal sense. It was a hair-raising experience to watch him paint—with an excessiveness through which color spurted about like blood. He was not aware of his actions and felt himself united with the subjects he painted. He painted himself in the form of glowing clouds, in the thousand suns which threaten to destroy the earth, in the terror-stricken trees crying out to the skies, and in the frightening distances of his ground planes.

[3] The quotation actually derives from Théophile Silvestre, *Les Artistes Français* (Paris, 1861), a volume known to Vincent; see Letter B13. (I am indebted to Professor Lee Johnson, University of Toronto, who kindly identified the source in Silvestre.)

All this would be nothing, if it only gave a picture of the convulsive sensitivity out of which such works were created. However, the terror in these pictures is to be compared to the excited effect of the component elements, in which a sense of beauty is preserved despite the quality of wild revolt. The visible emotion of nature is merely a relative concept based upon incidental experiences, and in the cosmic process it is subsumed within a majestic system. A great wave which terrifies the shipwrecked sailor also describes a godly curve, and even the frightened face of the unlucky fellow clasping fast to a floating plank forms a harmonious element within the total frenzy of waters. Similarly, the fragmentary elements in a picture by van Gogh, although born from a paroxysmal experiencing of nature, resolve themselves into a consonance of color and line, to which the emotion of the creator merely assigns the strength of expression and ultimate limits in the determination of form. Wildness turns into decoration. For this reason one does an injustice to the memory of the artist if one assigns a special importance to the man's pathological existence in determining the value of his artistic achievement. The fact that the man was insane when he created his most magnificent paintings in the mental hospital in Arles, where he had voluntarily confined himself,[4] . . . is of no greater importance to his art than the facts that Delacroix sometimes suffered from stomach troubles or that Géricault once broke a leg. It is axiomatic that his madness determined his human fate. This was the result of the richness of his nature, a chance fate which befell him after relatively too great a period of concentration. To predicate hereupon on this the madness of the artist as artist is the same kind of insubstantial nonsense as attributing piety to a painter of pious scenes or criminality to one of criminal scenes. Should one need proof of the conscious powers of this creator, one need only recall the letters which he wrote from the mental hospital, in which he was able to speak of his sickness with the same objectivity one uses in discussing a merely physical disability. Simultaneously, he was able to develop ideas about painting which are among the most profound observations ever made in the realm of art.

Vincent van Gogh's views were from the beginning determined by a thoroughgoing socialism. By this one does not refer to a narrow theory, such as that accepted by Proudhon's great friend Courbet,[5] nor to the rosy teachings of English utopian reformers like Morris and Crane,[6] who

[4] An apparent confusion with the hospital at St. Rémy, where Vincent stayed voluntarily from May, 1889 to May, 1890.

[5] Courbet had painted the portrait of the Socialist, Pierre-Joseph Proudhon (1809–65); see L. Nochlin, *Realism and Tradition in Art: 1848–1900: Sources and Documents* (Englewood Cliffs, N.J.: Prentice-Hall, Inc., 1966), pp. 49–53.

[6] William Morris (1834–96) and Walter Crane (1845–1915) were leaders of the "Arts and Crafts" movement.

are so very far from the point, and least of all to the poor man's painters,[7] who have done such good business in sensitivity mongering here in Germany. What van Gogh understood as socialism was the naked deed of a noble being—sharing! Nothing is more noticeable than that in every personal decision this man was willing to risk all in order to follow his own instincts and to create with a spirit which rejected any search for individual recognition as an artist. As a young man he had worked in the art business. It was not mercantile instinct which motivated him, but rather the wish to be among beautiful things and thereby to give aid to those who produced such things. Furthermore, he wished to open the eyes of those who were blind to such beauty, so that everyone could participate in this form of human blessing. Then, as he was forced to comprehend the deplorable character of his chosen role, he realized that he must enter into a more active career, and he became a teacher in England, where he sought out a following of students. Again, the role began to appear too limited for him. Next, the thirst to achieve a wider sphere of influence brought him to the profession of his father. He became a parson and wished to be ordained as a preacher, but the restrictive forms of theological study prevented his success. He went as a lay preacher to the miners in the Borinage. It was finally in this place, upon realizing that for these oppressed people the Word remained only words, that his true profession was discovered. By way of these detours the artist came into being.

His beginnings are of no incidental importance for [understanding] the mature person. He remained what he had been from the start—a man who wished to share himself with others. He fulfilled his destiny more wonderfully than a poet could imagine. It is as if this one person had felt the reproach which belongs to the egotism of our whole epoch and had sacrificed himself, in the manner of the great martyrs, whose destiny has been visited upon us since ancient times. He was as grandiose for not belonging to our period as he was for belonging; and he was grandiose in the choice of his heroism.

In every period of his short life his socialism developed further, becoming broader, mightier, and more deeply felt. Through the exertion of his best qualities he achieved such a measure of his own ideals that one can only stand in puzzled wonderment. Not so much as an atom's worth of personal glory, not even as this is manifest in its mildest form as a consciousness of one's own originality, tarnished the purity of his way of thinking. Individuality ascended in him to the godly heights of the antique sensibility, where it existed only as an unconscious force. He took from others and gave to others, as if there existed within his domain no predetermined rights of ownership. Particular possessions

[7] I.e., *Armeleutemalerei,* an outgrowth of the sentimentality of the Biedermeier period.

were viewed as belonging to the heavenly realm, which lay before everyone's eyes as an immeasurable treasure. So it happened that what would have appeared to a narrow consciousness as a *discovery* could claim no special distinction from him. Not only in his early periods but also precisely in the two years of his mature blossoming, when he was capable of doing whatever he wished, did he take a true delight in rendering the simplest of motifs. A judicious sense of self-preservation was a factor in this; since he feared his own demons. His fantasy drove him toward unrestrained or unmeasured activity; as quickly as he gave in to this tendency, it inevitably would produce a sickness. For this reason he attempted to set outside limits upon himself. His preferred ideal, according to his own confession, was to paint saints' images. Holy persons as conceived by him [were] people of today wearing the uniform expressions of primitive figures.[8] The excitement which this caused him had a shock effect. He restricted himself to the simplest of natural objects, without being able to prevent them from becoming reflections of his own spiritual state. He devoted his fervor to still life subjects, which have the effect of [personal] outpourings; he painted landscapes without figures, but in which a drama transpires nonetheless. And as with nature, the paintings of beloved masters (Delacroix, Daumier, and sometimes Millet) served as a support against the frenzy of his inspiration. He remained true to the original compositions, and yet they appear in the paintings which resulted from this remarkable form of combined creativity as nothing more than the beds in which he planted his own flowers. He was not arbitrary in his choices. One feels able to comprehend Delacroix better, although van Gogh's version of the *Good Samaritan* [F 633/H 698] remains his own. One approaches more closely the famous *Drinkers* of Daumier through the version which van Gogh appears to have produced in one moment from the copy which he had [F 667/H 687]. And in his translations of the scenes of Millet, a new world of marvelous additions combines with the original creations. Thus was expressed the true worth of this kind of socialism. He did not limit himself to the ways of masters from the past. Gauguin provided his friend with a number of [model] drawings, which were reinterpreted and clothed in a luxurious vegetation—stronger, healthier than Gauguin had been capable of conceiving them. Work together! Share with one another! That is the steadily maintained motif in all the correspondence of van Gogh.[9] Give each other material and spiritual support! This advice by him, who was the strongest of his whole generation and who realized in himself the boldest aspirations of all the others, gives to his theories a golden aureole.

This wise stewardship [of resources] was not strong enough to

[8] See Letters 524 and 531.
[9] E.g., see Letters 524, 535, and 538.

keep the fiery spirit contained within its fragile shell. However, it was not his departure from us which forms the tragedy. He had expressed himself fully, and the gesture with which he departed from life in the summer of 1890 at Auvers was too simple and understandable for us to be distressed about having to pay him back somehow. He departed because he could continue no longer. The tragedy is that a human being such as he, pure and strong like no one else, broke apart just because of his purity and strength; that his altruism, blessed with miracles which need not take second place to the beautiful legends of the ancients, had to remain isolated and die away like the cries of a child in the crowd. The tragedy is that we produce our heroes only in the form of anomalies. Nevertheless, we may be consoled with the good fortune of the immortal work van Gogh left behind.

VINCENT AND GAUGUIN
AS CLASSICISTS (1909)

Maurice Denis

Van Gogh and Gauguin sum up with brilliance their epoch of confusion and rebirth. Alongside the scientific Impressionism of Seurat, they stood for barbarism, revolution, and passion—and ultimately for wisdom. At the beginning their efforts conformed to none of the usual classifications, although their theories departed little from the older Impressionism. For them, as for their predecessors, art consisted in the rendering of a sensation and the exaltation of an individual sensibility. All the elements of excess and of disorder which are found in Impressionism exasperated them from the first, but it was only little by little that they became conscious of their role as innovators and that they perceived that their Synthetism or Symbolism was precisely antithetical to Impressionism.

Their work gained its influence from its savage and paradoxical aspect. . . . Without the cleansing and negating anarchism of Gauguin and van Gogh, the example of Cézanne, with all that it encompassed of tradition and order, would not have been understood. The elements which were constructive in their work were carried along by those which were revolutionary. . . .

Whereas they are intimately linked within the art of Cézanne, the two tendencies [of subjective and objective deformation][1] are realized in different ways by van Gogh, Gauguin, Bernard, and all other Syn-

The original version of Denis' here much abbreviated "De Gauguin et de Van Gogh au Classicisme" appeared in *L'Occident*, 15 (May, 1909), 187–202, and it was reprinted in his *Theories* (Paris: Bibliothèque de l'Occident, 1912), pp. 154–70. (Editor's translation and footnotes.)

[1] This distinction between *subjective* and *objective* deformation is basic to the art theory of Denis.

thetists. One is in rapport with their thinking and sums up well the essentials of their theory if one reduces it to [the concept of] these two deformations. Yet, just as the idea of decorative deformation reflects the habitual preoccupation of Gauguin, so does, in contrast, subjective deformation give to the painting of van Gogh its character and its lyricism. In the case of the former artist, beneath his rustic and exotic semblances one can discover at the same time a rigorous logic and artifice of composition, in which, I dare say, a degree of Italian rhetoric survives. In contrast, the latter, who comes to us from the country of Rembrandt, is an exasperated Romantic: he is moved more by the picturesque and the pathetic, to be sure, than by ordered plastic beauty. They thus represent [together] an exceptional instance of the blending of the classic and the romantic traditions. We will now look for a few concrete examples by these two masters, who are known from [my] youth,[2] in order to illustrate an essay which is otherwise perhaps too abstract and obscure.

In the impetuous and irregular execution of van Gogh and in his brilliant investigations and his violence of tone, I find everything which now attracts the young *tachistes* and discover the reason why they content themselves with pools of pure color or a few stripes.[3] They admire his aggressive attitude in the face of nature and his abnormal, exasperated and yet truly lyrical vision of things. They admire his insistence upon saying everything he feels and upon affirming the most capricious fluctuations of his sensibility. This was done by using extremely rudimentary means—furiously executed strokes and great relief in his impasto! His unorthodox manner of attacking the canvas was like that to which the last of the Romantics attached the label of genius, and which Zola indicted so forcefully in his *L'Oeuvre*.[4] For this mystical, exquisite, and poetic painter, the simpleminded and trivial conceptions of Naturalism [nonetheless] have left their traces, which I see surviving even in the present generation. The element of temperament along with an admixture of animal vitality has assured his continuing prestige. In short, van Gogh has led the younger generation to a revival of Romanticism.

I have before me a beautiful self-portrait by Vincent [Fig. 15].[5] The eyes are green, the beard and the hair are red upon a sallow, but proudly composed face. The background, where there is a Japanese

[2] Whereas Denis, when younger, had met Gauguin, there is no evidence that he knew Vincent personally.

[3] I.e., the *Fauves*.

[4] Vincent read Zola's *L'Oeuvre* in January, 1886, when it first appeared in serialized form (see Letter 444); see also Letters 524 and 543 and the discussion of this novel in Lövgren, *The Genesis of Modernism*, pp. 28–42.

[5] Denis' appreciation and ownership of this painting lends further strength to its attribution to Vincent, which once was doubted.

print, counts for little. It is a study, albeit a study which is premeditated and born of reflection. I see here certain blemishes upon which I have already commented, but also an intense expression of life and truth. The tragedy in his countenance is synthesized with great success through the use of a few energetic strokes and a few patches of color. He indicates summarily but unforgettably the *essential character* of the subject, and there is an emotion which vibrates throughout this rough sketch, which was executed by a true painter. All this contributed to produce a work of the most lofty style. . . .

INTRODUCTORY APPRECIATIONS (1911)

H. P. Bremmer

A PAIR OF SHOES [FIG. 4][1]

Vincent produced a considerable number of still life subjects in his early period. The choice of a pair of old shoes as subject indicates that he was not overly finicky. Moreover, the issue of subject is not likely to have been an important consideration for him, since it was a characteristic of his to penetrate with his intellect to the nature of all objects, no matter how apparently unimportant. In fact, subject matter is of quite secondary importance to the aesthetic value of a work of art; it is merely of some relevance to one's own preference in seeing one or another object reproduced which one considers attractive. In the future people will increasingly grasp [the fact] that beauty is not a quality inherent in objects, but [that it] relates to what we experience through them; in the past this truth was lost sight of because of the tendency to view works of art more or less as enjoyable possessions. Vincent was the first to break definitively with the idea that the subject in a still life representation was of great significance. . . . [His Shoes, for example], suggests a rapport [between subject matter and] human existence; the fact of the shoes having been worn by someone is expressed as the central motif. Thus it was not caused by a casual, to some extent bizarre, wish to be the first to employ such a subject; rather,

Bremmer's *Vincent van Gogh: Inleidende Beschouwingen* (Amsterdam: W. Versluys, 1911) represents not only the earliest book-length study of Vincent but also, as these excerpts reveal, a treatment, unusual even today, of the Dutch and French periods as a deeply meaningful continuity. (Editor's translation and footnotes.) Reprinted by permission of Floris Bremmer.

[1] Although now generally attributed to the Paris period (see de la Faille, F 255/H 248), this and several related Shoe paintings were assumed by Bremmer and others to have been executed in Nuenen.

it was much more through the urge and necessity of his own character that Vincent arrived at the representation of this particular object. . . .

Above all, one sees here the emphasis upon generalized imagery and broad effects of lighting, accompanied by a pungent contrast of colors, which has been the dominant attitude in art since the Renaissance. The inspiration with which these shoes were painted was visual 'in character. Whatever Vincent expressed of greater depth occurred to him through his observation of the object itself. The tendency towards freely creative interpretation characteristic of his later periods is here not yet apparent. Thus, one may well say in this case that by oneself one would not have perceived the object in this manner, but not that it can not be so perceived. . . .

[Moreover], one may observe how the shadow areas contain a certain delicately subdued quality, as, for example, in the inside of the shoe on the right, and how there is an illusion of shadowy vagueness if one peers into the shoe at the left. One notices, too, how in the latter a piece of the legging is bent over to hang down to the left, so as to provide a play of light and a compositional accent which would be inconceivable for a painter not sensitive to fine gradations of light and color nuances. . . .

Finally, there is the placement of the shoes, so close to each other, which suggests the sense of a certain inherent relationship between them. . . .

Thus did the painter succeed in imparting a sense of life to a pair of dead objects. *La nature morte,* as the French call still life representations, appears to me an outmoded and limited term which is too strictly derived from the character of the subject matter. . . . With greater understanding of art, the deprecating designation, "it is merely a still life," should progressively disappear from usage. Just what it is possible to offer in depth of imagination through such subjects will already have been discovered by the inquisitive observer of this work of art.

THE POTATO EATERS
[FIG. 2] [2]

It has been asserted that this is the first painting executed by Vincent, after he had produced, apart from his drawings, of course, a series of preliminary studies in an oil medium. . . .[3] He wished to depict here a fragment of farm life, how people who must work hard for their daily bread, as he said somewhere in a letter, have so honorably

[2] Called by Bremmer the *Peasant Mealtime.*

[3] Although the *Potato Eaters* was indeed preceded by a considerable number of preliminary drawings and oil sketches from late 1884 to early 1885, numerous other oil paintings were finished by Vincent at an earlier date; e.g., see de la Faille, pp. 42–64.

Fig. 1
VAN GOGH:
Sorrow (1882), drawing.
Collection Lady K. Epstein,
London.

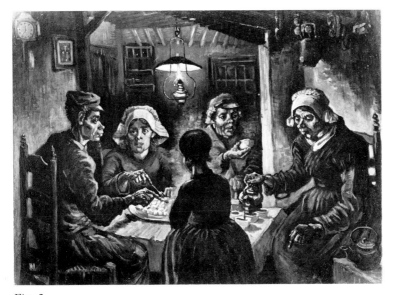

Fig. 2
VAN GOGH:
The Potato Eaters (1885).
Amsterdam, Rijksmuseum Vincent van Gogh.

Fig. 3
VAN GOGH:
Still Life with Open Bible (1885).
Amsterdam, Rijksmuseum Vincent van Gogh.

Fig. 4
VAN GOGH:
A Pair of Shoes (1886).
Amsterdam, Rijksmuseum Vincent van Gogh.

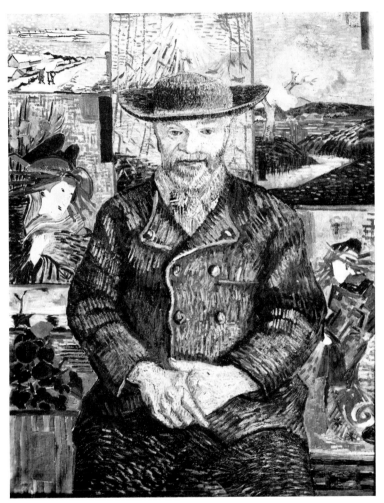

Fig. 5
VAN GOGH:
Portrait of Père Tanguy (1887).
Paris, Musée Rodin.

Fig. 6

The Postman Joseph Roulin (1888).
Boston Museum of Fine Arts (Gift
of Robert Treat Paine, 2nd).
(Courtesy of Museum of Fine Arts,
Boston).

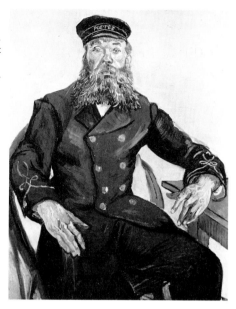

Fig. 7

The Night Café on the Place Lamartine, Arles (1888).
New Haven, Conn., Yale University Art Gallery (Bequest of
Stephen Carlton Clark, B.A. 1903).

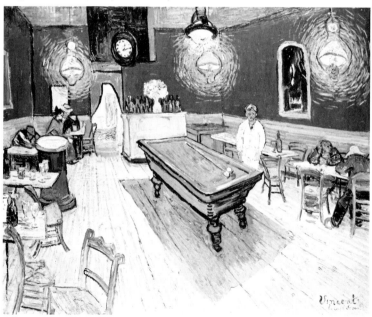

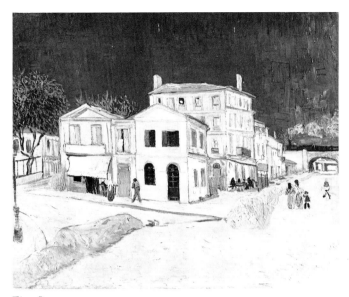

Fig. 8
VAN GOGH:
The Yellow House on the Place Lamartine, Arles (1888).
Amsterdam, Rijksmuseum Vincent van Gogh.

Fig. 9
VAN GOGH:
Vincent's Bedroom in Arles (1888).
Amsterdam, Rijksmuseum Vincent van Gogh.

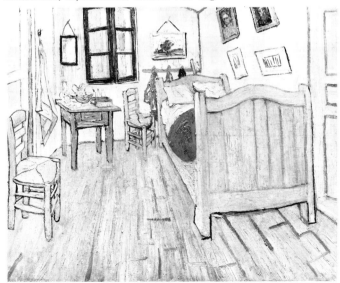

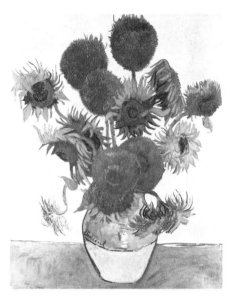

Fig. 10
VAN GOGH:
Still Life: Vase with Fourteen Sunflowers
(1888).
London, The National Gallery
(Courtesy of the Trustees, The National
Gallery, London).

Fig. 11
VAN GOGH:
La Berceuse: Mme. Augustine Roulin
(1889).
Chicago, The Art Institute of Chicago
(Courtesy of The Art Institute of
Chicago.)

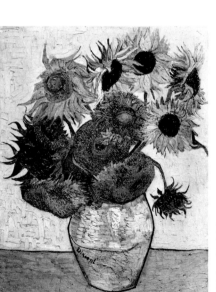

Fig. 12
VAN GOGH:
Still Life: Vase with Twelve Sunflowers
(1888).
Munich, Bayerische
Staatsgemäldesammlungen.

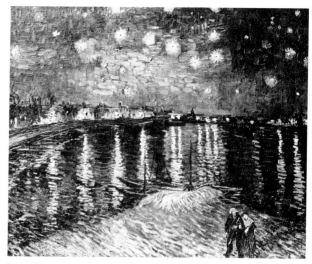

Fig. 13
VAN GOGH:
The Starry Night: The Rhône at Arles (1888).
Present owner unknown.

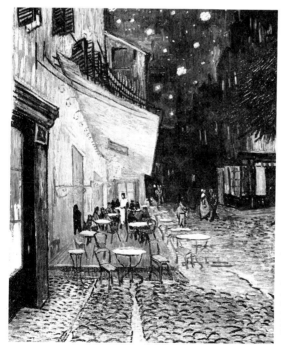

Fig. 14
VAN GOGH:
*The Café Terrace on the
Place du Forum, Arles, at
Night* (1888).
Otterlo, the Netherlands,
Rijksmuseum Kröller-
Müller.

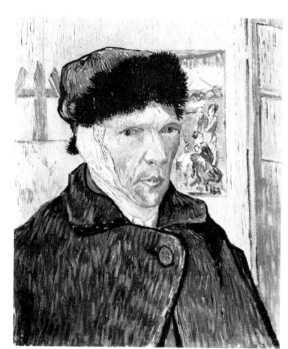

Fig. 15
VAN GOGH:
Self-Portrait with Bandaged Ear (1889).
London, Courtauld Institute Galleries.

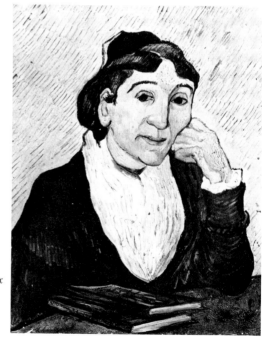

Fig. 16
VAN GOGH:
L'Arlésienne: Mme. Ginoux against a Cherry-colored Background (1890).
Rome, Galleria Nazionale D'Arte Moderna.

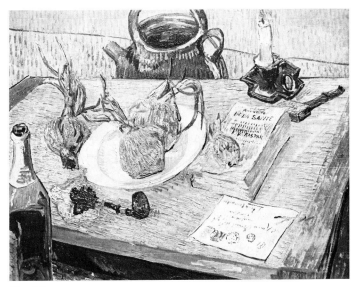

Fig. 17
VAN GOGH:
Still Life: Drawing Board with Onions (1889).
Otterlo, the Netherlands, Rijksmuseum Kröller-Müller.

Fig. 18
SIGNAC:
Still Life with Book of Maupassant (1883).
Berlin, Nationalgalerie.

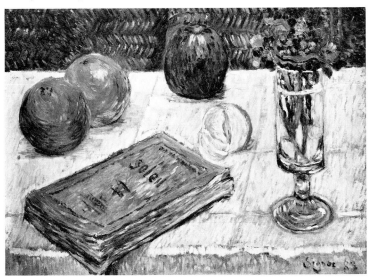

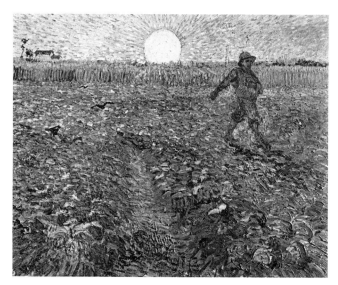

Fig. 19
VAN GOGH:
The Sower (1888).
Otterlo, the Netherlands, Rijksmuseum Kröller-Müller.

Fig. 20
VAN GOGH, after DELACROIX:
The Good Samaritan
(1890).
Otterlo, the Netherlands,
Rijksmuseum Kröller-Müller.

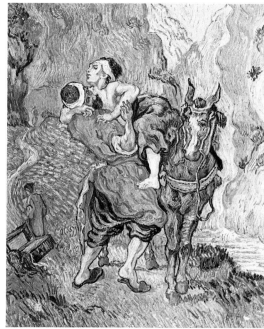

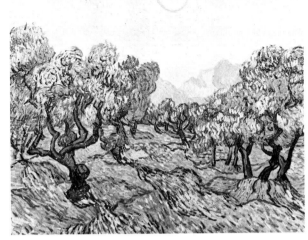

Fig. 21
VAN GOGH:
Olive Trees: Yellow Sky with Sun (1889).
Minneapolis, The Minneapolis Institute of Arts
(The William Hood Dunwoody Fund).

Fig. 22
VAN GOGH:
The Starry Night, Cypresses and Church (1889).
New York, Collection The Museum of Modern Art
(Lillie P. Bliss Bequest)

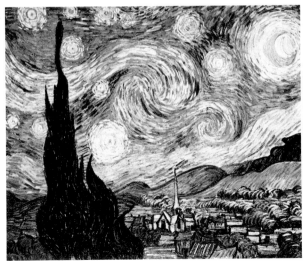

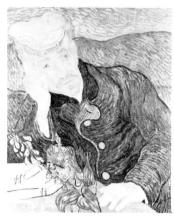

Fig. 23
VAN GOGH:
Portrait of Dr. Gachet (1890).
New York, S. Kramarsky
Trust Fund

Fig. 24
VAN GOGH, after REMBRANDT:
The Raising of Lazarus (1890).
Amsterdam, Rijksmuseum
Vincent van Gogh.

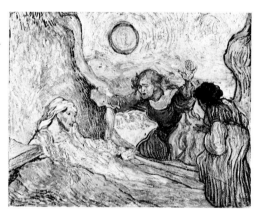

Fig. 25
VAN GOGH:
Crows in the Wheatfield (July 1890).
Amsterdam, Rijksmuseum Vincent van Gogh.

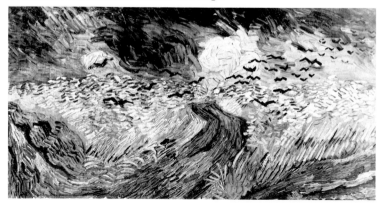

earned their livelihood [Letter 404]. This is a complete painting, and not merely a representation directly inspired by nature which is called a study, since the artist has assembled here a number of impressions collected during different periods of time.

The first thing we note is how pressed together the people appear in the small room. If one wishes to demand of a painting that it contain a generously built-up composition with an open foreground area, then this is a very bad and ugly example to take. Yet, with closer examination one will conclude that the dogmatic attitude of the Renaissance can not be maintained, because it is very clear that one can not speak here of failed intentions, but rather one must speak of a totally different conception. Should one find this piece extremely ugly, just as one once spoke of *la laideur magnifiée* in Millet, then that is a personal view. It would be more reasonable to appreciate the point of departure of the artist, if one wishes to judge his work fairly.

We are so bound by a specific tradition in art to certain ideal representations of space that these have been identified with reality itself. With an interior scene by Josef Israels,[4] to name but one example, there is enough room to move around in so that one gets a comfortable view of the inside of the house and consequently associates this with the idea of a realistic interior scene. Should it happen, which is seldom the case, that someone who loves this type of art actually visits such a fisherman's residence, then he is at once inclined to appreciate it through the eyes of the painter and not in terms of the actual spatial setting. . . . Small and confined as such residences are, one can never gain a sufficient vantage point from which to view the whole setting; in truth, it is Israels who provides an idealized reconstruction of space, whereas it is Vincent, by contrast, who represents space as he sees it and as he is forced [in reality] to see it. . . . People should realize from this how limited their ability is to observe reality objectively and how they are always inclined to abandon themselves to a predetermined manner of seeing.

One may therefore describe the conception of the painting which we are discussing as realistic, since the artist commences with what he sees. . . . In the last analysis, however, even this realism of Vincent's represents a specific manner of seeing, which does not embrace the total significance of his work; other factors are present, which go deeper than his manner of pictorial presentation [and] which result from his conception of the figural representations as *human beings*.

We are told here something about the mystery of their existence, not only about a specific class of body type and clothing style, but about more profound characteristics, which through the combination of all

[4] Israels (1824–1911) was considered the "Dutch Millet" and, of course, was an important early inspiration for Vincent.

these factors lend to this painting a psychological meaning. The cultural distance which exists between us and the simple people of the land is now better comprehended. The feeling comes over us that, while we may well be able to talk with these people, we nevertheless will definitely remain strangers, and that this is an unalterable fact.

We thus are able to discover in this work the revelation of a deeper conception of life, the enigmatic quality of human existence, which ultimately is the most distinguishing factor in this work of art. It is the product of a thinking painter, for whom the main motif remains the human being and his surroundings, even though we may discover along with this much to interest us visually. A thinking painter, and yet not someone who represents ideas. In this respect Vincent distinguished himself from many others who imagine that they can represent a richly intellectual experience through the choice of a profoundly meaningful subject. Whoever reflects upon this question and fathoms it correctly will find in both the simplest and the most complicated subject matter a similar degree of speculative content. Although Vincent may not have produced in writing a whole philosophical system, he was nevertheless a thinker, because he was filled with a sense of the deeper cohesion of the cosmos and because in everything he did one feels a religious motivation. . . .

Hence, one contemplates these figural images as they are presented and as they deserve to be understood—human beings of a rugged type, having the authentic character of the peasant farmer and lacking dissimulation as to their, for others, ugly and almost animallike qualities. Look at the man at the left, with a wooden stiffness in his whole body and a determined gesture in the arm with the thrust-out hand with which he pricks the potatoes. The whole figure is concentrating upon the business of eating; [he appears] obtuse and wears no other expression than a slightly bestial glance. Everything is expressed with a determined vehemence of conviction by the painter. We see here re-created before us a farmer in the unadorned, hard nakedness of his existence. Never before Vincent was this fact presented so forcefully; neither Millet, Israels, nor even Zola himself had expressed so soberly the homely awkwardness of such a figure. The silent, blunt behavior is so intensely presented that, even if dressed in other clothing, we would always recognize in this man a certain type of farmer.

Similarly, the girl who stands before the table, in her rugged, crude body type looks as if she had been carved from a piece of wood. Through the use of a single continuous contour outline, which is as soberly conceived as that of a doll, she constitutes a strikingly fixed presence, which dominates the middle of the painting. . . . In this figure, too, Vincent's sense of inner meaning shines through the representation of a heavy material substance, giving us a notion of the psychic force which determines so exactly the right sense of suspended movement.

The farm wife at the right, with her squarely seated posture, appears to represent the family matriarch. How eminently well expressed is this genuinely rustic calmness and manner of doing things. . . . Upon viewing this figure, who wishes to deny that even such a person as she also carries throughout her life the inevitable burdens of human existence which face us all?

Appearing as a semi-idiot who is inured to the rough, unruly out-of-doors life, a man's figure is visible through the dim background shadows. He sits withdrawn, somewhat apelike in his posture, . . . an unimportant appendage to the family unit.

The farm woman sitting behind the table is a younger type, who is more lively in character. . . .

A table is placed in the middle of the scene; it is stoutly made, but shows traces of abraded edges. . . . here he apparently wished to reveal something more than the poetry of such an interior—how this all grimly reflects an image of life's hardness. One senses this also in the mugs which are being filled by the woman at the right. One feels here that more is expressed than the mere fact of four mugs—that their placement so close together fits in with the total action depicted in the painting and reflects the same idea of interrelated unity that one associates with the family itself. In his usage [of the mugs] is to be discovered once again the sharply articulated anthropocentric outlook of Vincent, who was inclined to relate all such inanimate objects to the life of human beings. . . .

Vincent had seen many such interior settings during his early life, and gradually he transformed them all into a single image growing out of his personal experience. One in no way senses in this work a fleeting impression, but rather a generalized perception which contains much more than a realistic impression of life which is depicted.

VINCENT'S BEDROOM IN ARLES [FIG. 9]

Now here is an example of what Vincent produced during the mature phases of his activity in France, something which in comparison with the work from an earlier period appears quite different. . . .

Indeed, this painting appeared shocking to many who saw it for the first time, and almost everyone expended some time and effort before becoming accustomed to it and before realizing that it represented serious painting. . . .

The most common objection was that the perspective was faulty, that everything was sliding off the floor plane, and that this did not correspond to reality. . . .

Here again it is that well-known prejudice which threatens—namely convention, which has led to the depiction in art of things not as they

are but as they are represented according to traditional formulas. In other words, paintings are made according to an ideal form of perspective, through which objects are depicted in terms of relationships determined by how people *remember* them to coexist satisfactorily, but not by how people can *observe* such relationships from a single, determined, physical position. . . .

Should one now imagine this room [in reality], one should not conceive of it as part of a luxurious house in which one finds rooms arranged *en suite*. In representing it, therefore, one can not allow oneself a greater distance than the length of the actual room, so that one's back must be placed flatly against the (here missing) fourth wall. Should one then draw one's perspective as scientifically as possible while in a room having such short dimensions, one will arrive at a representation in which the nearer [of two closely placed objects] appears considerably larger than does the object placed further away, if one thinks of the actual physical relationship of scale between the two. The more one retreats in distance from both objects, the more they will seem to return to the mutual scale relationship which is familiar to us. . . .

At this point it is necessary to state quite frankly that none of this has anything to do with art and that ultimately it is quite unimportant, even if a painter represents an interior in a form which can not be observed in nature. The significance of art is not determined by the degree of objective truth which is contained therein. The search for truth does not belong to the domain of art, but to that of philosophy. By saying this, I do not intend to claim that the analysis developed above is in any way a plea for the artistic value of the painting under discussion. Neither is it a reason to argue that Vincent was wise in abandoning traditional conceptions, although one must add here that he was not alone in this. Both Jan van Eyck's *Arnoldfini and his Bride*[5] and the paintings of Vermeer are proof of this. The latter artist, while generally expressing himself in a quite realistic manner, often reproduces only half-figures, should he not be able to view them completely because of the spatial limitations of a chosen interior, or else he does not include the floor and begins with the truncated image of a table, as in his *Sleeping Servant Girl*.[6]

What then is the significance of such a painting [as this one by Vincent]? . . . It is the room in which Vincent temporarily lay sick; "and to avenge myself, I painted it; I went and painted my yellow bed as if with fresh butter" [Letter 554]. I do not quote this as an anecdote, because in terms of such considerations I remain unmoved, and one must avoid such narrative forms of appreciation. But that yellow of

[5] This early fifteenth-century painting is at the National Gallery, London.
[6] Alternatively known as the *Drunken Maid* and now at the Metropolitan Museum, New York.

"fresh butter" is of importance here, since the quintessence of his feeling was therein contained. He wished to reproduce objects not as he perceived them, but as they had gestated inside him into a positive image. Whereas he painted the bed a bright yellow, for the quilted blanket [he chose] a deep red, for the chair a yellow, for the walls a violet, and for the window a green; everything was rendered with an explicit vividness of color. . . .

Whatever one can discover which is unusual about this room, one must admit from a disinterested standpoint that the last thing one experiences is a sad or monotonous impression. One might have found here the atmosphere which characterizes all [representations of] interiors executed in an impressionistic style and which commonly expresses a feeling of sadness and grief.[7] Of all the greater value therefore is this mood of unmixed joy, since it not merely represents a superficially resuscitated sensation, but a basic trait of a serious being who had also known pain and suffering in life. In addtion, there is the factor that Vincent had lain sick in this bed. It is not so important that this had been a sickroom, as that someone had felt so much the power of the blessed in himself, that, after all that confinement, he could still paint with such visible magnificence.

Indeed, one must experience such a painting as a revelation. As a statement of fact it is worthless, because it does not correspond with a normal sensory perception. Everything the artist had preserved from his own earlier experience he collected together and, with the help of his memory, he produced not a specific room but an idea he had of it. The contemporary public, which is educated according to a naturalistic and materialistic conception of life, must attempt assiduously to grasp the insights mentioned above, if it wishes to enter into a much richer and broader realm of experience! . . .

SUNFLOWERS [FIG. 10]

The sunflowers I have chosen comprise an emotionalized image which arises quite spontaneously from the inner life of the artist. Earlier experience, to be sure, participates in this process, but only as a secondary factor, only as a means of expression. The conception, the strange manner of representation, in short, all which at first appears as an aberration, in fact derives from the thoroughgoing, personal conviction in which such a painter puts his trust. Such a pot of flowers constitutes an intuitive image which springs from the depths of his consciousness. To attempt in any manner to produce such a creation rationally will not work. There is present a creative power, a genius, which, as it were,

[7] Probably a reference to the tonal impressionism of The Hague and Amsterdam schools rather than to French Impressionism.

suddenly ignites and blazes forth like a flame and, if necessary against his will, forces [the artist] to make the painting in a certain way. . . .

At first glance the flowers may give an effect of pastry coloring; there is little here of the delicacy of flowers. Forgetting for now that art is not intended to imitate reality, we do sense immediately that the massive forms and the twisting lines of the individual leaves seen against the background are images which a flaccid-spirited person would be incapable of producing. Indeed, those crackling, angular, hard, biting, stiff, and forbidding elements are the work of someone who is struggling to find a way which leads to clarity in his means of representation. There is a quality of drama in these flowers, so that we experience through them a chapter in the artist's own life, and the special love for this species of plant life which led him to paint it time and again. The genuine and deep human element which, for that matter, constituted a major characteristic in all of Vincent's art, is so intensely infused [in these sunflowers] that we feel that he had not so much studied them visually as he had, as it were, talked to them. On the basis of first impressions we described them as somewhat massive; a closer look, however, forces us to recognize that the splotches of paint indicate no more than a personal and confident manner of composition; . . . there is much more plasticity here than one originally noticed, and the imagined heavy substance of the flowers gradually dissolves before our eyes. If one now glances at the outer peripheries of the flower petals, where the white ground of the canvas repeatedly shows through, then one appreciates that it is very easy to sense the quite complicated pictorial structure and the vibrations of life that are embodied in the forms which are represented. . . .

This is for me a magnificent work. A mighty thing, because it looks out at us as the convincing manifestation of someone who can conceive such a subject in a manner which far transcends normal human insight into the phenomena of nature. It was a great and magnificent thing for Vincent as well, since, despite all the pain which it might have caused him, his imagination was thereby led into a translucent sphere of understanding. What at first appeared obscure, now appears as light. "Until now all great men have created something superior to their own being," said Nietzsche. In this we can again sense the community existing among great persons, a community which does not rest upon their deeds, but which expresses itself in the similarly imaginative characters of their spirits.

VINCENT AND IMPRESSIONISM (1911)

Pierre Godet

Perhaps had he not enjoyed contact with the French modernists, Vincent would have remained a second generation Israels or a Dutch Millet and less refined, free, or great [than either]. This is, however, simply a manner of speaking, and it should not be forgotten that we are not concerned here with a matter of chance: genius is *obliged* to be at the right place at the right time where the conditions indispensable for its blossoming are to be found. That is what occurred in this instance. *Color,* as he encountered it in the French Impressionists, was for van Gogh the great liberator. It was the incendiary of his internal flame. It provided his unsatisfied passion for creation with an instrument of expression which knew no bounds, because it was independent of the motif and had a strictly plastic value.

From that moment of contact on, his flight was as unwavering and as rapid as that of an arrow, and even twenty years after his death he either astonishes or shocks by the audacity with which he imperiously and single-mindedly affirms his own presence. [Because of this contact], nature was able to offer herself to him in all her richness; everything he now saw became his "subject," in that he now carried with him a principle of style and of unfettered creativity which was suitable to all purposes. When hardly settled in Arles but already sensing that his time was limited, he commenced to run through canvases by the hundreds; there were landscapes of every kind, diverse figural studies of chance models, flower pieces, and other still life representations. One should not expect to be able to describe them; nothing is more futile than the description of paintings, especially paintings such as his. They are all what he was pleased to call "studies," [e.g., in Letters 524 and 535] which

The editor's translation of approximately one half of the text of "Vincent van Gogh," *L'Art Decoratif*, 26 (September 1911), 81–94, has been included here.

is to say paintings executed directly and entirely from nature. Each was produced in one or two sessions with an ardor which, however, did not allow for the slightest negligence or offhand virtuosity. In this sense one might say that van Gogh painted impressions. But his outward methods mattered little, and the results achieved only make one sense more vividly how much he diverged from the Impressionists, after having received from them an indispensable stimulation.

Impressionism, as a pictorial system or movement, and independent of individual sensibilities, rests entirely upon an optical discovery—the analysis of colored light and its reduction into pure elements. It is for this reason that it [Impressionism] was concerned essentially with painting the atmosphere, the "luminous realm," and at the same time the most fugitive effects thereof. Such interpretations—whether executed as drawings or in color—are always based upon the diverse aspects imposed upon objects by the variable conditions of the light, in particular upon the phenomenon of reflection, with its multiple alterations and combinations, and upon the mutual rapport between warm light and cool shadow effects (which is to say, the famous blue shadows, that are today considered "true," but once were called "incorrect").

Van Gogh did away with all this. For he was not properly a painter of "the effect of light" or a *plein-airiste,* and he was not at all a painter of fugitive moments. Although everything in his paintings was executed *en plein aire,* even *en plein soleil,* all this was quickly transformed into a smooth and abstract clarity, ideal and decorative in character, which is like that of the Japanese, the early Italian fresco painters, and sometimes Ingres or Manet. From Impressionist color he drew his clarity, purity, and intensity, but he extracted the local colors, and then he transposed these into brilliant and subtle symphonies, which make of color an expressive instrument that knows only its own laws and that is emancipated from the world of reality in which it nonetheless has its origin. As a colorist he is actually less close to the Impressionists than to Delacroix, the French master who, along with Millet, he most admired. Beyond a passion for arabesque and a vehemence of gesture, the two masters share a sovereign liberty in the use of color for purely musical purposes, an exquisite sense of harmonious accords, a gift for orchestration.

The brushstroke, too, is for van Gogh a significant element. Whereas the little "commas" of Claude Monet proceed to interlace, accumulate, and pile up and finally dissolve into a general [effect of] vibration, which restores the illusion of the atmosphere or envelops objects in a precise momentary effect, the "hatchings" of van Gogh, neatly and directly rendered, produce an altogether different sensation and play an altogether different role. They comprise an obstinate method of simplification which is opposed to that of the luminists or *tachistes* and which aims to extract, with no concern for momentary effects of lighting, the typical

character of a landscape, face, tree, or flower. At the same time that they provide color, these hatchings draw and compose. Because they are arranged in a common direction, which is never arbitrarily chosen, they mark out the forms and express the structure; moreover, they compose, which is to say, they circumscribe the masses of color and define them sometimes in terms of darkish rings which van Gogh knows how to use without resorting to any pseudodecorative calligraphy. Alternatively, by the inclusion of certain convergences of the whole towards a single point, they create arrangements of an astonishing unity of concentration.

Thus did van Gogh, with his rapidly executed studies from nature, which in other hands would have comprised merely casual notations, arrive directly at a genuine synthesis. He attacked each individual motif with a conception of the whole, or rather with a powerful, unabating emotion, which addressed itself to the whole of nature and which already involved a generalizing principle. This is why he could take particular instances and ephemeral moments and put them at the service, under the guidance of his impassioned powers of vision, of the eternal truths. He is more *truthful* than the Impressionists, by being less *realistic;* in any case, his is another form of truth and, in my opinion, one which is more profound.

VINCENT VAN GOGH (1923)

Roger Fry

The Exhibition of van Gogh's works at the Leicester Galleries gives us, for the first time in England,[1] the opportunity of seeing something of the extraordinary artistic Odyssey which this strange being accomplished in the incredibly short time between his first devoting himself to painting and his tragic end. It is characteristic of his intensely personal and subjective talent that at each period he managed to convey so much of his beliefs, his passions, and of their effect on his temperament. Perhaps no other artist has illustrated his own soul so fully, and this all the more in that he was always the passive, humble and willing instrument of whatever faith held him for the time being in its grip. What strikes one all through his work, and with a fresh astonishment every time one sees it, is the total self-abandonment of the man. He never seems to be learning his art. From the very first his conviction in what he has to say is intense enough to carry him through all the difficulties, hesitations and doubts which beset the learner. He works like a child who has not been taught works, with a feverish haste to get the image which obsesses him externalized in paint.

One could see that he must have always worked at high pressure and topmost speed, even if his large output in so few years did not prove it. He has no time and no need for that slow process of gradually

This was the first article by the distinguished British critic to be devoted solely to Vincent and has been reproduced in its entirety from "Monthly Chronicle: Vincent van Gogh," *Burlington Magazine*, 43 (December 1923), 306–8. Reprinted by permission of The Burlington Magazine Publications Ltd.

[1] [The exhibition catalogue lists twenty-eight paintings and twelve drawings, most of the former representing the French periods. However, already in the winter 1910/11, twenty-two works of art by van Gogh had been included in the Manet and the Post-Impressionists exhibition which Fry himself had organized at the Grafton Galleries, London.—Ed.]

perfecting an idea and bringing out of it all its possibilities. He is too much convinced at the moment ever to have doubt, and he is too little concerned with the fate of his work or of himself to mind whether it is complete or not, so long as he has, somehow, by whatever device or method that may come ready to his feverish hand, got the essential stuff of his idea on to the canvas. This is not the way of the greatest masters, of the great classic designers, but no one can doubt that it was the only way for van Gogh. And so the fiery intensity of his conviction gave certainty and rhythm to his untrained hand.

What astonishes one most in this series is not only the rapidity of the work itself but the rapidity of the evolution which he accomplished. The *Pair of Boots* [Fig. 4] is a still life study in which the influence of his early Dutch training and his enthusiasm for Israëls are still apparent. This belongs to the year 1887.[2] The latest work is the *Cornfield with Rooks* [Fig. 25] done at Auvers just before his death in 1890. And the difference of spirit between these two is immense.

In between lies van Gogh's *Annus mirabilis* 1888, the year of his sojourn in Provence, of his comradeship with Gauguin and his first tragic outbreak. And in that year he had not only to sum up, as it were, all his past endeavour, but to accept and digest the influence of so dominating a character as Gauguin's. We see him in the *Zouave* [F 423/H 449], frankly accepting Gauguin's oppositions of flat, strongly colored, lacquer-like masses, but this is the only obvious evidence of Gauguin's effect on van Gogh's art.[3] *The Sunflowers* [Fig. 12] is one of the triumphant successes of this year. It has supreme exuberance, vitality, and vehemence of attack, but with no sign of that loss of equilibrium which affects some of the later works. It belongs to a moment of fortunate self-confidence, a moment when the feverish intensity of his emotional reaction to nature put no undue strain upon his powers of realization.

Van Gogh had a predilection for harmonies in which positive notes of yellow predominated. In his thirst for color and light combined, he found in such schemes his keenest satisfaction. Here he has chosen a pale lemon-yellow background to set off the blazing golden glow of the petals of his sunflowers, which tell against it as dusky masses of burnished gold. Here, as so frequently in van Gogh's art of this period and as in most of Gauguin's work, preoccupation with the arrangement of the silhouette is very apparent. And, moreover, the source from which both artists got the idea—the Japanese print—is evidently disclosed. A lapse from this careful organization of the surface unity on decorative

[2] [Or, more likely, 1886 (see Bremmer's article, n. 1, included in this volume, and de la Faille, F 255/H 248).—Ed.]

[3] [In fact, the exhibited and companion versions (i.e., F 423/H 449 and F 424/H 450) were executed circa July, 1888, or three months before Gauguin's arrival in Arles, which would preclude the influence presumed by Fry.—Ed.]

lines is seen, however, in another work, *The Yellow House at Arles* [Fig. 8]. Here the composition shows perhaps a reminiscence of that momentary period when Seurat and Pissarro were his guiding lights.

There is, by the by, a most interesting landscape here of fruit trees with figures which is carried out almost entirely in the style of Pissarro, modified, of course, as all the many styles van Gogh tried were, by his peculiarly emphatic temperament; though, perhaps, this is less clear here than elsewhere. Certainly one feels that he was bound to abandon so carefully planned, so slowly constructed and so minutely observant a method of painting for some other that would promise a more rapid realization of his idea.

But to return to the Arles picture. Perhaps nowhere else has van Gogh expressed so fully the feeling of ecstatic wonder with which he greeted the radiance of Provençal light and color. He had shrunk at nothing in order to find a pictorial phrase in which to sing of the violence of the sun's rays upon red-tiled roofs and white stone walls. To do this he has saturated and loaded his sky, making it, not indeed the conventional cobalt which is popularly attributed to Mediterranean climes, but something more intense, more dramatic and almost menacing. How utterly different is van Gogh's reading of Provençal nature from Cézanne's contemplative and reflecting penetration of its luminous structure. Here all is stated with the crudity of first impressions but also with all their importunate intensity—and they are the first impressions of a nature that vibrated instantly and completely to any dramatic appeal in the appearances of nature. In striking contrast to Cézanne, too, is van Gogh's indifference to the plastic structure of his terrain, which is treated here in a cursory and altogether insignificant way. The artist's interest was entirely held by the dramatic conflict of houses and sky, and the rest has been a mere introduction to that theme.

The canvases of the succeeding year, 1889, show another rapidly accomplished evolution. The brushwork becomes more agitated, or rather the rhythm becomes more rapid and more undulating, and all the forms tend to be swept together into a vortex of rapid brush strokes. There are no examples here of the more extreme developments of this period. One *Rocks in a Wood* [F 744/H 636], is quite unusual for this period. It shows, indeed, the new vehement rhythmical treatment of the forms and the agitated handling; but with this goes a singularly well-balanced composition without any strong dramatic effect, and with a peculiarly delicate and tender harmony. It expresses altogether an unfamiliar mood.

The one masterpiece of this period, *The Ravine*,[4] is not here, unfortunately—I believe it is now in America. In this, by some fortunate influence, all the agitated vehemence of handling of this period serves only to give vitality to the structure of rocks, and here, under the

[4] [I.e., F 662/H 671 or, less likely, version F 661/H 670.—Ed.]

dominance of a more steadily held impression, van Gogh has been able to persist until the loaded paint has become fused into a substance as solid and as precious as some molten ore shining with strange metallic lustres.

It is in the *Cornfield with Rooks* [Fig. 25] that, as far as this exhibition goes, we get a glimpse of van Gogh's last phase of almost desperate exaltation. Here the dramatic feeling has become so insistent as to outweigh all other considerations. There is no longer any heed given to questions of formal design, and van Gogh ends, as one might have guessed from his temperament that he must end, as an inspired illustrator.

A SINGULAR NOMAD IN
FRANCE (1928)

Henri Focillon

At the same time [that Cézanne was active], a singular nomad was touring France with a restless spirit. He did not arrive from the sunny shores where Cézanne had enclosed himself in golden solitude, but from the mystical essence of Holland. After various wanderings and stopovers, Vincent van Gogh [arrived]. He was a very strange and very contradictory soul, [embodying] a chaos of ideas, aspirations, and preferences, and a delirium pierced by the most beautiful rays. He was a rare, ardent, vigorous, and magnificent painter. He defended Meissonier[1] against the sarcasm of his colleagues, and he offered to God, in the form of a beautiful bouquet of yellow flames, his spray of rustic and radiant fritillaries.[2] He is presented as an isolated figure;[3] he was a vagabond and everywhere he stopped, he left his imprint like a trail of fire. He carried within himself the wish to be a theologian or a salvationist, and the frightful sunstroke of demented genius. But his painting remained exempt from these ferments; it remained filled with certitude and joy. It astonished Bernard and Gauguin, who worked with him at Arles and endured with him the first and frightening jar of his mental derangement. But nothing of this incident and his sad madness either created or modified the perspicacious powers of van Gogh and his

This brief analysis was translated in full by the editor from Focillon's history, *La Peinture au XIX^e et tu XX^e Siècle*, H. Laurens ed. (Paris: Renouard, 1928), pp. 276–78. (Editor's footnotes.)

[1] For Vincent's admiration for Meissonier, see Letters 542 and 556.

[2] I.e., *Fritillaries in a Copper Vase*, F 213/H 298, belonging to the Louvre Museum since 1908.

[3] An indirect allusion to A. Aurier's "Les Isolés: Vincent van Gogh" (see Aurier's article included in this volume).

exalted artistic conscience. His admirable letters reveal to us one who was possessed not by some restless demon, but by the intoxication of a vocation which was to martyr and exalt him, by an apostolic sentiment about painting. He took a long time to find his way; he sought out every milieu—London, Paris, Antwerp, and the Borinage—working now as an apprentice pastor, preaching to the working classes, now as a student of some academy, seeking out the advice of Mauve, and finally as a painter under the great sun, a painter freely on his own. But he did not give himself over to the enjoyment of his gift, to the magic of appearances. He sensed in the life of nature a secret exaltation which he wished to capture. All this signified for him a mystery filled with violence and sweetness, and he wished that his art would communicate its devouring passion to mankind. He took his rest in a corner of an orchard in the springtime, under some joyous roadway covered by foliage and strewn with sunlight, and on the banks of a canal which is lost in the country-side and barricaded by a drawbridge,[4] but he never knew a passive moment.

Thus, he was the most intense and the most richly lyrical of the painters of his period. One does not find in him a classicist who is seeking his path, but the precursor of a kind of solar romanticism.[5] For him, everything has expression, urgency, and magnetism. All forms, all countenances admit of an astonishing poetry—the decent and bearded postman in his uniform,[6] the passing men and women from the narrow alleys of Arles, and finally himself, for he never ceased to analyze and to scrutinize himself as the most captivating of all enigmas. Even at the time he painted the shoes which were worn down at the heels from tramping about or his straw hat, the most mysterious and golden among his still life paintings,[7] he felt himself besieged by a dream which did not come to him as a fugitive impression, but which made heavy demands upon his spirit. Such is the lesson one learns from seeing the extensive Kröller collection in The Hague, where his works are neighbors of Redon's. He and Gauguin were mutually impassioned. Certain of van Gogh's [works] are "cloisonné" in style, while others are moulded in the thick impasto of the Belgian realists.[8] But these are only passing episodes. In translating the fever and the gladness of life, he did not

[4] I.e., *The Langlois Bridge,* F 397/H 435, F 400/H 436, F 570/H 588, or F 571/H 587.
[5] I.e., the *Fauves.*
[6] Intended is *The Postman, Joseph Roulin,* Figure 6, F 433/H 466, F 434/H 463, F 435/H 462, F 436/H 464, or F 439/H 465.
[7] E.g., such shoes as in Figure 4, and the *Still Life with Straw Hat and Pipe,* F 62/H 70, from the Kröller-Müller collection.
[8] I.e., such nineteenth century artists as Charles de Groux, Henri de Braekeleer, Alfred Stevens, and Constantine Meunier, whom Focillon had discussed in his book under the heading "Le Réalisme en Belgique," pp. 34–46.

dally with laboratory procedures, with cloisonism and Pointillism. His touch sculpted his forms with undulating thickness, he banished heavy, opaque and drab tones, sometimes he poured out upon the canvas a volatile, blazing design [*Self-Portrait with Bandaged Ear* [F529/H XII]], and in this furnace which calcines his anguish, his sacrifices and his madness, he is like the father confessors who become ecstatic in their impassioned offering of the blazing mass; he is the last of those who adore the fire. Periods of high culture adulterate and impoverish the idea of the power of art. They neutralize art through the richness of inherited characteristics and the multiplicity of influences. But just because of the confusion which reigns, every so often one observes the rise of one inspired, who hastily restores the proper tonic. We are not yet able to measure the actual effect which van Gogh has had upon contemporary art, but it was considerable in relation to his colleagues. On two occasions during the nineteenth century the Low Countries have sent to us important harbingers. If only because these lands have produced Jongkind and van Gogh, they are to be counted among the major forces active within modern painting.

VAN GOGH
AND SCHIZOPHRENIA (1922)

Karl Jaspers

. . . It would be quite incorrect to believe that van Gogh's verbal references to his art document *directly* some kind of schizophrenic condition. It is nonetheless certain that an enormous difference exists between 1888 and the earlier years, which will be noticed by every disinterested and objective reader of [his] letters. It is also a fact that this contrast occurred rather suddenly and that it coincided with the beginning of a psychotic process which can be recognized on the basis of quite independent symptoms. For this reason it is possible to deduce that among the various factors which produced this novel tone of address [in the letters] one can be sought in the psychosis. In the letters dating from both before and during the psychosis one finds a completely identical seriousness. In their entirety these letters (and only a quarter of them date from the period of psychosis) represent the documentation of an existence and a mentality of the highest moral character, the expression of an absolute veracity, a deeply irrational belief, an infinite love, a generous humanity, and an imperturbable *amor fati*. These letters count among the most moving phenomena of the recent past. Their moral content stands out without any dependence upon the psychosis; rather, it is most genuinely verified as a result of the psychosis. . . .

 . . . Here follows my own . . . hypothetical characterization of the successive [artistic] "periods" which can be established:

 1. The period before 1886. Respectable studies of, at first, a

A selection of passages from Jaspers' controversial study *Strindberg und Van Gogh* (Leipzig: Ernst Bircher, 1922; Bremen: Johs. Storm, 1949). The German psychiatrist had seen a selection of Vincent's work at the 1912 Sonderbund exhibition in Cologne, but based his analysis primarily upon the German translation of the correspondence (see Introduction, n. 8). Translation and footnotes are by the editor. Reprinted by permission of Johs. Storm.

naturalistic, then, an impressionistic character. Everything is drawn and painted in terms of continuous planes. Nothing is dissolved into hatching stripes.

2. In 1887 [1] a continuous development towards greater dependence upon color. Still life and flower renderings of the highest quality. Everything remains—compared with later—in rest.

3. Second half of 1887 until early summer, 1888. Continuation of a steady development. The most beautiful flower paintings. [2] Gradual appearance of schizophrenia. In the works of art this is not yet recognizable. The period of "transition." The development of the "conceptualized" dematerializing hatching technique, particularly in the landscapes, which in general have a peaceful effect (for instance, the drawing and watercolor of a landscape with blue cart near Arles). [3] With ever greater assertion an abstract manner comes to the fore, which concerns itself with the nature of individual objects. Infinite richness, yet in reference not so much to botanically recognizable species of flowers as to the idea of generalized plant forms—in the overflowing movement of a field or a garden. One does not inquire what specific subject matter has been recorded and yet has the impression that he is observing the deepest essence of reality.

4. Summer, 1888. The already visible tension now becomes felt in every work of art. However, this powerful inner tension expresses itself with complete self-assurance and is dominated by a far-reaching and clear alertness, which is accompanied by a great sense of discipline and a moulding of vehemently observed experience. A steep ascent leads to the attainment of the highest peaks. Among the drawings are several good examples of this achievement: *The Village Street of St. Maries* [F 1435], the *Boats at St. Maries* [4] and the *House Café at Arles*. [5]

5. From the end of 1888 until 1889. Definitive entrance into the schizophrenic process thanks to an inaugural, violently acute condition dating from December, 1888. Increasing predominance of pure dynamics in the hatching. The tension remains controlled, but no longer attains so free and lively a synthesis. The works are instead more regu-

[1] Here and elsewhere under "period 2," the author's chronology should be set back by approximately a year, since Vincent had left Brabant by late 1885 and the Parisian still life paintings, especially the flower pieces, date mostly from 1886.

[2] As in n. 1 the author's chronology may again be inexact, since the period of late 1887 to early 1888 was not particularly characterized by flower paintings. In any case, the distinction between flower representations in Jaspers' hypothetical "period 2" and "period 3" can be understood to indicate the emergence of paintings executed in pure rainbow colors without a dark background.

[3] I.e., the subject now known as *Harvest in the Provence, At the Left Montmajour*; the four drawing versions are F 1483, F 1484, F 1485, and F 1486.

[4] I.e., F 1428 or the series F 1430, F 1430a, F 1430b, and F 1431.

[5] Probably intended was F 1453, a view of Vincent's Yellow House.

lar and display in a high degree, and in the best sense, a manner (such as the many depictions of cypresses with their colossal and abundant movements). The special characterization of objects, the concept of separate forms more and more disappears beneath a generalized emphasis upon movement of line as such.

6. Beginning in 1889 and increasing in 1890. During moments of the greatest emotional excitement drawings are produced which show impoverishment and unsureness. Elementary, impetuous impulses, which are no longer as richly creative and have a monotonous effect. The earth and the mountains appear like a slowly moving kneaded mass. All particular characteristics disappear; a mountain might just as well be an ant hill, due to the lack of specific contours. One sees a piling together of hatchings which are not concerned with differentiating the elements of life and appear as indefinite contour lines with no other character than that of emotionalized excitement. Earlier there was a constructive scaffolding which informed all movement, which now progressively fades. The paintings have an inadequate effect; details appear by chance. Sometimes the lack of discipline virtually extends to smearing without a sense of form. This represents energy without content, or doubt and terror without expression. No longer are there any new "conceptualized formulations.". . .

. . . In fact, through its release of certain forces, the mental sickness allowed for the onset of a period of productivity which previously had been precluded. The sickness freed him from certain inhibitions, the unconscious began to play a greater role and the constrictions of civilization were cast aside. From this source, as well, there also developed certain similarities with dream experiences, with myths, and with the spiritual life of children. This concept of inhibitions and their disappearance is manifested in a variety of ways. It is illustrated most graphically in the case of psychological paralysis. However, in this instance one is more inclined to speak of new powers. Above we have frequently employed the rather noncommittal concept of a "loosening up process." Spiritual states are hereby experienced, which previously had not been present. It is not only that through this form of stimulation an enhanced productivity is achieved, which also leads to the discovery of new means which then are added to the general artistic nomenclature, but also that new powers are aroused, which take on positive form in their own right. Such powers are in themselves, intellectually viewed, neither healthy nor sick, but they nonetheless flourish upon the bedrock of the sickness.

VAN GOGH AS AN EPILEPTIC (1932)

Francoise Minkowska

Jaspers has given us a living picture and a profound analysis of van Gogh.[1] It was his study which incited me to attack the problem "van Gogh." However, he described the artist as a schizophrenic. From the beginning I have had my doubts and today less than ever am I able to subscribe to his diagnosis. In fact, with van Gogh one finds no trace of [such typical schizophrenic traits as] dissociation, disintegration of personality, or autism. The value of Jaspers' study does not hereby vanish, however, since in more than one place Jaspers himself insists that the behavior of van Gogh very often departs from the orthodox pattern of schizophrenia. It is precisely this "atypical" schizophrenia which has led me to think of epilepsy. One should not forget that Jaspers based [his study] exclusively upon the letters of van Gogh and had at his disposal only a few facts about the artist's life; he did not even have the diagnosis of Dr. Peyron.[2] In short, his was the first essay consecrated to van Gogh in the literature of psychiatry and it was written at a time when all psychiatric studies in the German language were under the persuasive influence of the work of Bleuler.[3] It was also a time when psychic forms of epilepsy were relegated to a place of little importance. In

Excerpted from Francoise Minkowska, "Van Gogh: Les Relations entre Sa Vie, Sa Maladie et Son Oeuvre," *L'Evolution Psychiatrique*, 3 (1933), 53–76 (reprinted under same title in pamphlet containing two additional articles on van Gogh [Paris: Presse du Temps Présent, 1963]). Translation and footnotes are by the editor.

[1] In *Strindberg und Van Gogh;* see preceding article.

[2] Dr. Peyron, director of the hospital at St. Rémy, like Dr. Felix Rey at the hospital in Arles (see Letter 592), had diagnosed Vincent's illness as epilepsy; see V. Doiteau and E. Leroy, *La Folie de Vincent van Gogh* (Paris: Aesculape, 1926).

[3] Dr. Eugène Bleuler (1857–1939), the Swiss psychiatrist, had published *The Theory of Schizophrenic Negativism* (New York, 1912).

addition, the profound comprehension with which Jaspers, among other authors, speaks of van Gogh is, by itself, an argument against the diagnosis of schizophrenia.

In passing now to the painting of van Gogh, I have chosen [two] illustrations [Fig. 5 and 23],[4] [one] each from the pre- and the postpsychotic periods of his career. In order to facilitate the discussion, I have chosen works which are closely related in subject type. This comparison, in addition, will allow us to discuss the question of "stylistic change" due to the influence of psychosis.[5] First we shall take the portrait of *Père Tanguy* [Fig. 5], which was painted as early as the Paris period. It is executed completely with hatchings; each tiny detail, even down to the trim of the jacket, is painted with love for the thing itself, as if there were something essential about it. However, all these details, while having a complete existence of their own, unite and come together to form a whole. From this fact derives the striking impression of truthfulness and of life, an impression which is analytic and synthetic at the same time. In this context, one more remark: one speaks of the influence of Japanese art on van Gogh, and in this portrait from the Rodin Museum in Paris the background of the composition is formed by Japanese prints. These prints have their own special charm, even though they appear stylized and "painted" when compared to the freshness and the power which emanates from the figure of Père Tanguy himself. . . . In summation, I believe that one can find in the work of van Gogh the same bipolarity that one finds in his life: on the one hand, there is emotional concentration upon each detail, condensation in terms of color, and gathering together of all the parts, each in its place; whereas, on the other hand, the hatchings and the contour outlines are characterized by a brutal and violent quality, although, as in each of his paintings, everything contributes to the simple and powerful veracity which emerges.

If we now pass on to the [second work], the portrait of *Doctor Gachet* [Fig. 23], and compare it with that of Père Tanguy we see that a new element has penetrated the work of van Gogh. It is the serpentine line, which is repeated time and again and which spreads out everywhere and imparts an unfettered quality to the whole design. One simple detail: the border of the jackets in the two portraits. In the later example we are far from the relative calm found in the portrait of *Père Tanguy*; one now feels oneself drawn by an irresistible force, as had been the artist himself. . . . [Likewise, in] the *Crows in the Wheatfields* [Fig. 25] . . . there is a heavy and menacing sky which weighs down upon the earth, as if wishing to crush it. The field of wheat moves

[4] In the original article three sets of comparisons were used.

[5] A reference to Walter Riese, "Ueber den Stilwandel bei Van Gogh," *Zeitschrift für die gesamte Neurologie und Psychiatrie*, no. 98 (1925), 1ff.

tumultuously, as if wishing to escape the embrace of the hostile force watching over it. It makes a desperate effort to raise itself towards the sky, but the descending black crows accentuate further the imminence of the destruction, the fall, and the annihilation. Everything is engulfed by the inevitable shock. All resistance is useless. Van Gogh himself put an end to his life and to his work.

On this supreme note, the work of art and the psychosis become mingled; the latter, far from constituting exclusively a destructive factor, heightens still more the opposition of the two movements [i.e., elevation and fall] which, at all times, compete with one another in the creative spirit of van Gogh. Without doubt, in this, his final work,[6] the artist has given a striking symbolic expression to opposing inner forces. In our own more prosaic manner, we can say that these two movements, one of elevation and one of fall, form the structural base of epileptic manifestations, just as the two polarities form the base of the epileptoid constitution.

The life, the psychosis, and the *oeuvre* of van Gogh form an indivisible unity. Thus, I am unable to discover sufficient reason to speak of a basic "stylistic change." In this instance the psychosis has not destroyed or modified anything profoundly. In its liberating role, it adds a novel note by embodying at its summit the inner tragedy of the artist.

[6] Once widely believed to be Vincent's final painting, the *Crows in the Wheatfields* actually was completed two weeks prior to his death (see Letter 649).

A REVIEW OF
PSYCHIATRIC OPINION (1937)

Sven Hedenberg

Many books have already been written on the life of this artist. The somber and solitary story of his life appears to have had the capacity to capture as much interest as has the unique quality of his canvases. It has been asked whether or not pathological forces in his sickness gave him inspiration and directed his hand in the mixing of his colors and in the formation of his outlines. It appears that during the last years of his life, his technique underwent a change, and it remains to be discovered whether this change followed from a development which already had been indicated in his earlier work or, instead, constituted for his art something unknown and new which resulted from his sickness.

One of the greatest German psychiatrists, Karl Jaspers, a professor at Heidelberg, published in 1922 a book which treats just these questions.[1] Beginning in December, 1885, according to this author, one discovers the first mysterious symptoms manifested in mild physical and psychic sicknesses. The true psychosis, declared Jaspers, was visible in any case commencing in 1888. . . .

Jaspers discovered a notable change in the works of art produced after 1888. One sees in all such canvases an agonizing groping about. The artist sometimes had difficulty in finishing his paintings. There were various analyses and syntheses. Considerations of technique gained the upper hand and became excessive. He painted in terms of traits, such as spirals, curves, and angles, which tended to convulse the natural motif. His skies became inflamed, his trees became twisted, as if they wished to tear themselves out by the roots, and the earth trembled. His paintings

Excerpted and translated by the editor from Sven Hedenberg, "Vincent van Gogh," *Theoria*, 3 (1937), 185–205 (in French). (Editor's footnotes.) Reprinted by permission of the author's widow and the publisher.

[1] In *Strindberg und Van Gogh*; see Jaspers' article included in this volume.

became sensationalized, but he remained nonetheless possessed by the desire to be able to grasp something of reality. He loved nature and lived through it. . . .

. . . Jaspers declared, furthermore, that it would have been a curious coincidence if the new style [of 1888] had commenced [only] during the period when his psychosis became evident. The schizophrenia from which van Gogh suffered, according to Jaspers, could not have produced anything absolutely novel, but something was created, nevertheless, which, without the psychosis, never would have been revealed. . . .

In reference to the illness of van Gogh, said Jaspers, one has only a choice between general paralysis and schizophrenia.[2] Jaspers considered the first very improbable and schizophrenia, by contrast, very likely. However, there is still much uncertainty regarding a diagnosis of schizophrenia for Vincent van Gogh. . . .

Certainly, the work of artists who have gone mad constitutes a subject which is as intriguing as it is problematic. Pathological experiences, which are reflected in the work of art and which break down the old style in order to produce a new one, are fascinating.

Doctor Walther Riese of Frankfort on the Main has written an article which arrives at conclusions opposed to those of Jaspers and which is concerned with [van Gogh's] changes of style.[3] For one thing, Riese has observed that Jaspers did not admit that the psychosis might have had an epileptic base, which was the opinion of the doctor who treated the artist.[4] Much pleads for schizophrenia, but Riese is not as sure as Jaspers. Riese is occupied above all with what he calls the artist's changes of style. What is most characteristic in the art of van Gogh, says Riese, is that he was preoccupied with geometric forms, which are entirely opposed to nature in their treatment of natural form. This was his own manner of expression and he pushed his principle so far that, "from natural objects he extracted his 'symbol' or, to put it better, his concept." According to such an exposition, the natural object ought to lose a degree of importance and withdraw to the background. For this reason a cypress tree can also be seen as an ardent flame, and a mountainous landscape resembles a rolling sea. The forms in his art, the means, apart from the colors, remain always the same—straight lines, curves, points, circles, ellipses, rosettes, etc. The multiplicity of the geometric formations is therefore the reason for the ornamental character of his work from the final years.

[2] *Ibid.*, p. 121. "general paralysis" refers to cerebral paresis resulting from syphilis, which debilitation has generally been ruled out for Vincent, since it is not marked by episodic crises and, once apparent, would have effectively prevented further painting and correspondence.

[3] See preceding article, n. 5.

[4] See preceding article, n. 2.

Is this style a schizophrenic expression of a sick personality, as Jaspers assumes? Assuredly not, says Riese. Van Gogh in his art serves only the creative possibilities of pure form, which were already determined at an earlier date and which could develop along with either schizophrenia or any other condition. The story of the life of this artist is the story of a struggle first of all towards a particular type of form. What van Gogh sought was a *uniform simplicity*. He wished to reproduce the simple, the absolute, and the true. Even in his manner of rendering things, he sought for simplicity and arrived, therefore, at a geometric unity, at the use of lines, circles, curves, etc, before the profundity of which approach individualized and accidental aspects fall away. And one should not forget that the principal means of expression for such an artist was the line, which basically is an element completely foreign to nature.

Riese ascertained that, in principle, these configurations of lines in the art of van Gogh appeared before the occurrence of his illness. There was neither a dramatic rupture in his development nor any change in style; merely a regular development of artistic considerations. The anguish and the uneasiness which strikes one in so many canvases by van Gogh ought not necessarily to be taken for a psychotic state of mind. "If an artist such as van Gogh strives after an absolute form of art with the full power of his mentality and in full exertion of his imagination on behalf of specific antinatural and unexplored art forms, then he is indeed certain to find himself in an exceptional emotional state, in an 'unusual spiritual condition.' However, to imagine this as the excitations of a madman is to draw sadly mistaken analogies." To be sure, there are a number of works from the artist's final years which suffer from a certain degree of weakness and from a visible tendency towards ornamentation, which recalls the work of the alienated.[5] But one can not forget that this sick artist, who, admittedly, neither could nor ought to have worked during his periods of acute anguish, did nonetheless create part of his *oeuvre* during the intervals of crisis, before [the signs of] his illness had fully disappeared and when he remained strongly under its influence. Historians of art also are of the opinion that such works date more or less from the periods of crisis.

Riese terminates by saying that the artist fell sick and had intermittent phases of anxiety, but that, at other times, he not only appeared rehabilitated, but also was capable of augmenting his creative talent. In a condition of full consciousness, he sought and discovered his own style before the outbreak of his illness and developed it through to a state of perfection. Doubtless the development was a stormy one, but it occurred without the least rupture between any pre-psychotic and psychotic style

[5] A term commonly used for schizophrenics.

and as a complete artistic necessity. Whereas his crises definitely produced some abnormal works, during the intervening periods of calm and recovery, his development followed an undeviating course. . . .

The element which above all captures one's interest in the late works of van Gogh is what Prinzhorn, in his *Bildnerei der Geisteskranken,* calls "spontaneous inflammation of the [brush or pen] stroke." [6] There is a sort of passionate rhythm in the execution of traits which gives the effect of dynamic violence, a technique which one can observe, according to Jaspers, with schizophrenic painters. No one can deny, says Prinzhorn,[7] that van Gogh, through his sickness, received an impetus that elevated him to a plane, which, previously, would have been impossible for him to attain.

Jaspers appears to have wished to say of this technique that the stylistic traits depending upon curves, spirals, and angles, were inspired by a life so intense that they devour, so to speak, the original motif which the artist had intended to reproduce. Everything is dissolved into particularized morsels, and herein schizophrenia is manifest in his art. Yet, if such were the case, the progress of the sickness would have had to have been very advanced and of considerable age. And one may also note that what in general is considered characteristic of schizophrenic art, if one may speak of this as art, is precisely its rigidity, angularity, and inertia. . . .

This character of immobility carries with it an impression of unreality. All [sense of] rhythm is absent, and, with this, the most important element disappears. This strangeness in the renderings by schizophrenics has a psychopathological origin, and for myself this source seems to be the same as that for the tendency towards isolation and insociability found in schizophrenics. With schizophrenic dissociation of the personality, life lived in common with humanity increasingly diminishes and the schizophrenic then becomes an entity which is excluded from the human confederation. Prinzhorn himself has stressed this as a factor of great importance. A schizophrenic has nothing to offer others, because his sphere of interests does not relate to that of others. His thoughts are episodic rather than forming a chain or series. . . . This is why there is no rhythm, neither ascension nor descent, no progression and no diminution, as we find in normal human life. . . . Because of this, what he renders in his drawings or paintings is stamped with some form of momentary and isolated reality which has no meaningful connection with

[6] The phrase in Hans Prinzhorn, *Bildnerei der Geisteskranken* is "Selbstentflammung des Striches."

[7] *Ibid.,* p. 341; in a single reference to van Gogh, Prinzhorn, who in 1921 was with Jaspers in Heidelberg (the location of a notable collection of "schizophrenic art"), stated: "No one would dispute that in his sickness van Gogh received an infusion of productive potency which raised him to a previously unattainable level of plastic creativity."

other relationships or with the reality of other individuals. His manner of life is fragmentary, and what he renders are, in truth, only fragments and rhapsodic interludes.

With van Gogh one discovers nothing of this poverty, this stiffness, and this immobility. On the contrary, he is a painter of movement. Everything he reproduces, deeply rooted trees as well as the sun and the hills, is depicted with a great sense of life and rhythm. This is directed by a spiritual life which alternates between despair and ecstasy, between intensity and calmness. His manner of drawing and painting, with its curves, spirals, angles, and circles, is definitely produced by the effort he made to find an expression appropriate to his sensitive experiencing of life. . . .

How could one otherwise explain that the artist was able to produce until the very last such perfect works? One of his final paintings, the portrait of *Doctor Gachet* [Fig. 23], is a work of grand and harmonious beauty. The artist shows himself here, shortly before his death, a great painter of incomparable mastery. . . .

The characteristic development which the technique of the artist passed through, judging from the assembled evidence, appears to have been a logical evolution of style and, if one wishes, an expression of what one could call an augmentation of the intensity of life. Van Gogh was incontestably mad during the final two years of his life, and this illness clearly occasioned in its victim a number of troubling and unusual sensations, some violent tensions of the spirit, and some impressions which he had never experienced previously. Perhaps he had a confused vision of reality being engulfed and vanishing somewhere above in the tempestuous clouds. Perhaps he saw stretches of earth and chains of hillocks twisted like hands which are wrung under the impact of suffering. A state of epileptic torment, like the beginning stages of schizophrenia, could surely have led to a state of spirit filled with fantastic sensations of other worlds and of other forms of existence.

VINCENT AS A PSYCHOPATH (1941)

Gerard Kraus

TEMPERAMENT AND CHARACTER

On this point much has been written by art historians, psychologists, and psychiatrists, and, although there is very little agreement about many personal characteristics of van Gogh, there does exist general agreement that he was given to extremes and that his personality was characterized by many contradictions. This is the reason, moreover, why opinions immediately vary widely as soon as any attempt is made to give a single name to the remarkable structure of Vincent's character. In addition, his personality escapes a diagnostic definition, unless one is willing to say that he was a psychopath, and, in my view, there can be no doubt about this. As a child he already was "strange," and his many abnormal characteristics regularly brought him into conflict with his surroundings and produced serious difficulties in his life. Thus at least one definition of a psychopath is fulfilled in this instance. . . .

VINCENT AS ARTIST

As far as I know, no one has as yet asserted that Vincent owed his talent and his creative powers to his illness, although the opinion of . . . Jaspers,[1] who believed that his schizophrenia brought new qualities and

Excerpted from Gerard Kraus, "Vincent van Gogh en de Psychiatrie," *Psychiatrische en Neurologische Bladen,* no. 5 (September–October 1941), 985–1034. Unlike most psychiatrists writing before World War II, Kraus was familiar with the full range of Vincent's paintings in the original. Translation and footnotes are by the editor. Reprinted by permission of Mrs. Gerard Kraus.

[1] In *Strindberg und Van Gogh*; see Jaspers' article included in this volume.

depth, comes gravely close to this position. This opinion, which I find disputable on theoretical grounds, is clearly unjustified *vis à vis* the art of Vincent. There is no real reason to assume, as does Jaspers, that the hypothetical psychotic process would have commenced only in Arles. Moreover, this opinion contains a misconception about Vincent's artistic activities during the Dutch period, in which respect further injustice has been done by others who have contrasted it too much with the "great" French period. In my opinion the relationship between his artistic activities and his sickness consists merely in the fact that the same characteristics which allowed him to become an artist could also, because their development remained unchecked, have contributed to his becoming sick. Minkowska and above all Riese have expressed themselves in a similar manner.

The issue just discussed must remain separate from another, which I would formulate thus: does a relationship exist between the sickness and the fact that van Gogh—assuming the origin of his talent to have been separate from his illness—ultimately discovered a way of life in art and became an artist? I would answer this question, along with Westerman-Holstijn,[2] in the positive. He fundamentally was not an artist at heart. Instead, he was "one called" and driven by some power to give witness. Art provided him with the possibility of expressing himself and of offering his love at the moment when his first preference for work as an evangelist, which demanded too much direct contact with other people, was cut off as a result of his sickness.

THE CONTENT OF THE WORK

Nowhere in the work of Vincent can be found a pathological representation; none of his hallucinations or other experiences of sickness are therein assimilated. . . .[3]

The illness, nonetheless, did have a great influence upon his choice of subjects. The fact that he was principally a painter of landscapes is connected with his hyper-emotionality, which brought him into conflict with his fellow man. Such figural models as "Sien," the fishermen, the alms house inhabitants, the farmers, the weavers, and the Roulin family were chosen from the working classes. This was not merely because of his social consciousness, but also at the same time because his irritability and other peculiarities drove him in this direction: "I am not a person who has much chance to become intimate enough with those [middle-class] types of girls that they will agree to pose for me" (Letter 395). A

[2] A. J. Westerman-Holstijn, "Die Psychologische Entwicklung Vincent van Gogh," *Imago*, 10:4 (1924), 399ff.

[3] The author here objected in particular to A. Bader, who in *Künstler-tragik: Karl Stauffer, Vincent van Gogh* (Basel: Schwabe, 1932), claimed to have uncovered a "hallucinated human countenance" in *Crows in the Wheatfields* (Fig. 25).

simple model caused him less difficulty: "I am happy with that model [i.e., "Sien"]. . . . For example, if things are not going smoothly, and I stand up angrily and say, 'It's no damned good,' or something even stronger, then she doesn't take it as an insult, reacting as most people naturally would, but she allows me to quiet down and to start over from the beginning" (Letter R8). . . .

The copying of religious representations was emotionally too stimulating for him; indeed, with a few exceptions, he did not dare to attempt such subjects. The fact that he never painted the cloister garden at St. Rémy apparently was connected with his oversensitivity to impressions and, in particular, with his fear of religious influences during a period when he perhaps was reacting against unbalanced visions which he had experienced along with his "crises."

THE FORMAL QUALITIES
IN THE WORK

. . . The evolution of the art of Vincent and his changes of style —in my mind, Riese has illustrated this convincingly—did not originate in and were not determined by the illness. The most one may say is that these changes, like everything about Vincent, were accelerated to a particularly quick tempo by the impetus of his emotional life. Moreover, his art passed through many stylistic changes, and it is not clear why precisely the development in Arles should be brought into relationship with the psychosis. I am, to be sure, in agreement with Westerman-Holstijn, who feels that Expressionism was more native to his general intellectual outlook than was an extroverted Impressionism. It is therefore understandable that this latter direction, which he followed under the influence of the colorists when he was in Paris after his earlier periods of isolation, was soon abandoned. Already during his Dutch period he had exhibited an expressionistic tendency, and one more easily can view the Paris period as an interruption of this (although such a view also oversimplifies) than one can, along with Jaspers, view the more abstract-symbolic manner of working in Arles as something completely new, which for this reason must be related to his psychosis. In addition, it is not at all justified to see something sick in the mere fact of a change in style. One encounters this in many, if not in most, artists. Considering how sensitive and emotionally suggestible was Vincent's nature, one should not expect otherwise than that the coupling of his Germanic genius with a Latin spirit, along with the influence of the Japanese [art] and the southern sun, would have produced results of great significance. . . .

THE VALUE OF HIS WORK

On this subject I can be quite brief, since I estimate the direct influence of the illness of van Gogh upon the cultural value of his *oeuvre* as a whole to be practically nonexistent. Perhaps alone in [the painting of] the Wheat Fields with the Ravens [Fig. 25], which in my opinion is a much overly praised painting, can one sense a certain diminution in quality. His work indeed carries the stamp of his sickness in the irregularity of his productivity, in the choices of subject matter, and in several technical particularities which have been noted above. Yet, the beauty remained intact and complete and was preserved until the very end. . . .

THE POPULARITY
OF VAN GOGH (1953)

Fritz Novotny

Whether or not the popularity of van Gogh is of a special kind represents a valuable subject of study insofar as it also allows for a better understanding of the art and of the personality of the painter. . . . It is an indisputable fact that the magnitude of the popularity of van Gogh knows no parallel, at least if one uses as a measuring rod the number of reproductions which have been made of his works. From the work of no other master have so many facsimiles been made, especially so many in color. In addition, exhibitions of van Gogh's works in recent years have consistently drawn record numbers of visitors. . . . In short, it is the work of this "modern" painter, one of the founders of modern art, which stands at the forefront of popularity rather than that of some Realist or of a Victoran Romantic, whose folksiness is in need of no explanation.

Does this all point to a genuine enthusiasm, a real understanding of the essential character of the art of van Gogh? In a lecture given over the BBC radio on the occasion of the major London van Gogh exhibition of 1947 (incidentally, bearing the same title as the present article), Mr. E. F. E. Schoen answered this question in the negative. He found "that an extensive and uncritical attraction to the art of van Gogh exists and that sentimental factors, which have nothing to do with the pure aesthetic enjoyment of great art, are mixed in with this attraction." Such sentimental factors derive from a knowledge of the dramatic life story of van Gogh, from a "curiosity about his abnormalities," and from an admiration for the moral qualities which played such an important role in the creation of his art. Certainly, such motives as these exist, although they are as little able to preclude an understanding of genuine artistic

A virtually complete translation, by the editor, of Fritz Novotny, "Die Popularität Van Goghs," *Alte und Neue Kunst*, 2:2 (1953), 46–54. Reprinted by permission of the author and Anton Schroll & Co.

merit as they are able, possibly, to deepen such understanding. But are these factors of great importance?

Most questionable, as with all generalities, is [Schoen's] lumping of all the various manners of appreciating the art of van Gogh into one category, and the concept of "popularity" is itself ambiguous enough. Nonetheless, in this case one can exclude at least one kind of popularity, since the role of fashion or educational prejudice surely has been minimal in building the fame of van Gogh. The many prints of the *Sistine Madonna* [by Raphael] in the homes of earlier generations and the many color reproductions of the Sunflowers [for example, Figs. 10 and 12] by van Gogh in the homes of today do not belong in the same category. The popularity of the old masters constitutes a pseudopopularity; in general it represents merely the vacant popularity of a name, a result of general education, and only rarely is a true fascination for the actual work of art imbedded therein. This is the false popularity of great art, which is closely related to the true popularity of phony art, the sentimental kitsch of much genre painting. With van Gogh, however, we have a quite extraordinary phenomenon—great art here becomes popular in the true sense.

Should the subject themes, which is to say, the moving quality or significance of the subjects rather than the character of the artistic form and manner of expression, constitute the determining factor in this popularity, then the dark pictures of the Dutch period—the farmers and weavers, scenes like the *Potato Eaters* [Fig. 2], and, in addition, the many later paintings after Millet, Rembrandt, Delacroix, and Daumier —would have to be the ones best loved. This, however, is not the case. In general awareness, van Gogh is much more the painter of the sunflowers and the chairs with straw caning, the landscapes of Provence, and the many monumental portraits of everyday people.

Moreover, even the dramatic and gripping life story of van Gogh plays a less than crucial role in reference to the effect of his work. For, despite many more or less "popularized" accounts, the biographical facts are far from being known to all the people who nonetheless are moved in one way or another by his art. It is to be asked, in reference to the argument of Schoen, whether such knowledge as this would not, in fact, be rather desirable in terms of the understanding of the work, first, because of the variable degrees of truth and value which are contained in such biographical descriptions and, second, for the deeper reason that the problematic relationship between the life and the work might become better appreciated.

In reference to the first question, the very agitated and eventful life of this artist is not easy to describe, if one does not content oneself exclusively with sensationalism. It is also understandable that the life drama of van Gogh, the special character of his tragedy, invariably leads to description in the form of superlatives and psychological exegeses.

What is, in fact, this special character? Apparently everything which happened in his life. Thus van Gogh has become for posterity a suffering and heroic figure, comprising a legend in which reality has been transformed earlier in time than is the usual case. Since his life was indeed filled with suffering, this is cause enough to describe as heroic the many forms of demanding exertion with which such a life and such an outpouring of work were sustained. However, it is nevertheless incorrect to view in isolation the sufferings of a solitary individual, who at the time —before he finally became an artist—suffered more on behalf of others than on behalf of himself. This comprises discrimination against the others. In this context one should not abstain from the sobering consideration that ultimately he could view such sufferings as the price which had to be paid for the achievement of something very grand, for his art. For what purpose, however, suffer the nameless? The special character of van Gogh rests much more on what he accomplished than on what he suffered. . . . The ruling principles of this activity, which operated throughout the periods of seeking which preceded his periods as an artist, but which also lasted for a considerable duration into the latter periods as well, were characterized by great simplicity. In van Gogh's spirit and in his humanity there existed a powerful simplicity, of which, of course, much in his art speaks, but which, however, was not embodied in similar measure in his painting. There were limits both for his life and for his art. His sickness and his temperament created such limits, so that in the realm of personality, too, not everything was so simple. Yet, an abnormal power of will was able time and again to bind together in unity all forms of personal obstinacy and disparity. But, in reference to art, simplicity is not a question of will, since such a quality can never be forced. Art does not enjoy this privilege, at least it is not given to a painter in his own time. Clearly, van Gogh wished that his art would embody the greatest possible degree of simplicity; [yet,] this dream of innocence was impossible even for van Gogh to realize in his work. All his strivings on its behalf and the many transformations through which his manner of representation passed make up one of the fundamental themes, one of the most important messages, in his letters.

It is quite another matter when we come to the mysterious powers which were at work during the later phases of his career, beginning with the conclusion of the Paris period. For van Gogh it was a burning question as to how much of the human side of the farmer and worker representations from the Brabant period could be subsumed in his new sense of form. Could sympathy be expressed in painting, if it were not, as formerly—most profoundly and magnificently, in the conception of the *Potato Eaters*—actually expressed as part of the thematic content?

In fact, recognizable pictorial themes of that type disappear almost completely from his later works, [except rarely as, for example, in] the

long series of paintings after works by Millet. . . . Yet, here too, . . . the individual element in the forms of van Gogh is so emphatic that the latter works no longer comprise merely imitations of the model which was used. Whether or not we wish to characterize these new personal forms of van Gogh as more powerful, harder, and less sentimental, it is unquestionable that in such paintings, and, in general, in all his painting following the Paris years, if these are judged retrospectively in terms of the earlier manner of representation, the thematic idea has now become more complicated and filled with greater tension. In the painting of the *Potato Eaters,* for example, the dull, dark colors—the "greenish soap" color of that period—and the hard, "proletarian" character of the drawing detail determined the pictorial language. Since there also is a similar consistency of form and content in the paintings of the mature periods—and that this is so needs no special emphasis—a decisive change consequently must have occurred in the content and in the pictorial language. For, the formal language has been radically altered in one cardinal respect—the color. Among all the characteristics of Vincent's painting, it is the color which has the greatest effect upon the greatest number of people. The streaming, unmixed colors (which were scarcely to be exceeded even by the extremely strident colorism of the following generation) clearly represent the most striking of the formal means which have made his paintings so popular. This fact is not to be wondered at particularly, and it concerns a relatively external effect. In itself, this usage could provoke either fascination or fright (as indeed it did at first). It is true, in any case, that the violent power of his colors, which to such a high degree is foreign to natural appearance, even as are the excessive forms in his drawings, is not consciously noticed to any particular degree by many viewers. These same people would withhold their approval from similarly strong deformations and violence in the drawing and color if found in works by other masters. As great as are the grip and the magnetic power of these formal devices of van Gogh, they nonetheless almost without exception remain means of representing individual objects. The viewer feels himself conducted towards such details, he is constantly beset by a kind of binding power which draws his visual attention and his feeling towards some kind of living center in the separate objects, whether they be living beings or only plain inanimate objects. It is understandable that attempts to describe the magical power of van Gogh's painting so frequently have sought cover in the formula, "he has expressed the heart, the essential character of things." One can give to this rather harmless superlative a more precise meaning, moreover, if one attempts to clarify in what respect van Gogh's manner of representing the "essential nature of things" is to be differentiated from similarly deep characterizations of particularized objects by other artists. The unique concentration upon individual objects in van Gogh's pictorial world draws its power from a tension, an opposition in his manner of

representation to pictorial usages that are directed to mutually antagonistic goals. In the manner of representation used by van Gogh, appearances become an illustration of the "elements," of that which is found in nature, but in which individual objects are brought into a determined order. The streams of movement, which in his paintings encompass all individual, living and dead objects, are, rationally understood, directly opposed to the particularization of appearances, and logically irreconcilable with this principle. However, artistically they signify something which can be looked at in various ways. For example, in terms of historical developments, this pantheistic intoxication with color and movement was the aspect of van Gogh's painting by which he plunged furthest into the new perceptual world of Post-Impressionist art. It is in this aspect that his role in the creation of this new perceptual world most clearly can be seen. In terms of the narrower confines of his personality, the peculiarity of the passionate quality in his temperament constituted a lasting source of agitation. Finally, it appears (to repeat an earlier point) that a primary cause of the frequently shocking and constricting forcefulness with which he depicted individual objects—the human figures, a chair, every tree, and the various objects in a still life representation—resides in the fact that the painter wished to defend his representations against hyper-individual sensations, to the illustration of which he was otherwise susceptible. This aspect remains puzzling and in need of explanation to most viewers, and it is indeed puzzling to the point of seeming demonic. An enchanting and exciting aspect of determinateness which contrasts with the frequently threatening lack of determinateness just discussed is offered to the viewer by the immediacy with which images of particular things are depicted.

To the recognition of such tensions as these in the mature art of van Gogh a knowledge of the facts and the demonstrable traits of his personality makes little contribution. Repeated attempts have been made to discover a relationship between that which remains veiled forever, his life, and that which remains forever on display, his work. Insight into such relationships has not made a very great contribution to the popularity of van Gogh. The factors which do play a decisive role are, in fact, not peripheral, but central to the actual artistic process. What is singular in the popularity of van Gogh and is directly related to what is singular in the art of van Gogh is contained in the following observation: the viewing of works of van Gogh invariably leads one back, and in a very particular way, to the reality of the represented objects. Naturally, this is true in principle for any art which is more or less based upon a conscious realism. Every form of painting which takes as its point of departure the experiencing of reality must afterwards retain a certain measure of this reality. It is, to be sure, this measure of reality which makes a difference here, since it declines progressively as one accommodates oneself to plastic representation in terms of stylized forms. Should one al-

ready be very familiar with the characteristic flat countrysides and wood-lands in the landscapes of Ruisdael, then one is inclined, while looking at genuine flat country landscapes, whether Dutch or not, and at real forests, to seek and find something "Ruisdael-like." There are art lovers who forbid themselves such habits, because they believe that this leads to blindness towards the specifically artistic element, which is precisely that which distinguishes a painting by Ruisdael from natural appearance and which is called, as a collective designation, "stylization." The danger of bypassing this essential experience is in fact less, if one experiences a landscape painting by such a painter—and this is valid for the Baroque period as well, despite its realism—only in terms of these characteristic forms, rather than [approaching it] as if one were reexperiencing an actually viewed natural reality. This holds true in even greater degree if one reexperiences, let us say, a landscape by Cézanne in this manner while viewing nature. Such an experience obviously is more appropriate, if one pays attention only to the element of pictorial structure, since paintings like those of Cézanne allow for a better idea of the structure of things than do objects from the real world. In general one can say that a manner of observation which is, above all else, attendant upon an experience of form should not preclude a certain degree of reexperiencing of reality. The painting of van Gogh assumes a special position in this context. One might imagine that the aggressive power of his forms, his colors, and his linear structures, ought also to be experienced essentially as illustrations of structural considerations, as is the case in the painting of Cézanne. In the instance of van Gogh, however, one experiences only the single aspect, that previously mentioned anti-individual tendency in his art. In actuality, it is the separate objects in his paintings which have a stronger fascination for most viewers. And this is, in fact, the appropriate manner of experiencing these paintings. One can say that one has not really experienced the art of van Gogh, if one, upon having, from time to time, experienced in reality a railway underpass, a flat stretch of land, a piece of deserted street, or a factory on the outskirts of the city, and then having seen the same objects in paintings by van Gogh, does not experience the real objects more deeply. That which in all other contexts may be considered peripheral and which does not contribute to the experiencing of "pure art" in the strictest sense, here with van Gogh relates directly to what is most essential in the artistic experience. In this characteristic aspect, a small part of his utopian vision of art for the people in some marvelous way has been fulfilled. Whereas one is normally inclined on the whole towards skepticism in respect to hopes of seeing an extensive appreciation of art, it must nonetheless be recog-nized that in the case of van Gogh such an extreme unlikelihood has occurred. His art has had a profoundly penetrating effect, and, although by no means containing only easily understood characteristics, it has proven approachable for an astonishingly great number of people. It has

led them as has the work of no other single painter, to a deeper experiencing of nature. Often this consists in no more than that one, for example, while viewing the terrace of a café in the evening, is reminded of van Gogh's painting of such a café seen under a starry sky [Fig. 7], because suddenly everything which belongs to the essential character of the scene seems to have been expressed in this painting. A further step leads to this reflection: how can it be that so much of the character of the subject can be concentrated in a painting which leaves out so many of the actual details in nature and which simultaneously is so filled with the subjective personality of the painter? How does one explain that the many *staffage* figures in the landscapes of van Gogh (the promenading couples and the other people in the gardens and on the streets), despite the apparent haste with which they were sketched in, nonetheless give the impression of being irreplaceable individuals and, at the same time, helpless and melancholy members of the masses, just as such strollers sometimes appear at specific moments on a Sunday street? And always there are new and far-reaching questions which occur to one. How can a painting such as this report so much about the reality of objects and yet also represent "pure painting" so clearly? The answer would involve a further description of the particular character of the realism of van Gogh. . . . What is the significance of the fact that not anything of the darker side of the grievous destiny of this painter is reflected in the paintings of his last years, during which time they continually become much more luminous and achieve an almost overpowering brightness?

Such questions and such reflections, which always lead back to the most essential and most purely artistic qualities of the work, are of concern, to be sure, to only a restricted circle of viewers, although even here the number is considerable. How justly has his own, highly confident prophecy been substantiated, now more than one hundred years after his birth: "Yes, here in my head, behind the walls of my brain, great things reside. I shall be able to give something to the world, which perhaps will keep people concerned for a century and which perhaps will require a century to think about."

VAN GOGH'S SYMBOLISM (1965)

Jan Bialostocki

The art of the Middle Ages, the Renaissance, and the Baroque employed a metaphorical language, which was constructed from traditional images and symbols, was connected to a religious, humanistic, or dynastic ideology, and was more or less generally understood. In discussing elsewhere the iconography of Romanticism,[1] I attempted to delineate how iconographic tradition was altered by the fundamental upheaval in art which occurred at the end of the eighteenth century. Traditional allegorical content and religious themes and symbols no longer excited any interest. As a result of powerful and radical changes in the continuity of tradition, such elements of meaning often became misunderstood. In the study already mentioned I explained how old themes were filled with new content and how the new interests also produced new themes. The artists of the nineteenth century selected their themes not from inherited tradition, but from the observation of life and from recent literature. It is in this context that one can identify the favorite themes of the Romantics: man in confrontation with nature, ships which are tossed to and fro by the waves and thereby illustrate human impotence, and windows which, opened wide to the world, symbolize human hope and longing. The Realists discovered their themes in the world of human labor. They painted the pain and exertion of everyday life and chose motifs which drew sharp attention to the oppression and the hopelessness of the lower strata of society. One of their preferred motifs, which also was to reappear in van Gogh, was the village cemetery. Courbet

"Van Gogh's Symbolik" translated in full, by the editor, from *Stil und Ikonographie* (Dresden: Veb Verlag der Kunst, 1965), pp. 182–86. (Editor's footnotes.) Reprinted by permission of Jan Bialostocki.

[1] I.e., *ibid.*, pp. 156–81.

and Manet, among others, took up this theme time and again, whereby they were able to combine a Realist manner of observation with a Romantic mood.

The Impressionists rendered a new world accessible to art: not work and suffering, but life; their life, as reflected in the strikingly conceived "snapshot technique," [2] becomes the source for the themes used by the Impressionists. These include scenes not only of the streets, of beaches, of harbors, and of landscapes at the health and recreation centers located near Paris, in Normandy, and in Brittany, but also of railway stations, of theaters and their lobbies, of bars, of coffee houses, and of gardens. The paintings of the Impressionists depict the life which was familiar to them without including any statement about the meaning of what is represented. The Impressionists painted no allegories and employed no symbols. There are some exceptions to this, but they have little significance. It was the Symbolists who first returned to the earlier iconographic concerns. Vincent van Gogh was one of the first artists who considered the symbolic value of his images as a matter of primary importance. He was concerned—as he expressed it himself— "with more than only the green landscape and flowers." Conditioned by a preacher's manner of thought and speech, he continuously, indeed unwaveringly, expressed himself in his letters in terms of metaphor.

However, the symbols which appeared in his art are completely different from the old symbols and allegories of the art of the Renaissance and the Baroque. To be sure, he, too, frequently employed traditional elements of expression, as, for instance, when he assembled books and a candle in an early still life representation [Fig. 3], things which, if depicted together, are strongly reminiscent of the older symbolism. However, in general, van Gogh called a new symbolism into life, which was derived from a direct appreciation of tangible objects and of the content, associations, and moods which are therewith connected. A bird's nest, a house, a chair, shoes, farmers working (sowing or reaping), ravens, the sun, and sunflowers—all these have become the means of attaining a symbolic art for van Gogh. And beyond all this the restless and infirm psyche of the artist was displayed in a preference for certain motifs, for paintings which are informed by an original and elemental power (Jung called such things "archetypal" images) and which symbolize either the healthy side of life, such as friendship, or else the dark and the evil, of night, even madness and death.

Conscious and unconscious symbolism often reside together in van Gogh's creations, but not always. It occurs sometimes that the intended effect of the painting is different from the actual one achieved. The famous *Bedroom in Arles* [Fig. 9], a picture which according to our sensitivity is burdened with dramatic unrest, was explained by the

[2] Literally *Detailaufnamen.*

artist himself as an attempt to express a mood of simplicity, rest, and recovery [Letter 554]. "I wished to arrive at an impression of simplicity, as this is described in *Felix Holt* (by George Eliot). When I say this to you," he wrote to his sister, "you will quickly understand the painting, although it is probable that those who are unprepared would find it ridiculous. Nonetheless, it is not at all easy to achieve simplicity with the use of piercing colors, and I am of the opinion that it can be useful to show that one can achieve simplicity with the help of other colors than only grey, white, black and brown" [Letter W15].

The Sower subject, which he used in both paintings and drawings, was inspired by the parable from the New Testament; the Reaper signified death. "I see in this reaper an indeterminate form, who hacks away in the sweltering heat like a devil, in order to finish with his work. I see in him the image of death in the sense that humanity is the grain which he cuts down. It is therefore, if you will, the opposite of the Sower, which I attempted earlier. However, this death has nothing sad about it; it occurs in the bright daylight under a sun which inundates everything with a delicate golden light." And further on, "It is an image of death, such as the great book of nature speaks to us of it, but what I have sought is the 'almost smiling'" [Letter 604].[3]

The Reaper is repeated in the output of van Gogh with a stubbornness which borders on possession. Whether borrowed from Millet or derived from nature, he appears as if overwhelmed by the sun-scorched landscape of Provence. The thought of death is to be found in the art of van Gogh from the very beginning. Whereas death in the later representations is meant as a good death, in the earlier works death and disillusionment are always contrasted with a motif representing life. *Sorrow* [Fig. 1] [4]—a female figure, sunken in helplessness—was executed simultaneously with another drawing, which represents the roots of a tree:[5] "Now, in the landscape I wished to express the same sentiment as in the figure: although one convulsively and passionately roots himself fast to the earth, one is nonetheless half wrenched away by the storm" [Letter 195]. Pessimism, the homelessness of the modern man—as he himself felt these things—van Gogh expressed in the very early *Still Life with Open Bible* [Fig. 3], which displays together the Holy Book and Zola's *Joie de Vivre*. The former is opened to the quotation from Isaiah: "He was despised, and rejected of men; a man of sorrows, and acquainted with grief: and as one from whom men turned their faces away. . . . Surely he hath borne our griefs, and carried our

[3] The Reaper subject appears in *The Wheatfield behind St. Paul's Hospital with a Reaper*, F 617/H 614, F 618/H 613, and F 619/H 632.

[4] Less detailed versions of this subject are found in a second drawing, F 929 and a lithograph, F 1655.

[5] I.e., F 933 *recto*.

sorrows" (Isaiah 53: 3, 4). Anxiety and the feeling of being alone and abandoned, his sense of defeat led van Gogh to a form of compensation, when he painted pictures of houses, of human habitations, and of people who are gathered at table for the evening meal. This same motivation accounts for the representation of what was perhaps the most intimate symbol of that security for which he so longed. This was the bird's nest, an object which, apparently influenced by Michelet, he passionately collected. Another of the repeatedly reappearing "positive" themes in his art is the bridge—symbol of human contact and friendship—a theme, moreover, which would have been enriched through the associations it preserved with his native country.

What in van Gogh's iconography relates him, above all, to his predecessors is the element of human labor, which is visible in the images of the Sower and the Reaper already discussed. Several paintings, which include farmers working in the fields, remind one strongly of Millet, just as various studies of weavers who are seen standing before their looms closely relate to the early work of Käthe Kollwitz. Nevertheless, van Gogh painted above all his own life. The subjective element distinguishes him radically from other painters of human misery. Later, the role played by subjective elements, in comparison with that of the objective elements, will be increasingly enlarged. Material objects, including the humblest fragment of the ugly city profile of Arles, are saturated with an intensive sensitivity of feeling, which one experiences directly, but which one scarcely can describe.

The empty chair [F 499/H 522], symbol for the absence of a human being with whom one has felt a close relationship, has been enriched by medieval and even more ancient symbolic traditions and is also a repeated iconographic formulation in the art of van Gogh. At first, it was the chair of his father,[6] then of Gauguin, two people who were important to the emotional life of van Gogh and with whom his relationship was made more difficult by a richness of unconscious dependencies and psychopathic complications.

To the degree that the force of the psychic and artistic drama was intensified, new motifs appeared: the cypresses ("as beautiful as an Egyptian obelisque"), a tree which in southern countries is related to the cemetery and death, and the starry night, an always magnificent and dramatically conceived vision, which sometimes is conceived as the gate to eternity. Meyer Schapiro has wished to discover its origin in the apocalypse,[7] whereas Lövgren emphasizes the relationship to the

[6] E.g., in painting his own chair in Arles, F 498/H 521, Vincent included a pipe and tobacco pouch, which symbolic attributes he earlier had chosen in commemorating his father's death in a watercolor sent to Theo (see Letter 398 and *Complete Letters*, 2, illustration p. 356); for the general symbolism of an empty chair, see Letter 242.
[7] In "On a Painting by Van Gogh"; see Schapiro's article, n. 3, included in this volume.

poets of Symbolism, in particular the noticeable relationship to Walt Whitman, whom van Gogh read.[8] This vision had overpowered the fantasy of van Gogh as early as the spring of 1888: "I must also produce a starry sky with cypresses." [Fig. 22] The stars for van Gogh are related to death, and the origin of the first composition based on this theme is related to the death of his teacher, Anton Mauve [Letter 474]. Although he copied, while simultaneously modifying, the religious paintings of Delacroix and Rembrandt—even in his final periods—he nonetheless produced no paintings which can be related to traditional iconographic norms. His symbolism had its origin in immediate experience, in the richness which can be intuited about the meaning of objects—from observation, but also from the unconscious. For this reason his symbolism must not be considered conventional, but, rather, "direct." In reference to the representations by Bernard and Gauguin of the Mount of Olives, he answered with the landscapes which depicted live orchards [for example, Fig. 21]. A wide expanse of sky, either full of stars or hidden behind storm clouds, or dotted by the flight of black ravens [Fig. 25], expressed the growing unrest and the incipient drama.

However, it is not only the thematic content which is symbolic for van Gogh. The perspective is as well. With its close-up point of view, this "accelerated" perspective, which chains the viewer to the image, drawing him into the space, in contrast to the distance implied in the drawn out perspective of Cézanne and to the "aperspectival" planar perspective of Gauguin, is expressively potent. As with the great masters of the past, such as Rembrandt, van Gogh also gives a symbolic meaning to the purely artistic elements. Sadness, joy, life, and death assume in van Gogh's painting not only the forms of lonely old people staring into nowhere, not only the forms of joyous bridges under the serene heavens, the forms of golden, intense suns, of peaceful cypresses, of the chairs which contain the remembrance of a welcome presence, but also the forms of the restless or smooth relief of the painting surface, of the painful or soothing colors, the harmony, replete with genuine warmth, or else the final dissonance, in which life was extinguished.

[8] See Lövgren, *The Genesis of Modernism*, pp. 145–48.

LITERARY INSPIRATION
IN VAN GOGH (1950)

Jean J. Seznec

Van Gogh's tragic life and tragic death have been exploited in literature, and could not fail to be; but the literary sources and intensions latent in his own works are still little known, or at least their importance has generally remained unsuspected. . . .

If one considers Vincent's life and his correspondence with his brother, one soon realizes that the presence of books in his canvases is profoundly meaningful. "I have a more or less irresistible passion for books," he wrote in 1880, "and I want continually to instruct myself, to study if you like, just as much as I want to eat my bread." [Letter 133]. For a few months, he was employed at a bookseller's at Dordrecht; and at the time when he left the mental hospital at St. Rémy, he was dreaming of painting a bookshop at night. [Letter 634]. "There," he said, "would be a subject that would go well between an olive grove and a cornfield—the seedtime of books."

Another parallel motive is that of the reading figure. Not only did van Gogh himself treat that subject several times (as in the *Old Man Reading* [F 897, F 966, F 1001] and the *Novels' Reader* [F 497/H 517]); but he made mention of it in the work of other painters, for instance Rembrandt. He had a predilection for the *Reading of the Bible*; he also mentions a certain print by Rembrandt "where a little fellow sits reading, also crouching with his head leaning on his fist, and one feels at once that he is absolutely lost in his book." [Letter 248]. . . .

This concern for books and reading sets van Gogh apart from most of his contemporary fellow-artists, who were suspicious or even scornful of literature. "There are so many people," he wrote to Emile Bernard in 1888, "especially among our pals, who imagine that words are nothing;

This abbreviated version of "Literary Inspiration in Van Gogh," *Magazine of Art,* 43:8 (December 1950), 282–88 and 306–7, reduces the original by approximately half. Reprinted by permission of Jean Seznec.

but, on the contrary, it's as interesting and as difficult to say a thing well as to paint it, isn't it? There is the art of lines and colors, but the art of words exist too, and will never be less important." [Letter B 4]. Elsewhere he wrote, this time to his brother, "One must learn to read, as well as one must learn to see, and learn to live. . . . We know how to read, well let us read then!" Coming from a painter, such an apology for reading is curiously eloquent; the reason is that for van Gogh, literature and painting were interrelated and equal in dignity. "If you can forgive a man for making a thorough study of pictures, admit also that the love of books is as sacred as the love of Rembrandt, and I even think the two complete each other. . . . To try to understand the real significance of what the great artists, the serious masters, tell in their masterpieces—*that* leads to God. One man has written or told it in a book, another in a picture." [Letter 133].

Since this is the case, it is legitimate to establish between painting and literature all manner of connections and counterparts, and indeed this was van Gogh's constant and systematic practice. For each great artist, for each great writer, he sought a duplicate in the other field. "How beautiful Shakespeare is! Who is mysterious like him? His language and style quivering with fever and emotion can indeed be compared to an artist's brush. . . . [Letter 133]. What Rembrandt has alone or almost alone, among painters—that tenderness in the gaze which we see whether it's in the *Pilgrims to Emmaus* or in the *Jewish Bride,* or in some strange angelic figure . . . that heartbroken tenderness, that glimpse of a superhuman infinite that there seems so natural—in many places you come upon it in Shakespeare." [Letter 597]. Van Gogh even pushed his system of counterparts to the point of establishing a double scale of parallel values, in which there is the same ratio between the first-rate painter or the first-rate writer as between the minor geniuses in their respective fields, and in which any artist, whatever his rank, has so to speak his literary twin: Shakespeare "is as beautiful as Rembrandt, Shakespeare is to Charles Dickens or Victor Hugo what Ruysdaël is to Daubigny, and Rembrandt to Millet." [Letter 136]. Let us not forget, however, that if such analogies are permissible, it is because literature and painting are not separate domains; the difference lies in their means of expression, but what they have to express is the important thing. Consequently the languages are interchangeable, and one is justified in saying that "there is something of Rembrandt in Shakespeare, and of Correggio in Michelet, and of Delacroix in Victor Hugo . . . and in Bunyan there is something of Maris or of Millet, and in Beecher Stowe there is something of Ary Scheffer." [Letter 133].

What books did van Gogh read? As we can infer from this enumeration, all sorts of books; but above all the Bible and contemporary French novels. . . . One remembers Gauguin's definition of van Gogh: "A Dutchman whose brains had been seared by Daudet, the Goncourts

and the Bible." [1] One of his famous pictures sums up this double in-
spiration: it juxtaposes the Bible, opened at a definite place, Isaiah 53,
and a French novel, *La Joie de Vivre* by Zola [Fig. 3]. This juxtaposition
is of course intentional; van Gogh was looking not only for a contrast
in colors—an opposition between the broken-white and the yellow-
brown of the Bible and the lemon-yellow of the novel; he was looking
also for moral contrast. . . . Vincent . . . would always remain a reader
of the Bible; but there were also *modern* Bibles which teach the
gospel of our times—and these are the French books. To his father,
these were abominable; but to him, they too were sacred books, and
Zola could challenge the venerable prophet. . . . Zola was indeed one of
the idols of van Gogh, who constantly recommended to his brother the
reading of his novels, "which I consider among the very best of the
present time." [Letter 333]. He admired in Zola the vigorous analyst,
"whose diagnosis is both so callous and so exact," [Letter 451] and the
great historiographer, who "did for French society under Napoleon III
what Frans Hals did in painting for the Dutch Republic of the seven-
teenth century." [Letter B 13]. As he wrote to Theo, "What we have read
has come in the end to very near being part of us"; thus, van Gogh
absorbed his books in such a way that it was, for instance, under Zola's
influence that he exaggerated the powerful character of his portraits,
The Postman Roulin [for example, Fig. 6] or *Père Tanguy* [for example,
Fig. 5], "in which most people will see only caricatures." . . .

Three other major novelists of the naturalistic school are repre-
sented in a single canvas: Guy de Maupassant by *Bel-Ami*, and Jules and
Edmond de Goncourt by *Germinie Lacerteux* [F 360/H 237]. Van
Gogh admired Maupassant; he liked his jovial, rakish mood, and in
accordance with his own system of classification tried to rate Maupassant
in relation to Zola as a great painter in relation to one still greater.
"What Van der Meer of Delft is to Rembrandt among the painters, he is
to Zola among the French novelists." . . . [Letter 498]. Is van Gogh
himself to be the Zola or Maupassant of his generation of painters? No,
. . . he draws back: "I don't think that I am the man to do it"; but he
can at least prepare and open the way for these painters of whom he is
dreaming. After all, "did not the Flauberts and Balzacs make the Zolas
and Maupassants? So here's to, not us, but the generation to come."
[Letter 525]. The role he assigned to himself was thus that of a pre-
cursor.

The Goncourts, again, were among Vincent's favorite writers. He
admired them not only as art critics, but as painters of modern life, and
particularly of the modern woman; he "feels to the marrow the beauty
of their feminine analysis"; [Letter 442] he would like to emulate them.
. . . In another canvas, next to Richepin's *Braves gens* and Zola's *Bon-*

[1] [See "Gauguin on Vincent" in this volume.—Ed.]

heur des dames, we see still another novel of the Goncourts: *La Fille Elisa,* the story of a prostitute [F 335/H 246].

Gauguin has told us an anecdote about van Gogh and *La Fille Elisa.*[2] It was during the winter of 1886, in Paris; Vincent had been starving for several days—but, through a miracle, he had just sold one of his canvases for five francs. He came out of the art dealer's, clutching the coin in his hand, when he was accosted by a girl of the street. "Van Gogh," Gauguin relates, "had kept up with French literature. He thought of *La Fille Elisa,* and gave his five-franc piece to the poor girl." Gauguin's interpretation is cynical; Vincent did not need a literary incentive to perform a deed of charity; but it is true that very often he did think in literary terms, and his very emotions seemed to come to him through the filter of literature. The profound affection which linked him to his brother was sometimes expressed or transposed on a literary plane, for instance, while he was reading *The Zemganno Brothers,* wherein Edmond de Goncourt, by telling the tragic story of two circus acrobats, had symbolized precisely his intimate collaboration with his brother Jules, interrupted by death. Vincent wrote to Theo that if he knew this story, "You will know that I dread more than I can tell you lest the effort of getting money will exhaust you too much." [Letter 550]. . . .

. . . As for Gauguin, according to Vincent he too was a character from a novel. "One day, when he was in a cheerful mood, he declared that this blusterer, this braggard of a Gauguin was the *Tartarin of painting.*" [Letter 571].[3]

Let us now see whether it is possible to detect in a particular picture by van Gogh a literary element or ingredient. We must not look, of course, for any direct illustration of the books he read, but rather for a more or less conscious reflection of his readings. One day, having painted an old coach in the yard of an inn, he wrote Theo: "Do you remember that wonderful page in *Tartarin,* the complaint of the old Tarascon diligence? Well, I have just painted that red and green vehicle in the courtyard of an inn." [F 478a/H 811]. So the actual model was confused with the memory of a reading. . . . [Letter 552].

Some literary influences, however, make themselves felt in a more subtle manner. While Vincent was painting Madame Ginoux, he was still under the Japanese spell cast not only by prints, but by Pierre Loti's *Madame Chrysanthème,* which accounts for the *Arlésienne* [Fig. 16], too, looking somewhat like the *Mousmé* [F 431/H 460]. The latter portrait he had explained in a letter thus: "If you know what a *'mousmé'*

[2] [Related in *Avant et Après* (See "The Pink Shrimps," in *Paul Gauguin's Intimate Journals,* trans. Van Wyck Brooks [Bloomington: Indiana University Press, 1958], pp. 55–56), where it was inserted from the "Diverse Choses" manuscript, pp. 225–27 (see "Gauguin on Vincent," n. 1, in this volume).—Ed.]

[3] [A reference to the picaresque hero of the Tartarin novels by Alphonse Daudet, which books Vincent admired greatly.—Ed.]

is (you will know when you have read Loti's *Madame Chrysanthème*) I have just painted one. . . . A '*mousmé*' is a Japanese girl—Provençal in this case—twelve to fourteen years old." [Letter 514]. Again it was Loti who was indirectly responsible for the famous *Woman Rocking a Cradle,* [that is, *La Berceuse,* for example, Fig. 11], for that picture (which on the surface is only the portrait of good Madame Roulin) contains a suggestion from *Pêcheur d'Islande,* thus justifying its title. In a letter to Theo, Vincent himself has explained that a conversation with Gauguin about the loneliness and melancholy of Icelandic fishermen had given him the idea of painting such a picture, for it seemed to him, "that sailors, who are at once children and martyrs, seeing it in the cabin of their boat should feel the old sense of cradling come over them, and remember their own lullabies." [Letter 574].

In the same way, Vincent explained the deep meaning of the *Night Café in Arles* [Fig. 7]. In that picture, "I have tried to express the idea that the café is a place where one can ruin one's self, run mad, or commit a crime. So I have tried to express as it were the powers of darkness of an *assommoir,* by soft Louis XV green and malachite, contrasting with yellow-green and hard blue-greens, and all this in an atmosphere like a devil's furnace, of pale sulphur. And all under an appearance of Japanese gaiety, and the good nature of Tartarin." [Letter 534]. Here are two more literary reminiscences in addition to *Tartarin*: Tolstoy's *Power of Darkness* and Zola's *L'Assommoir.* There is something still more significant, however; van Gogh tells us that he did not care for the picture, which looked "exaggerated, atrociously ugly and bad," until he came to read an article on Dostoievsky; then he suddenly got the feeling that, on the contrary, pictures of that sort "are the only ones which appear to have any deep meaning"; [Letter 535] in other words, Dostoievsky brought him his justification.

It is hard to conceive that Vincent's landscapes might have been influenced by literature to any degree; yet even there, his vision and interpretation of nature were affected by his readings. While he was in St. Rémy, he read a novel by Edouard Rod, *Le Sens de la vie,* which failed to impress him except for a description of the Alps; some time afterwards, he informed Theo that he had painted a landscape on the basis of that description [F 622/H 619]. Actually, however, this landscape is not an imaginary one: it represents a hilly district in the vicinity of the hospital; but to van Gogh, it seemed to resemble that described in the book. Once more we witness this strange confusion in the artist's mind between literature and reality.

Important as they are for our understanding of the genesis of van Gogh's works, these literary substrata are still not the most important. Deeper still, we can distinguish a current which runs all through these works, namely, the will to transmit a message.

Let us go back to the Bible. The Bible, for van Gogh, meant essen-

tially the Gospels, the culmination of the Old Testament; for in Christ, and Christ alone, is consolation to be found. "It is undoubtedly wise and just," he wrote to Emile Bernard, "to be moved by the Bible. . . ." Yet he painted no religious pictures, because "Christ, as I feel him, has only really been expressed in paint by Delacroix and Rembrandt" (let us recall at this point that Vincent copied Rembrandt's *Lazarus* [Fig. 24] and Delacroix' *Pietà*), [F 630/H 625]. "After that there's Millet, who painted (not Christ himself, but) Christ's teaching." [Letter B8].

That is what he, in turn, wanted to do; instead of illustrating the Gospels or representing the biblical episodes—a thing which Millet did very seldom—to express the *spirit* of the Gospels. . . . It is enough to show the suffering of the common people—the common people of today; instead of trying to reconstruct by imagination the biblical past, one must attach oneself to the miseries of the present time.

That is exactly what the modern Bibles did—all the French, English, American and Russian novels. On the table in front of his *Arlésienne,* van Gogh placed two of these books of charity: Dickens' *Christmas Carol* and Harriet Beecher Stowe's *Uncle Tom's Cabin.* These were two of his favorite books. Of the *Christmas Books* he said, "There are things in them so profound that one must read them over and over"; [Letter 583] and about *Uncle Tom's Cabin* he declared: "I love this book, there is so much slavery in the world." [Letter 130]. To denounce misery; that is what Michelet had done, and George Eliot and Carlyle and Zola and Richepin: "all these men and women who may be considered to stand at the head of modern civilization, and who call on all men, whoever they are, who bear a heart in their bosom." [Letter 160]. Misery—van Gogh knew what he was talking about, as one among those who had "taken a free course at the great University of misery"; he had known the humblest toilers of this world, the miners of the Borinage, the plowmen of Brabant, "all those who wear the stigmata of a whole life of struggle, borne without flinching ever." In Paris one autumn evening, having admired Notre Dame, splendid among the chestnut trees, he added this astonishing remark: "But there is something in Paris more beautiful than the autumn and the churches and that is: the poor." [Letter 75].

The artist, too, has a social mission. Millet realized it, and that was why van Gogh considered "not Manet but Millet to be that essential modern painter, who opened new horizons to many." [Letter 355]. . . .

. . . There is a figure of a pathetic woman, to which he gave an English title—*Sorrow* [Fig. 1]. The story of that figure is a revealing one, which uncovers once more the deep intertwining, in van Gogh, of literature and life. The woman who sat as the model was the poor, starved, pregnant woman with whom he lived in The Hague. "For my part," he said, "I always felt and will feel the need to love some fellow

creature, in preference an unhappy, forsaken or lonely creature. . . ."
[Letter 219]. At the bottom of the drawing appears a sentence which
fits very well with this sentiment: "How is it that on earth there can be
a lonely, forsaken woman?" This sentence, however, is a quotation; it
comes from a book by Michelet, *La Femme*, a sequel to another book,
L'Amour. That book, which he had read as early as 1874, made a tre-
mendous impression on the young Vincent. Michelet appeared to him
as an apostle, advocating pity for this victim of modern society—woman.
"This book," he wrote, "has been a revelation to me as well as a Gospel
at the same time." [Letter 20]. According to Michelet, the nineteenth
century was the century of woman's misery, abandonment and despair;
man's mission was to liberate her, to free her from all the servitudes that
oppress her. Now Michelet, who inspired van Gogh, had in turn been
inspired by a work of art, . . . as he himself tells us: "You know in the
Louvre, that group of Puget, *Perseus Delivering Andromeda*. The great
sculptor represented, through his whole life, unfortunate prisoners; such
is little Andromeda. . . . "Happy the man" (Michelet solemnly con-
cludes), "who liberates a woman, who frees her from the physical fatality
to which Nature condemns her, from the weakness which is her lot in
her loneliness, from so many chains, and miseries."

Thus Puget's *Andromeda* is woman liberated; van Gogh's poor
creature is woman awaiting her liberation. Through Michelet, an un-
expected link appears between the baroque, mythological sculpture and
the bare, realistic drawing of the modern master. . . .

This Dutchman, one day, discovered the sun, and we know with
what enthusiasm he hailed the light of the South: "I have never had
such a chance, nature here is so *extraordinarily* beautiful. Everywhere
the vault of the sky is a marvelous blue, and the sun sheds a radiance
of pale sulphur. . . . I cannot paint it as lovely as that is." [Letter 539].
But while he was discovering the sky of Provence, van Gogh was gradu-
ally rediscovering, at the same time, the great classical tradition. That
self-taught man who could never learn any Latin or Greek, through
sheer intuition, through the suggestion of landscape and climate, went
back to the Renaissance, and still further back, to Greece. He was quick
in perceiving under the jovial atmosphere of the country something
ancient and sacred. "All through the Tartarin and Daumier side of this
queer country, where the good folk have the accent you know, there
is a great deal of Greek still, and a Venus of Arles as well as of Lesbos,
and one still feels that youth in spite of all." [Letter 539]. He felt,
indeed, that he himself was becoming part of the noble Mediterranean
tradition: "Some time ago I read an article on Dante, Petrarch, Boc-
caccio, Giotto and Botticelli. Good Lord! it did make an impression on
me reading the letters of those men. And Petrarch was quite near here
at Avignon, and I am seeing the same cypresses and oleanders." [Let-
ter 539].

The following year, in 1889, in the middle of the summer, he listened to the cicadas: "Outside the cicadas are singing fit to burst, a harsh cry, ten times stronger than that of the crickets, and the burnt-up grass takes on lovely tones of old gold. And the beautiful towns of the South are in the state of our dead towns along the Zuyder Zee, that once were astir. Yet in the decline and decadence of things, the cicadas dear to the good Socrates abide. And here certainly they still sing in ancient Greek." Finally, he exclaims in a magnificent outburst, "I very much hope to read Homer at last!" [Letter 599].

So this man from the North, this nostalgic Hollander, perceived Greece beyond Provence, and Homer beyond Tartarin. He recreated, so to speak, a radiant classicism, and he wrote to his brother: "When you have seen the cypresses and the oleanders here, and the sun—then you will think still oftener of the beautiful *Happy Land* of Puvis de Chavannes, and many others of his." [Letter 539]. As for himself, he had no need of Puvis' academic allegories to express the eternal youth of the Mediterranean. A blossoming tree was enough, for he was the same van Gogh who said, "It is much better to paint olive trees than the Garden of Olives." [Letter B 21].

Hence the intensity which makes us pause in front of van Gogh's canvases. Each of them has a spiritual content, each of them crystallizes a genuine emotion. Of course, they are self-sufficient, in the sense that one does not have to explain them; but we have the obscure feeling that they say much more, and much graver things, than appear on their surfaces. They are laden with meaning—allusions, reminiscences, meditations and even forebodings; they are pregnant with repressed compassion and tenderness, evangelic fervor or pagan ecstasy. Each adds to its literal, obvious value a hidden, symbolic one which is like a third dimension. This again is a fact of which we are more or less vaguely aware; but van Gogh's readings justify that feeling, because they provide the key to his mental and moral universe. This passion for books, this extraordinary sensitiveness to literature, are invaluable clues for those who want to take the full measure of this valiant and pathetic genius, and probe the secret resources of his mind and of his heart.

VAN GOGH AND
COLOR THEORY (1961)

Kurt Badt

INTRINSIC AND
REPRESENTATIONAL VALUES
OF COLOR (JANTZEN)

In order to relate the present study [of the color theory of Vincent van Gogh] to one of the most important critical definitions within recent German art history, I should like to refer to Hans Jantzen's distinction between the intrinsic and representational values of color.[1] . . .

In what mutual relationship do the intrinsic and representational values of color stand in the case of van Gogh? It is clear that the intrinsic values predominate over the representational values, since those characteristics which involve representational value, namely, "material substance, hardness, thickness, roughness or smoothness of surface, solidity as well as placement in reference to space and lighting," did not essentially engage the attention of van Gogh in his painting. It was not his preoccupation "to explain the nature of the supporting object or substance," but to represent the destiny of some being, either human or material. He progressively eliminated all realistic elements from his art, if one understands "realistic" in the original sense of [being concerned with] material things. To such characteristics belong materiality, hardness, thickness, roughness and smoothness which are manifested in objects as variously combined degrees of light and shade. A smooth object displays different

From an appendix to Kurt Badt, *Die Farbenlehre Van Goghs* (Cologne: M. DuMont Schauberg, 1961), pp. 147–51. Translation and footnotes are by the editor. Reprinted by permission of the publisher.

[1] Quoted from Jantzen's *Ottonische Kunst* (Munich: Münchner Verlag, 1947), p. 114 (where, however, n. 66 traces this theoretical distinction to a lecture of 1913).

tonalities in its coloring and the reflections of adjacently placed sub-
stances, if compared with a dull object, which manifests only its own
coloration, records no reflections, and reduces the contrast of light and
shadow (for example, the trunk of an oak tree).

Van Gogh entrusted the "explanation of the nature of the support-
ing object or substance," as far as was necessary, to his drawing, to his
linear configurations, irrespective of their coloration. In that he increas-
ingly extricated his linear contours from their isolation in (conceptually
colorless) black and subjugated them to the element of color (by exe-
cuting them in color), he hereby indicated that he intended to introduce
the intrinsic values of color even into the fundamental structure of his
representations. This occurred, to be sure, not only in reference to "the
beauty, intensity, and capacity for reciprocal or complementary enhance-
ment and diminution of color," but, rather, through granting a con-
tinuously renewed emphasis to these qualities, in reference to their
"material-ethical" effect.[2] Van Gogh considered color to be much more
the immediate bearer of non-naturalistic expressive factors, to be a
harbinger from the realm of the spirit which tells the story of human
destiny, rather than to be an artistic usage which can be explained purely
by either of Jantzen's hypothetical conceptual alternatives. To be sure,
time and again he studied and experimented with the natural laws of
enhancement and diminution of color intensities with reference to spe-
cific combinations of hues. Yet, this labor was undertaken not as a goal
in itself, not because of the intrinsic values of the so combined colors,
but because of the direct, expressive power which becomes immediately
visible through the use of the positive and negative, that is to say, the
weakened gradations of hue. Thus, for him, the intrinsic values are put
at the service of representational values, albeit not at the service of
objects, but rather of spiritual meanings which the intrinsic values in-
herently express. The "elementary powers," which for Jantzen "achieve
expression in the intrinsic values of color," were for van Gogh already
themselves "representational values." As such, these "elementary powers"
represented the physical embodiments of spiritual or emotional moods.
The sheer influence of light upon solid bodies which are resistant to cer-
tain rays and the illustration of such forms of appearance by means of
the laws of gradation as applied to concrete objects thus, for van Gogh,
related directly to the character of the human temperament.

In the history of color in painting van Gogh's art therefore appears
to assume a position in which the intrinsic values of color, which as such
can be enjoyed only as either a naive impression or a sentimentally ar-
tificial re-creation, are forsaken on behalf of representations which con-
cern the world of human destiny. The despair which was expressed in

[2] A concept derived from Goethe's *Farbenlehre*.

this form of representation van Gogh wished to counter with an act of consolation. He thus transformed such a world of despair through the means of harmoniously resounding colors. By this act even the paradoxical tragedy of human destiny—which he looked straight in the eye with the greatest courage—was celebrated and praised.

THE POTATO EATERS (1942)

J. G. van Gelder

Among those Dutch painters of the 'eighties who set out in a direction once and for all independent of the aims of the Hague School, the eldest was Vincent van Gogh. The son of a pastor, born at Zundert in 1853, he was the senior not only of such painters as Suze Robertson, Jacobus van Looy, Breitner, Toorop, and Van Rappard, but of the writers who figured in a related literary movement.[1] The variations between the ages of the leaders of this turbulent generation, while apparently insignificant, were, in fact, important enough to effect gradual shifts of attitude. Van Deyssel's pronouncement, in 1884, that the worshippers of the Idea and the World-Soul, Goethe, Shelley, and Hugo, were now succeeded by the "witnesses of life," expressed a feeling shared only by his immediate contemporaries. Had van Gogh read Van Deyssel's words, "We, the prophets of reality, the enthusiasts of facts, we who are raptured of perception," he would not have included himself in the "we." By that time his mind had become too deeply possessed by another conception of life, was too powerfully driven by a passion to paint man in his spiritual and physical sufferings.

Van Gogh's struggle to express this feeling with clarity was reflected in a letter to his brother, Theo, written some weeks after finishing *The Potato Eaters* [Fig. 2], in May, 1885. Having painted the half-crumbled gates of a churchyard, he wrote: "I wanted to express how

First published as "De Genesis van de Aardappeleters," *Beeldende Kunst*, 83:1 (1942), 1–8. The somewhat abbreviated version printed here in full appeared as *Vincent van Gogh: The Potato Eaters*, trans. A. D. S. Sylvester (London: Percy Lund Humphries, Gallery Books, no. 17, 1947). Reprinted by permission of J. G. van Gelder and Lund Humphries Publishers Ltd.

[1] I.e., the so-called "men of the eighties," such as J. Perk, F. van Eeden, L. van Deyssel, H. Gorter and Jan Veth.

those ruins [i.e., F 84/H 94] show that for ages the peasants have been laid to rest in the very fields which they dug up when alive—I wanted to say what a simple thing death and burial is, just as simple as the falling of an autumn leaf. And now those ruins tell me how a faith and a religion mouldered away, strongly founded though they were, and how the life and death of the peasants remain for ever the same, budding and fading regularly, like the grass and the flowers growing there in that churchyard ground. *Les religions passent, Dieu demeure,* is a saying of Victor Hugo's, whom they have also recently brought to rest" [Letter 411]. (This saying had, indeed, first impressed him three years earlier.)

Like many of his fellow-painters, van Gogh was familiar with the foreign literature of his time. He knew Gavarni and de Goncourt's *Soeur Philomène,* in addition to such older writers as Mouret, Michelet, and Balzac; he was among the first in his country to read Zola's *Germinal* and *Mes Haines*; he repeatedly quoted François Coppée and Jules Breton. But all these authors were to him less an inspiration than an affirmation of his own aims, which had achieved an established form by 1885, independently of tendencies and ideas prevailing in the milieux of Amsterdam and the Hague.

The practices of the Hague School were familiar to van Gogh through his relations with Tersteeg, the art-dealer, and Mauve, the painter, who had at first helped him in many ways. It was not so much the technique of such painters as Maris, Israels, and de Bock that van Gogh opposed, as that they did not paint with the vitality he demanded (he thought them "too dreamy"). Van Gogh was not looking for atmosphere or effect, but for the inner life of the object. In his search he left the Hague in 1883 and moved to Drenthe, which had been discovered before him by Liebermann and others. There he went as to another Barbizon: "It is no good in town. . . . I am going to renew myself in nature." Nevertheless, he was fascinated above all by human beings: "There are a lot of Ostade types among them: physiognomies which remind one of pigs or crows." [Letter 158]. When, later, van Gogh went to Nuenen in Brabant, the intimacy with the soil acquired at Drenthe was the foundation of his intention to become an interpreter of peasant life.

It is significant that the example of foreign painters of peasant life, such as Millet, de Groux, and L'Hermitte, rather than that of Dutch painters, impelled van Gogh to fulfil this aim. This is comprehensible when it is remembered that the tradition of the peasant-picture in Holland, which had evolved from the miniatures of the *Heures du Duc de Berry* and other calendar-pictures, had broken off abruptly towards the end of the seventeenth century. In and before the sixteenth century, for example, in Breughel, the calendral concept was prevalent in peasant pictures: not the peasants but their different labors were represented— the cycle that feeds us. But after the sixteenth century, town and village

became more clearly differentiated. Urban painters saw the peasants riding in to market; in literature and painting alike they were looked upon as quarrelsome, brawling bands, or as picturesque beings in an environment of crumbling walls and mysterious barns with corners dimly lit. Even Rembrandt, a miller's son, represented in his etchings the peasant's house, the decayed hut—but not the peasant. In the eighteenth century, the peasant appeared in drama as the dry old stick, the Clown. With this he disappeared from Dutch art, except to enliven topographical landscapes. When he reappeared, it was as the victim of a sickly convention, intended to be poetical and y-clept "romantic," exemplified in pictures of fishermen's cottages and of dunes with women staring out to sea. In the 'eighties, this genre was supplemented by indoor scenes, painted by Kever, Neuhuys, Blommers, following on Vermeer, Israels, and Artz. All these artists, who dominated the market, created a world of obscure light, vague forms, undefined objects—a mysterious and static twilight. To be weary and apathetic was the fashion in the lull before the impending storm of social change. Van Gogh, filled with a profound compassion for mankind, whose afflictions he had come to understand in Paris and London, and later in the Borinage, divined and accepted the approaching cataclysm.

For seven years after his sixteenth birthday, van Gogh had been in the art trade, in Paris and London. There he had become aware of the poor, had perceived social problems of which the Dutch were then oblivious, had become interested in painters whose work was reproduced in foreign magazines—above all, Paul Renouard and Raffaelli. He had collected reproductions,[2] visited the Salons, read about the latest work of the Barbizon School, the French Romantics and Manet. When he withdrew to Drenthe and to Nuenen, this background was sustained by means of his regular correspondence with Theo in Paris and of short visits to and from van Rappard. An interest in Millet had always been strong in him, and this was augmented by his encounter, in August, 1884, with Sensier's book on Millet.[3] This further developed his growing preoccupation with the peasant.

In December, 1884, a year after settling in Nuenen, van Gogh started to paint heads of the farm people [F 138/H 158].[4] "I do not know yet what I shall do with these heads, but I will derive the composition from the characters themselves" [Letter 391]. He hoped to have

[2] Vincent's collection of reproductions (preserved at the Van Gogh Foundation, Amsterdam) included the English artists Charles Green, Frank Holl, Charles Keene, Herkomer, and Frank Walker, and the French masters Millet, Daumier, Gustave Doré, Jules Breton, and Paul Gavarni.

[3] [Alfred Sensier, *J.-F. Millet* (Paris: 1881) first mentioned by Vincent in Letter 180. —Ed.]

[4] [For the numerous other examples, see de la Faille, pp. 64–69, 72–73, 84–92, 95–99, and 101.—Ed.]

finished about fifty heads by the end of January. He worked hard throughout the winter, and in March, 1885, the plan for a larger composition began to ripen when he conceived of painting "figures against the light of a window" [Letter 396]. He worked into the night: "Just now I paint not only as long as there is daylight, but even in the evening by the lamp in the cottages, when I can hardly distinguish anything on my palette, so as to catch if possible, something of the curious effects of lamplight in the evening, with, for instance, a large cast-shadow on the wall" [Letter 395]. On such a night the first sketch for *The Potato Eaters* was made [F 77recto/H 91].

In the middle of these exertions came a sudden interruption—the death of van Gogh's father on March 26. Theo arrived, with uncles and other relatives. There were discussions on aesthetics in Vincent's atelier, the room of a Roman Catholic priest. Theo saw the most recent studies, and again urged his brother to submit a work to the Salon.

Vincent did not return to work until April and made headway very slowly. But his father's death, after the consternation aroused by its immediate impact, strengthened the son's confidence in himself, the feeling that he too had a vocation. More than ever he saw himself as a painter of peasants: "I have no other wish than to live deep, deep in the heart of the country, and to paint rural life. I feel that my work lies there, so I shall keep my hand to the plough and cut my furrow steadily." In the same letter, he wrote: "This week I intend to start that composition of those peasants around a dish of potatoes in the evening, or perhaps I shall make daylight of it, or both, or 'neither of the two' you will say. But whether it will succeed or not I am going to begin the studies for the different figures" [Letter 398]. Apparently Theo had seen the rough sketch for *The Potato Eaters* in March, and Vincent was referring in this letter to a spoken incitement from him to enlarge upon it.

The first large composition (F 78/H 92) was helped by studies made during the winter—among them a drawing (F 1227 recto) in which Vincent had tried to solve some difficulties relating to the foreground figure of the little daughter, placing her to the left of the narrow room, so that, between her and the old woman on the right, the potato-laden table, over which the lamp hung lower than in the first sketch, became visible.[5] The advantage gained by thus putting two figures on either side to produce a positive equilibrium through the central point, where four hands groped for the dish, was, however, foregone by the rupture of the ring round the table and the over-emphasis of the girl's importance in the design, the consequence of which was that the peasants in the background, with gestures foreshortened, appeared to be crushed. Van Gogh therefore returned in the large composition [i.e., F 78/H 92] to the general scheme of the initial sketch, but added a fifth figure—a young peas-

[5] [See also the drawings illustrated in de la Faille, pp. 420–39.—Ed.]

ant woman behind the table—and a new gesture—the pouring out of coffee. The dish is placed to the left of the table, two persons probing into it with forks; the woman on the right pours out coffee, the old man is about to drink, and the little girl just hides the right-hand corner of the table, the heads above which form a ring—making the composition an internal whole.

Full of the great work now approaching consummation, Vincent wrote to Theo: "As far as I have got now . . . I see a chance of giving a true impression of what I see. Not always literally exact, indeed, never exact, for one sees nature through one's own temperament" [Letter 399]. At this time he was much stimulated by Gigoux's book on Delacroix, explaining Delacroix's color theory and views on drawing. Vincent wrote whole passages about it, being especially interested in the production of a black which yet contains light, and in "that question of drawing the figure beginning with the circle—that is to say taking for a basis the elliptic planes. A thing which the ancient Greeks knew already, and which will remain till the end of the world" [Letter 402]. He was further stimulated by the news from Theo that Portier, a dealer, had found "personality" in some of the painted studies. He was impelled by this sign of appreciation to start work on the final version of *The Potato Eaters* meanwhile, in April, making "in one day by heart" and sending to Portier a lithograph after *The Potato Eaters* [F 1661], meant to be the first of a series, *Les Paysans chez Eux*. This lithograph, which exhibits some of the features not present in the first big version and which appear in the final version, stands as a link between them.

While busy moving to his new studio on May 1, he began again on a larger canvas. The color problem brought new difficulties. Theo wrote to him about Impressionism, which was then gaining ground in Paris. Vincent replied: "I know very little about it"; he was not inspired by this movement, but by another kind of realism. The new canvas— the final version—was planned far better than the penultimate study in oil, while aided by new sketches some of which in themselves touch one by their amateurish character (F 1161). In the final version, the corner figures are more vigorous, and all the figures are moulded with greater plasticity and are more closely interconnected. Here light is subordinated and spatial relations are accentuated. The action of the hands of the younger couple on the left is more distinct and rhythmically relaxed. The gestures supplement one another, signifying action for action's sake. Each character is individualized, and, above all, everything is more expressive because of the dark contrasts of color, which were inspired by Delacroix's writings.

Vincent wrote to Theo: "I have tried to make it clear how those people, eating their potatoes under the lamplight, have dug the earth with those very hands they put in the dish, and so it speaks of *manual labor,* and how they have honestly earned their food. I have wanted to

give the impression of quite a different way of living than that of us civilized people. Therefore I am not at all anxious for everyone to like it or to admire it at once. . . . It would be wrong, I think, to give a peasant picture a certain conventional smoothness. If a peasant picture smells of bacon, smoke, potato-steam, all right, that's not unhealthy; if a stable smells of dung, all right, that belongs to a stable; if the field has an odor of ripe corn or potatoes or of guano or manure, that's healthy especially for people from the city. Such pictures may *teach* them something. But to be perfumed is not what a peasant picture needs" [Letter 404].

Thus van Gogh sent the canvas to Paris in mid-May, saying: "In contrast to many other pictures, there is rusticity, and a certain animation in it. And so, though painted in a different style, in another century than the old Dutch masters, Ostade, for instance, yet it, too, comes from the heart of the peasant life and is original" [Letter 406]. And that it was. The disrupted tradition was resuscitated and still lives. For although it was not until 1892, two years after van Gogh's death, that the picture was shown for the first time—in Amsterdam—it has had since then an almost classic influence on the art of the Netherlands. It has become a foundation and was capable of becoming a foundation, because its point of departure was pure and true, its passionate vision supported by a conviction which was genuine and original at a time of much pretence, vagueness and mirage. To his own work can be applied that saying which in his view "expressed so perfectly Millet's color and technique": *Son paysan semble peint avec la terre qu'il ensemence.*

The drawings (e.g., 1229 verso) whose production followed the completion of *The Potato Eaters* clearly manifest van Gogh's ideal of drawing, derived from Delacroix: *ne pas prendre par la ligne mais par le milieu.*[6] Shortly afterwards, Vincent wrote—*and this was the birth of expressionism:* "I should be desperate if my figures were correct, you must know that I do not want them to be academically correct . . . my great longing is to learn to make these incorrectnesses, these deviations, remodellings, changes of reality that they may become, yes, untruth if you like—but more true than the literal truth" [Letter 418].

[6] [Quoted by Vincent (in Letter 408) from J. F. Gigoux, *Causerie sur les Artistes de mon Temps* (Paris, 1885).—Ed.]

VAN GOGH'S RELATIONSHIP
WITH SIGNAC (1962)

A. M. Hammacher

The influences that count for most are not always those consciously acknowledged by the person in question, or by the people who know him best. Nor need they be those for which there exists an evident basis in fact. It is much more difficult to ascertain the unconscious impressions to which an artist has been subjected; sometimes these can only be inferred from certain affinities of style or substance. Nevertheless the unacknowledged impressions which work freely in the artist's unconscious, are at least as important as any others.

Van Gogh's adoration of Monticelli is well known and clearly visible in some of his canvases, especially in the series of flower pieces dating from his first half-year in Paris. But much more fundamental changes were taking place, which can not be explained by reference to Monticelli. In the literature, and particularly in those studies which deal with his Paris years, the possibility that van Gogh was seriously influenced has been treated all too negligently. The letters of the period show a connection, but nothing more. As Vincent van Gogh was lodging with his brother Theo, his comments on his stay in Paris are scarce and full of lacunae. So the principal indication will have to be found in van Gogh's arrival in Paris. In March, 1886, van Gogh suddenly appeared in Paris. From that moment onward he must have seen Signac's work at Theo's and elsewhere, in all kinds of places which he frequented, and in galleries and exhibitions. He does not mention him in the letter written in 1886 to the English painter H. M. Levens (Letter 459a). At the time he did not know what the Impressionists stood for, but, although he did not consider himself an adherent of their group, he began by admiring Degas

A complete essay which appeared in the illustrated exhibition catalogue *Van Gogh's Life in His Drawings: Van Gogh's Relationship with Signac* by A. M. Hammacher (London: Marlborough Fine Art Ltd., May–June 1962); hereafter cited as *Marl. Cat.* Reprinted by permission of Marlborough Fine Art Ltd. (Editor's footnotes.)

and Monet. He knew Toulouse-Lautrec; he often called on Guillaumin. The art-dealer Portier, who lived in the same house as Theo and Vincent (54 rue Lepic), took Guillaumin along to Vincent who at that moment was painting one of the two still lifes with Parisian novels and a flower in a glass, pictures that would have been inconceivable without the early still lifes by Signac, especially those dating from the year 1883. A. S. Hartrick too saw this particular still life by Vincent on an easel in Theo's comfortable flat in the house in the rue Lepic.[1] When Vincent had gone to Arles, Theo paid a visit to Signac, who then made a better impression on him than on earlier occasions. Vincent, however, knew Signac much better, as they went out painting together in St. Ouen and Asnières. From Signac he learned the meaning of the evolution of divisionism, more than from Seurat, whose studio he visited for the first (and last) time only a few hours before starting on his journey to Arles. Van Gogh never applied the principle of divisionism in the carefully balanced, systematic way favoured by Seurat, who had thought out the method theoretically. Vincent was afraid of the dogma inherent in the original discovery. What Signac painted *before* he started "divisioning" in the theoretical sense of the word was more important to him. He deeply admired the work done by Seurat and Signac, but he was unwilling to follow them in the matter of pointillism.

Now let us begin by considering what we know about the personal relation between van Gogh and Signac, after the former had left for Arles. At Theo's request Signac went to see Vincent in Arles. The little house had been locked up by the police, and Vincent was in hospital after his violent quarrel with Gauguin, followed by the mutilation of his own ear. Van Gogh hoped they would allow him to leave the hospital for a while to show Signac the works in the *Maison Jaune*, the Yellow House. Yet he felt some mistrust in regard to Signac's visit: ". . . what's the use of his putting himself out on purpose to come and see me?" (Letter 580). In March 1889 Vincent saw Signac, which did him "a lot of good" (Letter 581). Indeed, they had some trouble with the police before they got into the little house; but Vincent thought Signac "so good and straightforward and simple" in his behavior on this occasion. Instead of "violent" he found Signac very quiet, a man "with balance and poise." It surprised him that he could have a conversation with an Impressionist that did not lead to discord and conflict. The terror caused by his vehement discussions with Gauguin had evidently not yet subsided. He gave Signac a still life of two herrings on a piece of paper "as a keepsake" [F 510/H 532]. Signac sent Theo a faithful account of his

[1] See Hartrick's article included in this volume. The painting meant is one of two versions of *Still Life: Romans Parisiens*, F 359/H 231 and F 358/H 230.

visit. Much later (1923) Signac is reported [see Letter 590a] to have told Coquiot [Gustave Coquiot, *Vincent van Gogh* (Paris: Librairie Ollendorff, 1923) p. 194] that Vincent was wearing his famous bandage and fur cap, and that together they saw in the little house the masterpieces, *Les Alyscamps*, the *Night Café*, the *Rocking Woman*, the *Lock* [that is, the Langlois Bridge subject], *St. Maries*, the *Starlit Night* etc.[2] He told Theo that he had found Vincent in good condition, that he was greatly interested in the things he was doing, and he urgently suggested that Vincent should get a better place to live in than the asylum. Theo never answered this suggestion. Signac was struck by the fact that Vincent tried to excuse his brother. From the hospital he wrote Signac a lively, witty and cordial letter (Letter 583b, March, 1889) with two splendid sketches in it. As a consolation he counted on his "deep friendships, even though they have the disadvantage of anchoring us more firmly in life than would seem desirable in the days of our great sufferings." At the time Signac was staying at Cassis, a small port near Marseilles. He never saw Vincent again. This was the end of their personal relation.

Van Gogh's work shows distinctly that the paintings which Signac did before 1886 made a deeper impression on him than the tendency which later, among Seurat's circles, was to lead to a doctrinaire divisionism.

When in Paris, van Gogh at first kept his Dutch vision; that is to say he used a rather dark color scheme, although it had gained some greater freedom in Antwerp, and in his still lifes he kept to traditional composition as regards the view-point. The first change occurred in the touch, and to a certain extent in the color. The brush-stroke in the series of flower pieces that was painted in 1886 is much more relaxed, freer from restraint, in some cases even milder than in the Brabant paintings. The color problem with which he was confronted was how to get out of the grey harmony, and to create a harmony of daring extremes in broken and neutral tones: blue and orange, red and green, yellow and violet, in flower studies. The color was to become *intense, violent*. He was always getting back to this principle. The landscapes of that year can be recognized by their greens and blues. There are also Japanese influences; there is a certain "shallowing," a disregard for perspective. The brightening of the palette is soon followed by an altered view-point (which induced Theo's future brother-in-law, André [in Dutch, Andries] Bonger, to speak of "flat painting"); the painter surveyed his subject from a great height.

This *japonaiserie* affected all the painters of that time. This changed

[2] I.e., such works as Figs. 7, 11, 13, and 22, and F 397/H 435, F 416/H 456, F 486/H 513 and F 568/H 551.

spatial vision, which abandoned the still life conception of Fantin-Latour and others, is clearly to be seen in Signac's works of 1883.[3] In such still lifes the objects are so disposed that there are no longer any intersections, which means that to a certain extent the oldest form of still life composition—that of the sixteenth century—made its appearance again. In Signac's work the brush-stroke is streaky, reminding one of a drawing, and the forms are vigorous and somewhat angular. We are not struck by the tonal conjunction, by the atmosphere of light, but by the connection between the colors. At any rate there is a clean break with the grey harmonies. The somewhat oblique disposition of the object in the plane evokes a certain tension. The works produced by Signac about 1883 show a remarkable resemblance to still lifes done by van Gogh from the end of 1886 to 1888. As far as we know nothing can be found in contemporary work by other painters which can be said to be so nearly related. From the *Still Life with the Torso* [F 360/H 237] to the *Still Life with the Drawing-board and Onions* [Fig. 17], done in Arles, van Gogh's conception of the disposition of the objects and of space does not differ from Signac's in the year 1883.

The use of the well-known yellow French novels as a pleasing element in the disposition of objects on the surface of a table, with a distinct suggestion of the letters of the titles, is to be found in 1883 in Signac's picture with the novel *Au Soleil* by Guy de Maupassant [Fig. 18]; in this painting the close juxtaposition of separate and conflicting patches of color plays an important part. Van Gogh applied this composition, making use of books, in the oval *Still Life: Three Books* [F 335/H 246], which is earlier than the two versions of the *Romans Parisiens,* painted in 1886—then again in the *Still Life with the Torso* of 1887, and even as late as 1889 in Arles. Remembering what Signac did in 1883 and in the following years until 1887, one can not ascribe this change in van Gogh (as has been supposed)[4] to the group of young painters led by Anquetin and Bernard, with whom he exhibited in 1887. It is an established fact that this group was actually opposed to Signac, and refused to exhibit with him. Van Gogh defended Signac, and warned Bernard against sectarianism. Another little picture by Signac has been discovered: *Seated Woman Putting on her Stockings,*[5] which probably also was painted in 1883. In this picture again the view from above, the streaky, "hatching" strokes of the brush, the warm, mixed tones with

[3] The author cites here *Still Life with Violets* (*Marl. Cat.,* no. 77) and *The Gateau* (*Marl. Cat.,* no. 78); the latter work has a composition possibly derived from Monet, as pointed out by F. Cachin in *Paul Signac* (Paris: Bibliothèque des Arts, 1971), pp. 8 and 12.

[4] I.e., by L. Gans, "Vincent van Gogh en de Schilders van de Petit Boulevard," *Museumjournaal,* 4:5–6 (1958), 85–93; see also Roskill, *Van Gogh, Gauguin,* pp. 98–130.

[5] *Marl. Cat.,* no. 79.

liberal use of pink and vermilion, green and bright red, are closely connected with *Woman with Tambourin* [F 370/H 299], which Vincent van Gogh painted at least three years later. In Vincent's picture there is a kindred brush-stroke (but sharper), and a kindred variety of cooler and warmer tones, culminating in a limited but powerful red. In the same connection Signac's *Port en Bessin*[6] dating from 1883, and the small but very clear and strong oil-sketch *The Construction of The Sacré Coeur*[7] must be mentioned with equal emphasis, and also the two still lifes with the little bunch of violets and the one with the *Yellow Book* (1886–87).[8]

Nordenfalk attributes the use of books as a motif in some of van Gogh's still lifes in the first place to his fervent interest in literature.[9]

Yet one should beware of over-stressing the iconological elements. Personally I am of the opinion that the violent reaction to *yellow* which can be observed in van Gogh was symbolic as well as pictorial: to use the Freudian term, it was "over-determined." There can be no doubt of the strength of these pictorial and psychical forces. When van Gogh was painting, what he had seen of Signac's work influenced the color as well as the composition. Signac's curious, almost abstract still life with *Yellow Book* must be assigned, according to a catalogue, to 1887. At any rate it was created before the systematic Seurat-period. 1887 is the year in which Signac was actually struggling against his love of the impure, the local, the grey intone (see Rewald, p. 77). His surprising view-point, with the subject seen almost entirely from above, and the placing in this of a single yellow novel, turn this still life into what we would call nowadays an experimental work. The broken-white, the violet, the yellow are a combination also adopted by van Gogh. In van Gogh's oval *Still Life: Three Books*, one may observe in the characteristic draping of the folds of the tablecloth, in the view-point, in his limiting the number of books to three, as well as in the placing of them in the middle of the picture, a remarkable resemblance to the more theoretically and yet more rigidly conceived theme of Signac's picture of 1887. At any rate this is the end of the period in which the relation Signac–van Gogh had a clear significance. The *View of Montmartre*,[10] dating from 1884, in the Carnavalet Museum—dedicated by Signac "à l'ami Cuvillier"—has in the manner of painting and also in the composition (the lamp-post to the left) an affinity with the series of views of Montmartre painted by van Gogh in and after 1886.

These facts about the period before Signac's divisionism and before

[6] *Ibid.*, no. 74.

[7] *Ibid.*, no. 81, a sketch for the more detailed version dated 1882 (illustrated in Cachin, *Paul Signac*, p. 7).

[8] *Marl. Cat.*, nos. 77 and 90, and this volume, Figure 18, respectively.

[9] In "Van Gogh and Literature"; see also Seznec's article included in this volume.

[10] Illustrated in Rewald, p. 48.

van Gogh's arrival in Paris strengthen my impression that it was in the first place to Signac (whose works were also on show at Theo van Gogh's, and with whom Vincent later went painting) that we should largely attribute the change in van Gogh's vision, touch and color in the Summer of 1886 and in 1887.

But apart from these questions of aesthetics there is the fact that, humanly speaking, Signac must have been deeply impressed by the brief period in which van Gogh broke into his life like a flash of lightning and went out of it just as suddenly. There exists a touching watercolor which Signac painted in Arles a few months before his death.[11] This proves that Signac, obviously looking back into the past, had visited the *Maison Jaune* once again, the unfortunate little Yellow House, where the joint establishment of Gauguin and van Gogh led to such violent explosions. There he stood again, Signac in his old age, and once more lived through his visit to the little house with the suffering van Gogh. And he made a watercolor of the *Yellow House*, freely painted, without restraint, with the title written on it.

No one can demand a clearer proof of the fact that although the meeting of those two may have been transitory, it nevertheless had a profound emotional effect.

[11] *Marl. Cat.*, no. 94.

THE YELLOW HOUSE (1953)

Douglas Cooper

In the middle of February, 1888, Vincent van Gogh suddenly left Paris for Arles. Almost exactly two years before, at the beginning of March, 1886, he had arrived, with no less suddenness, in Paris from Antwerp. During those two years he had been constantly involved in artistic controversy, had experienced the bracing effect of living through a period of great artistic creation and had been given an insight into the mysteries of color through direct contact with the Impressionist painters and their pictures. But after two years Vincent felt that he had absorbed all that Paris could teach him. He needed to work out his own salvation. Nevertheless, his decision to move to Provence was not motivated entirely by selfish considerations. Admittedly he felt that he personally would never be able fully to realize the kind of painting which he half-imagined unless he abandoned the North. But, in addition, it seemed to him that the Impressionists had already extracted from the North all the artistic inspiration that it could provide for the moment, that they had made Paris and the surrounding countryside peculiarly their own and that those young painters who had hopes of carrying their work a stage further, should move to fresh surroundings. So, impulsive as ever, Vincent suddenly decided to follow the example of Delacroix, who had become his hero, and go as far south as possible.

For the first two months of his stay in Arles, Vincent lived in a small hotel. But he found this cramped and unnecessarily expensive. Moreover, as he hoped to attract other painters to the South, he realized that he would need a small house which could serve as a center for their

Douglas Cooper's original lecture "The Yellow House and Its Significance" was published in *Mededelingen van de Dienst voor Schone Kunsten der Gemeente 's-Gravenhage*, 8:5–6 (1953), 94–106, but has been reduced here by half and subsequently edited by the author himself. (Editor's footnotes.) Reprinted by permission of Douglas Cooper and Haags Gemeentemuseum.

joint activities. He therefore looked around for a "place of retreat" until at the end of April he found what he wanted at 2, place Lamartine, on the northern edge of the town. He announced his discovery to Theo immediately [Letter 480 of May 1, 1888].

The house that Vincent described is the little two-storey building that occupies the center of his famous picture [Fig. 8]. It was his home for almost a year, from May, 1888, till April, 1889. There he hoped to work in peace and recover his strength which had been undermined by years of overwork, undernourishment and ill-health. At last his life seemed to have a focus, although the expenses of making the Yellow House habitable were considerable. Vincent eventually decorated his studio with Japanese prints and some lithographs by Daumier, Géricault, Delacroix and Millet, while he also painted specially a series of large canvases of great yellow sunflowers in a vase [for example, Figs. 10 and 12]. But the house was not sufficiently furnished for him to live there before September 17th. [Letter 538]. Then he sat down and wrote to Theo that: "The sense of tranquillity that the house has brought me amounts to this—that from now on I feel I am working to provide for the future." [Letter 540].

Vincent had already sent a sketch and a rather picturesque water-color of the Yellow House to Theo, but he had also promised him a painting. This he executed towards the end of September together with a rough drawing, and in October he made the famous painting of his bedroom [Fig. 9]. His powers as a painter had seldom been challenged to the extent that they were by the seemingly unpromising *motif* of his house. Yet this group of buildings had an intense emotional significance for Vincent, for they were the center of his little world. On the extreme left is the restaurant where he ate, further still to the left, but not visible, is the famous night café [Fig. 7]. Roulin the postman [Fig. 6] lived between the two railway bridges on the left, and the road leading out of the picture is the road Vincent tramped so often to get to Montmajour and Tarascon. "The subject is frightfully difficult," he told Theo, "but that is just why I want to conquer it. It's terrific, these houses, yellow in the sun, and the incomparable freshness of the blue." Vincent undoubtedly did conquer it—perhaps thanks to his newly-won "sense of tranquillity"—and the result is one of his most intense and completely successful pictures. No other painting by van Gogh expresses so convincingly and ecstatically, yet with so little violence of expression, the significance of what he had experienced visually and emotionally in Provence. And we feel this the more acutely because it is a typically Impressionist subject and type of composition, treated in a very different way. The sky here is cloudless, there is no haze, and no shade anywhere. The heat beats up from the roadway casting a sulphurous luminosity along the walls of the houses, yet for once the sun itself is not visible. All is still except for a train in the background; even the few pedestrians

are hardly moving. The sky is painted in a deep and lyrical cobalt blue, which allows it to extend into infinity; the buildings and the road are all carried out in yellow and directly related colors, that yellow which Vincent described as "the embodiment of the utmost clarity of love." This picture then is based on a contrast between two strong colors— blue and yellow—and its message is conveyed entirely in terms of color, for it is devoid of narrative detail. Nature has been carefully observed, but the artist has not tried to record exactly his retinal sensations. There is no suggestion here of those subtle atmospheric nuances of tone which are fundamental to Impressionist painting. The subject of this picture is not light but the reality of the artist's feelings about that squat little house with its yellow walls and big windows, and it is not without interest that Vincent's first idea was to paint it as a night piece "with the windows lit up and a starry sky." In the final picture, however, he has deliberately emphasized that sunlight streams into the darkness within through the large apertures, so that the whole house glows and one feels that it really is, as he called it, a "house of light."

Milliet, the Zouave officer to whom Vincent gave painting lessons, thought the picture "horrible." But, replied Vincent, "Zola did a certain boulevard at the beginning of *L'Assommoir,* and Flaubert a corner of the Quai de la Villette in full heat at the beginning of *Bouvard et Pécuchet,* and there is nothing rotten about either of those." Vincent chose to situate his picture in his own way, and it is significant that he chose the works of two great Naturalist writers. Now I would like to set the *Yellow House* in another perspective and suggest that Vincent may also have had in mind a number of not dissimilar pictures by Dutch artists—for their names were always on his lips. I am thinking of Vermeer, Pieter de Hooch, Jan van der Heyden, and perhaps most of all of Saenredam's *View of The Old Town Hall, Amsterdam.*[1]

Within a month of arriving in Arles, Vincent wrote to Theo that one could not abide by the subtly graduated tonal values of the Impressionists and still use color full-bloodedly, because "nature" in the South insists on being translated into pure colors. He had therefore come to believe in the necessity for a new art of color and design. In other words, Vincent realized that just as the atmospherically filtered light of Paris and the Ile-de-France had been ideal for Impressionism, so the brilliantly lit, harsh landscape of Provence was ideal for the painters of the Post-Impressionist generation, who had begun to see that their understanding of reconciling nature with art could be expressed pictorially with colors contained in linear outlines. "Things here have so much line. And I want to manage to get my drawing more spontaneous, more exaggerated," he wrote.

[1] In the Rijksmuseum, Amsterdam.

That is to say, the landscape itself had begun to impose a style for which he was predisposed. And Vincent wrote to Theo: "We like Japanese painting, we have felt its influence, all the Impressionists have that in common; then why not go to Japan, that is to say to the equivalent of Japan, the South?" So he regarded it as unlikely that he would ever again leave Provence, and in his letters to Theo and Emile Bernard written during the spring and summer of 1888, Vincent never tired of discussing the technical consequences of his discovery that after all, he could employ pure colors and still paint coherent and valid pictures. Yet, while he was "absolutely convinced of the importance of staying in Midi, and of absolutely piling on, exaggerating the colour," Vincent realized that they had to be kept in check by "a good, bold design."

By mid-August, 1888, Vincent's obsession with realism in painting had already led him to the point of using color symbolically.[2] However, he did not adjust to this by adopting a pre-conceived set of intellectual symbols and forms, therefore he did not need either to reduce his sensations or knowledge by abstraction, or to rely on some pre-determined aesthetic formula in order to reconstruct a natural scene. On the contrary, Vincent drew and painted what he saw as faithfully as he could, respecting this visual image in its essentials until the end; but in the course of painting he deliberately heightened the effect by exaggerating the descriptive colors (and to some extent the line too) in order to convey the intensity of thought and emotion which he had experienced. Thus a painting by van Gogh can be read as an image of reality, as decoration or as a human document without our being aware beforehand of all its underlying symbolism. A painting by Gauguin on the other hand, demands to be understood and interpreted intellectually before it can be properly appreciated not only visually, but even as painting.

Now, as Vincent evolved this highly individual idiom compounded of realism, symbolism and personal feelings, painting and drawing tended to become for him more and more a single process, until in September he told Theo that he had arrived at the point when he "would not draw a picture with charcoal. That is no use, you must attack drawing with the color itself in order to draw well." [Letter 539]. That phrase inevitably reminds one of Cézanne's no less famous dictum: "Le dessin et la couleur ne sont point distincts; au fur et à mesure que l'on peint, on dessine; plus la couleur s'harmonise, plus le dessin se précise."

It is curious indeed to think of Vincent and Cézanne arriving at similar conclusions by such very different means, for their method of working and their aims were so essentially different. Nor is there ultimately any

[2] In the original version of this article, the author illustrated this point by referring to Vincent's description of the *Portrait of Eugène Boch, A Belgian Painter* (F 462/H 490), called by Vincent *The Poet* in Letter 520 of August 11, 1888.

similarity between their work. We can therefore only attribute it to the light and the appearance of Provence itself, adding that whereas Vincent has left us a vivid record of how he, as a northerner, felt about the countryside, Cézanne, who was a native, has left us an astonishingly accurate record of how his eye registered its natural appearance. In the landscape around Aix one can see motifs which are identical in form and tonality with the pictures of Cézanne. On the other hand, the countryside of Arles and St. Rémy never looks like a picture by van Gogh. Now we must beware of concluding from this that the vision of Cézanne has more validity, pictorially, than the vision of van Gogh, or vice versa. But we should be clear in our own minds that for all Vincent's concern with realism, it is Cézanne's and not Vincent's pictures which are true to nature.

The similarities between Vincent's handling of color and the so-called *cloisonnisme,* which Gauguin, Bernard and others were evolving simultaneously in Pont-Aven, will be obvious. But there is a fundamental difference between them. Van Gogh never renounced realism as his aim, and every one of his pictures is instinct with the breath of life. Gauguin was not concerned with this at all. His pictures are composed with abstracted shapes and symbols standing in for reality, and he used flat areas of color to evoke a mood and to heighten the decorative effect. Vincent, on the other hand, started from the principle that the greater the area of a given color, the greater its expressive value. Gauguin's image is two-dimensional; Vincent saw and felt in depth. On the pictorial plane his vision had been formed by the Japanese, who had taught him how to simplify, organize and yet remain close to nature. But he was no less concerned with spiritual values, and he had learnt from Delacroix that color was the means by which the artist could attain to them. So Vincent did not hesitate to use color in an arbitrary way. "I myself have been seeing the stronger light of these parts now for months and months," he wrote to Emile Bernard, "and the result of this experience is that the people who stand up best, from the point of view of color, are Delacroix and Monticelli." [Letter B16].

Now, apart from being Vincent's home, and thus the center of his life in Provence, the Yellow House was intended to play its part in a great scheme. Vincent's idea was to form a society of artists, each of whom would contribute annually a certain number of pictures instead of money to a common pool. Theo, an intelligent, informed dealer, and a close friend of many of the most important Impressionists and younger artists, was to act as secretary, banker, publicity and sales manager. And since this was to be a communal venture, all proceeds from sales, no matter by whom the picture, should be paid into a common account. Then, at the end of the year, the profit would be shared between all the members "so that the society could at least guarantee its members a chance to live 'courageously' and produce their work without worrying

about where the next franc would come from." [Letter 468]. The Yellow House, as he never tired of repeating, could accommodate one or two friends besides himself, so that it could serve as permanent headquarters for any members of the society who felt the call to follow Delacroix, Cézanne or Vincent to the South. Vincent longed to share his knowledge and experience with others, and was supremely conscious that a group of human beings working in harmony can achieve far more than one man alone. Yet his scheme soon reduced itself to the argument that he and Gauguin could live together in Arles on the same money that Theo had to provide for Vincent alone. When Theo sold a painting by Gauguin and sent him 500 francs, Gauguin left for Arles and arrived on October 24, 1888, sick, disillusioned, but hoping for a more settled future. Vincent was fascinated by Gauguin's assertive personality, and by his confidence in his own power as an artist. Gauguin, who had great intellectual force, began to impose his pictorial ideas on Vincent as they worked together in the public gardens of Arles, in the Alyscamps or in the vineyards. Under Gauguin's guidance Vincent, as he said, found himself "turning to abstraction," that is to say, painting less from nature and attempting to rely more on his memory and imagination. We can follow the blood-draining process in an unpleasing series of pictures—*La Salle de Danse* [F 547/H 555], *Promenade à Arles* [F 496/H 516], *Les Alyscamps* [F 486/H 513], *La Liseuse de Romans* [F 497/H 517], and *La Berceuse* [Fig. 11]. In each van Gogh made more use of stylizations, of geometrical forms, of consciously elaborated, sinuous contours; his use of color too changed, and he worked with flat areas arranged for a more decorative effect. Vincent's pictures lost that feeling of depth which they had before. Also he stopped painting panoramic views, although he had told Theo in July that "except for the difference in color and the clarity of the atmosphere" the landscape of Provence reminded him of Holland and required to be painted in the tradition of Koninck and Ruysdael. What is more, Vincent clearly attempted to control his usually passionate brushwork, while he muted his color harmonies. Thus, there is something artificial and unnatural about these pictures. Even the trees in *Les Alyscamps* are like cardboard cut-outs.

Gauguin claimed that before his arrival in Arles, Vincent could only manage "soft, incomplete, and monotonous harmonies; the sound of the bugle was lacking. I undertook the task," Gauguin continues, "of explaining things to him, which was easy for me, for I found rich and fruitful ground." [3] *The Yellow House* was painted a full month before Gauguin's arrival and is one of the pictures that most triumphantly give the lie to Gauguin's claim.

For Vincent the immediate presence of nature was indispensable. So it was inevitable that the relationship between van Gogh and Gauguin

[3] Quoted from *Avant et Après* (see "Gauguin on Vincent" in this volume).

should end calamitously, though fortunately Gauguin's disastrous influence on Vincent's painting was short-lived. When he was alone once more in his Yellow House, Vincent felt at peace and resumed painting in his style of the previous summer, as we can see for example in the two versions of *Self-Portrait with a Mutilated Ear* [Fig. 15 and F 529/H XII], in the *View of Arles* [F 516/H 534], or in the *Crau: Peach Trees in Flower* [F 514/H 531] painted in April, 1889. But the period of the Yellow House was drawing to a close. For during Vincent's absence in hospital at the end of December, 1888, the landlord decided to turn him out and signed a lease with a new tenant. It was not until April, 1889, however, that Vincent finally departed.

ON VAN GOGH'S COPIES (1943)

Carl Nordenfalk

The few works by van Gogh which have the character of direct illustrations are all copies after earlier masters. Thus, while in St. Rémy, he painted *The Good Samaritan* [Fig. 20] and the *Pietà* [F 630/H 625] after Delacroix and a *Raising of Lazarus* [Fig. 24] after the middle section of the well-known etching by Rembrandt. He also returned to the most preferred model of his youth, Millet's *Sower* [Fig. 19 and F 690/H 675]. At the same time a series of paintings was executed on the basis of Millet's *Les Travaux sur les Champs*,[1] and works based upon Daumier[2] and others. He began with reproductions in black and white and transformed them according to his own feeling of what was needed in terms of color, sometimes basing this upon his memory of the original work. As a rule he repeated his models without much change in the composition. With the *Raising of Lazarus*, however, his aversion to seeing Christ represented in a less than perfect manner was so strong that he deleted the figure altogether. In its place he represented the great and miraculous power of nature in the form of the sun.

He wished to donate the copies after Millet to one or another school. "I gladly would see reproductions after Millet hanging in the

From Carl Nordenfalk, *Vincent van Gogh: Imago Imaginis* (Amsterdam: H. J. W. Becht, 1948), pp. 129–31. The editor has translated the following excerpt from this Dutch edition, which somewhat revises the original Swedish version of 1943. (Editor's footnotes.) Reprinted by permission of the author, P. A. Norstedt & Söner, Stockholm, and H. J. W. Becht.

[1] Vincent had already executed studies of Millet's *Travaux* (known to him through the wood engravings of J. A. Lavieille) in the fall of 1880 in Cuesmes (see Letters 134–36). The ten "copies" from St. Rémy are illustrated together in Scherjon and de Gruyter, *Vincent van Gogh's Great Period*, pp. 239–40, and in de la Faille (as listed in notes to F 634/H 646).

[2] I.e., *The Topers*, F 667/H 687.

schools," he wrote. "I believe that there are children who would become painters, if only they had a chance to see things of good quality" [Letter 607].[3] In reference to his own copies, he stated:

> Painters invariably are asked to produce their own *compositions* and to be *nothing more than composers*. This is all right, but it is not the same in music, since, if someone is playing Beethoven, he adds his own personal interpretation. In music, and especially in singing, the *interpretation* is quite significant, and it is not demanded that only the composer himself play his own compositions (Letter 607).

Therefore, even copies can be regarded as evidence of van Gogh's antipathy towards free creation from one's fantasy. Painting meant for him the rendering of a visual impression according to a personal manner —whether this concerns an impression of nature or of an earlier painting.

Nonetheless, the copying, or rather the paraphrasing, of works by other painters can also be viewed from another point of view. Does it not materialize the notion of collective effort, which van Gogh already had harbored in Arles, but which seemed so difficult to carry out in practice? By means of this novel approach even Gauguin could be drawn into such a program of activities. During the period that the two men lived together in the yellow house, they had achieved quite different results in painting their neighbor, Madame Ginoux, as she sat at the table with her hand supporting her head. Van Gogh painted her as *L'Arlésienne* [F 488/H 515]—a humanly sensitive painting of a frail woman in her years of transition. Gauguin had represented her with a more masklike and stringent face in a drawing which he later used for the foreground figure in his *Café de Nuit* [Pushkin Museum, Moscow]. When Gauguin fled from Arles following the catastrophe, he left the drawing behind. It remained in Vincent's possession, and during his illness, by transforming the drawing into color, he created a new version of the *Woman of Arles* [Fig. 16], a work which was therefore drawn by Gauguin and painted by van Gogh. He made one copy after another of this collective creation.[4] When he sent one version to Gauguin shortly before his own death, it was accompanied with the words:

> I have tried to remain faithful to your drawing, which I greatly respect, although I nonetheless have taken the liberty of translating it through reference to colors which have the same sober character and the same style as are found in the drawing. Please accept it as a work by you and me, as a recapitulation of our months of joint work together. (Letter 643).

[3] Van Gogh meant by this not his own paintings but reproductions after Millet; see also Letter 242.

[4] The four versions are illustrated in de la Faille, p. 286.

In the copies after works by other masters, there is clearly to be discovered a new way of viewing color. Color theory and the palette of the Impressionists continue to form the basis of his work, but he no longer considers painting with unmixed rainbow colors a pure blessing. He now attempts to supplement these usages with a system of mixed tonalities, which he had developed in the Netherlands on the basis of Charles Blanc's writings about Delacroix.[5]

"What is novel becomes antiquated very quickly," he wrote to Theo shortly after his confinement at St. Rémy. "I think that, if I were to come to Paris while in my present mood, I should not distinguish between a so-called dark painting and a light Impressionistic one." [Letter 593]. His unlimited respect remained directed as much toward Delacroix and the Barbizon School as toward more recent developments. In artistic terms, the Impressionists actually were not viewed as more advanced than their predecessors, the Romantics. It was not necessary to ban ground colors completely from the palette. On July 9, 1889, he ordered, for the first time in recent years, yellow ocher, red ocher, and unburnt sienna. "In my best moments I dream again not so much of glittering color effects as of half tones," he wrote in September [Letter 604].

My fellow countryman, Carlo Derkert, has demonstrated [6] that already in Arles van Gogh had begun to combine the use of pure rainbow colors with tertiary mixtures which depart from those used in the Dutch periods principally through a more abundant admixture of white. However brilliantly his blue skies still sparkle above the yellow wheatfields, they nonetheless, as a rule, add an "indefinable" nuance of grayish yellow to the pure colors of the paint tubes. Only in St. Rémy, however, did he develop a consistent coloration based upon hues which were combined with grayish tertiaries. This usage imbues the *Raising of Lazarus* with its remarkable luster of old gold and silver, its coloration which so movingly renders a message heard from a realm which is suspended halfway between life and death.

[5] Principally from Blanc's *Grammaire des Arts du Dessin* (Paris, 1870), but also from *Les Artistes de mon Temps* (Paris, 1876).

[6] In an unpublished manuscript. However, see Derkert's "Theory and Practice in van Gogh's Dutch Painting," *Konsthistorisk Tidschrift*, 15, 3–4 (1946), pp. 97–120.

ON A PAINTING OF VAN GOGH:
CROWS IN THE WHEATFIELD (1946)

Meyer Schapiro

Among van Gogh's paintings the *Crows in the Wheatfield* [Fig. 25] is for me the deepest avowal. It was painted a few days before his suicide, and in the letter in which he speaks of it we recognize the same mood as in the picture. [Letter 649]. The canvas is already singular in its proportions, long and narrow, as if destined for two spectators, an image of more than the eye of one can embrace. And this extraordinary format is matched by the vista itself which is not simply panoramic but a field opening out from the foreground by way of three diverging paths. A disquieting situation for the spectator, who is held in doubt before the great horizon and cannot, moreover, reach it on any of the three roads before him; these end blindly in the wheat field or run out of the picture. The uncertainty of van Gogh is projected here through the uncertainty of movements and orientations. The perspective network of the open field, which he had painted many times before, is now inverted; the lines, like rushing streams, converge towards the foreground from the horizon, as if space had suddenly lost its focus and all things turned aggressively upon the beholder.

In other works this field is marked with numerous furrows that lead with an urgent motion to the distance. These lines are the paths of van Gogh's impetuous impulse towards the beloved object. Recall how Cézanne reduced the intensity of perspective, blunting the convergence of parallel lines in depth, setting the solid objects back from the picture plane and bringing distant objects nearer, to create an effect

Professor Schapiro's "On a Painting of Van Gogh," reprinted here in full and including the author's footnotes, first appeared in *View: The Modern Magazine*, 7:1 (October 1946), pp. 9–14, and was reprinted in *Perspectives U.S.A.*, 1 (1952), 141–53. Reprinted by permission of Meyer Schapiro. The version from *Perspectives* is reprinted here.

of contemplativeness in which desire has been suspended.[1] Van Gogh, by a contrary process, hastens the convergence, exaggerating the extremities in space, from the emphatic foreground to the immensely enlarged horizon with its infinitesimal detail; he thereby gives to the perspective its quality of compulsion and pathos, as if driven by anxiety to achieve contact with the world. This perspective pattern was of the utmost importance to van Gogh, one of his main preoccupations as an artist. In his early drawings, as a beginner struggling with the rules of perspective and using a mechanical device for tracing the foreshortened lines which bewildered and delighted him, he felt already both the concreteness of this geometrical scheme of representation and its subjective, expressive moment. Linear perspective was in practice no impersonal set of rules, but something as real as the objects themselves, a quality of the landscape that he was sighting. This paradoxical scheme at the same time deformed things and made them look more real; it fastened the artist's eye more slavishly to appearances, but also brought him more actively into play in the world. While in Renaissance pictures it was a means of constructing an objective space complete in itself and distinct from the beholder, even if organized with respect to his eye, like the space of a stage, in van Gogh's first landscapes the world seems to emanate from his eye in a gigantic discharge with a continuous motion of rapidly converging lines. He wrote of one of his early drawings [F 943]: "The lines of the roofs and gutters shoot away in the distance like arrows from a bow; they are drawn without hesitation" [Letter 219].

In his later work this flight to a goal is rarely unobstructed or fulfilled; there are most often countergoals, diversions. In a drawing of a ploughed field [F 1552], the furrows carry us to a distant clump of bushes, shapeless and disturbed; on the right is the vast sun with its concentric radiant lines. Here there are two competing centers or central forms, one, subjective, with the vanishing point, the projection of the artist not only as a focusing eye, but also as a creature of longing and passion within this world; the other, more external, object-like, off to the side, but no less charged with feeling. They belong together, like a powerful desire and its fulfillment; yet they do not and can not coincide. Each has its characteristic mobility, the one self-contained, but expansive, overflowing, radiating its inexhaustible qualities, the other pointed intently to an unavailable goal.

In the *Crows in the Wheatfield* these centers have fallen apart. The converging lines have become diverging paths which make impossible the focused movement toward the horizon, and the great shining sun has broken up into a dark scattered mass without a center, the black

[1] On the character of Cézanne's perspective there is an admirable book by Fritz Novotny, *Cézanne und das Ende der wissenschaftlichen Perspective* (Vienna: Anton Schroll, 1938; [reprinted 1970]).

crows which advance from the horizon toward the foreground reversing in their approach the spectator's normal passage to the distance; he is, so to speak, their focus, their vanishing point. In their zigzag lines they approximate with increasing evidence the unstable wavy form of the three roads, uniting in one transverse movement the contrary directions of the human paths and the symbols of death.

If the birds become larger as they come near, the triangular fields, without distortion of perspective, rapidly enlarge as they recede. Thus the crows are beheld in a true visual perspective which coincides with their emotional enlargement as approaching objects of anxiety; and as a moving series they embody the perspective of time, the growing imminence of the next moment. But the stable, familiar earth, interlocked with the paths, seems to resist perspective control. The artist's will is confused, the world moves towards him, he can not move towards the world. It is as if he felt himself completely blocked, but also saw an ominous fate approaching. The painter-spectator has become the object, terrified and divided, of the oncoming crows whose zigzag form, we have seen, recurs in the diverging lines of the three roads.

And here, in this pathetic disarray, we begin to discover a powerful counteraction of the artist, his defense against disintegration. In contrast to the turbulence of the brushwork and the smallest parts, the whole space is of an unparalleled breadth and simplicity, like a cosmos in its primitive stratified extension. The largest and most stable area is the most distant—the rectangular dark blue sky that reaches across the entire canvas. Blue occurs only here and in fullest saturation. Next in quantity is the yellow of the wheat field, which is formed by two inverted triangles. Then a deep purplish red of the paths—three times. The green of the grass on these roads—four times (or five, if we count the thin streak at the right). Finally, in an innumerable series, the black of the oncoming crows. The colors of the picture in their frequency have been matched inversely to the largeness and stability of the areas. The artist seems to count: one is unity, breadth, the ultimate resolution, the pure sky; two is the complementary yellow of the divided, unstable twin masses of growing corn; three is the red of the diverging roads which lead nowhere; four is the complementary green of the untrodden planes of these roads; and as the n of the series there is the endless progression of the zigzag crows, the figures of death that come from the far horizon.

Just as a man in neurotic distress counts and enumerates to hold on to things securely and to fight a compulsion, van Gogh in his extremity of anguish discovers an arithmetical order of colors and shapes to resist decomposition.

He makes an intense effort to control, to organize. The most elemental contrasts become the essential appearances; and if in this simple

order two fields are apart in space, like the sky and the roads, they are held together by additional echoing touches of color which, without changing the larger forces of the whole, create links between the separated regions. Two green spots in the blue sky are reflections, however dimmed, of the green of the roads; many small red touches on the wheat field along the horizon repeat the red of these paths.

In the letter to which I have referred, Vincent wrote to his brother: "Returning there, I set to work. The brush almost fell from my hands. I knew well what I wanted and I was able to paint three large canvases [Letter 649].

"They are immense stretches of wheat under a troubled sky and I had no difficulty in trying to express sadness and extreme solitude."

But then he goes on to say, what will appear most surprising: "You will see it soon, I hope . . . these canvases will tell you what I can not say in words, what I find healthful and strengthening in the country" [Letter 649].

How is it possible that an immense scene of trouble, sadness, and extreme solitude should appear to him finally "healthful and strengthening?"

It is as if he hardly knew what he was doing. Between his different sensations and feelings before the same object there is an extreme span or contradiction. The cypress trees which he compared with an Egyptian obelisk for their beauty of line and proportion, become restless, flaming shapes in his pictures. Yet he practiced his art with an extraordinary probing awareness; it was, in his own words, "sheer work and calculation." His letters contain remarkable illuminations on the problems of painting; one could construct a whole aesthetic from scattered statements in the letters. But when he looks at his finished work, he more than once seems to see it in a contradictory way or to interpret the general effect of a scene with an impassioned arbitrariness that confounds us. Sometimes it is a matter of the symbolism or emotional quality of a tone for which he possesses an entirely private code: "a note of intense malachite green, something utterly heartbreaking" [Letter 503]. In another letter he describes the painted version [F 737/H 739] of the ploughed wheat field with sun and converging lines also depicted in the drawing mentioned above [F 1552] as expressing "calmness, a great peace" [Letter B21]. Yet by his own account it is formed of "rushing series of lines, furrows rising high on the canvas"; it exhibits also the competing centers which create an enormous tension for the eye. To another artist, such lines would mean restlessness, excitement. Similarly, van Gogh speaks of a painting of his bedroom in Arles [Fig. 9] as an expression of "absolute repose" [Letter B22]. Yet it is anything but that, with its rapid convergences and dizzying angularities, its intense contrasted colors and the scattered spots in diagonal groups. It is passionate,

vehement painting, perhaps restful only relative to a previous state of deeper excitement, or as an image of his place of sleep.

In this contradiction between the painting and the emotional effect of the scene or object upon van Gogh as a spectator, there are two different phenomena. One is the compulsive intensification of the colors and lines of whatever he represents; the elements that in nature appear to him calm, restful, ordered, become in the course of painting unstable and charged with a tempestuous excitement. On the other hand, all this violence of feeling does not seem to exist for him in the finished work, even when he has acknowledged it in the landscape.

The letters show that the paradoxical account of the *Crows in the Wheatfield* is no accidental lapse or confusion. They reveal, in fact, a recurrent pattern of response. When van Gogh paints something exciting or melancholy, a picture of high emotion, he feels relieved. He experiences in the end peace, calmness, health. The painting is a genuine catharsis. The final effect upon him is one of order and serenity after the whirlwind of feeling.

Yes, there is health and strength for van Gogh in his paroxysmal rendering of the wheat field and the sky. The task of painting has for him a conscious restorative function. He believed already some time before that it was only painting that kept him from going mad. "I raced like a locomotive to my painting," he wrote, when he felt that an attack was coming [Letter 535]. He spoke of his art as "the lightning conductor for my illness" [Letter 604]. It is customary to describe van Gogh as an inspired madman whose creativeness was due to his unhappy mental condition, and indeed he admitted this himself. Looking back on the intense yellows in his work of 1888, he said: "To attain the high yellow note that I attained last summer, I really had to be pretty well strung up" [Letter 581]. But he saw also that he was not insane, although subject to attacks: "As far as I can judge, I am not properly speaking a madman. You will see that the canvases I have done in the intervals are restrained and not inferior to the others" [Letter 580]. Whatever may be said about the connection between his calling as an artist and his psychic conflicts, it remains true that for van Gogh painting was an act of high intelligence which enabled him to forestall the oncoming collapse. In his own words, he "knew well what he wanted." The psychiatrist and philosopher, Jaspers, in a book on great schizophrenic artists, in which he examines the lives of Hölderlin, Strinberg, and van Gogh, observes as a peculiarity of van Gogh "his sovereign attitude to his illness," his constant self-observation and effort of control.[2] The painter, more than the others, wished to understand his own state. With a rare lucidity he

[2] [*Strindberg und Van Gogh*; see Jarsper's article included in this volume.—Ed.] The psychosis of van Gogh . . . is still obscure, and some medical investigators regard it as an epileptic process rather than schizophrenia.

watched his behavior to foresee the attacks and to take precautions against them, until in the end his despair destroyed him.

If van Gogh derived from internal conflicts the energies and interests that animate his work (and perhaps certain original structures of the forms), its qualities depend as much on his resistance to disintegration. Among these qualities one of the most essential was his attachment to the object, his personal realism. I do not mean realism in the repugnant, narrow sense that it has acquired today, and that is too lightly called photographic—photography has also a deeper expressive side in its fascinating revelation of things—but rather the sentiment that external reality is an object of strong desire or need, as a possession and potential means of fulfillment of the striving human being, and is therefore the necessary ground of art. When van Gogh describes his paintings, he names the objects and their local colors as inseparable substances and properties, unlike an Impressionist painter who might be more acutely observant but would be less concerned with the object and would, on the contrary, welcome its dissolution in an atmosphere that carries something of the mood of revery without desire, as if a primordial separateness of man and the neutral things around him had been overcome through their common immersion in a passive state called sensation. For van Gogh the object was the symbol and guarantee of sanity. He speaks somewhere of the "reassuring, familiar look of things"; and in another letter: "Personally, I love things that are real, things that are possible . . ." "I'm terrified of getting away from the possible . . ." The strong dark lines that he draws around trees, houses, and faces, establish their existence and peculiarity with a conviction unknown to previous art. Struggling against the perspective that diminishes an individual object before his eyes, he renders it larger than life. The loading of the pigment is in part a reflex of this attitude, a frantic effort to preserve in the image of things their tangible matter and to create something equally solid and concrete on the canvas. Personality itself is an object, since he is filled with an unquenchable love for the human being as a separate substance and another self; he is able then to paint himself and others as complete, subsistent objects and through such paintings to experience their firmness and sure presence and to possess them. That is why, standing before the ominous sky and wheat field, with the oncoming crows, he is able to paint not only this sadness and solitude, but also the health and strength that reality alone can give him.

Yet can it give these to him? we must ask. Or is this a desperate effort to obtain from the landscape what it no longer possesses? Is van Gogh perhaps the last great painter of reality and the precursor of an antiobjective art because his earnest attempt to integrate himself through the representation of things is hopeless? Is this the crucial personal failure, the tragic artistic success for which he pays with his life? We

have seen how his devoted vision of the exterior world is disturbed by emotionally charged forms which subvert the perspective relations, how the convergence towards the horizon through which the whole space normally appears ordered with respect to the fixed gaze of the beholder, is confused by divergences and complexities arising from stresses within the artist which resist this harmony, this pre-established co-ordinating system in the glance. Nature is now foreign to man, its highest conscious-ness and reflector. It has ceased to be a model of inner harmony and strength. From this time on external reality will no longer offer artists "healthful and strengthening" objects of love, only random elements for dreams or aesthetic manipulation.

But dreams are just what van Gogh avoided as the paths to in-sanity. "To think, not to dream, is our duty," he wrote. To his friend Bernard, who described to him his new religious pictures inspired by medieval Christianity, the former theological student and missionary replied that such an attempt in our age was an impossible evasion: "It's an enchanted territory, old man, and one quickly finds oneself up against a wall" [Letter B21]; only the reality of our time could provide the ground of art and human satisfaction. But he himself could not survive on this ground. It implied faith in a social order of which he percevied the injustice and cruelty and growing chaos. At this moment already to artists of insight, "reality" meant for the most part the things that constrain or destroy us. Vincent observed that under modern conditions artists were bound to be somewhat crazy; "perhaps some day everyone will have neurosis" [Letter 574]. Without irony he opposed to Bernard's painting of the *Garden of Gethsemane* his own picture of the garden of the hospital where he was confined. He would not turn to an inner world of fantasy that might console him, since he knew that for him-self that surely meant madness. Towards the end he was drawn at times to religious fancies, but fought them off as unhealthy. The figure of the human Christ still attracted him. If he wrote of God as an artist whose one great creation, the world, was "a study that didn't come off" [Letter 490], he revered Christ as the supreme artist, "more of an artist than all the others, disdaining marble and clay and color, working in the living flesh" [Letter B8]. But the few Christian themes that he painted while in the asylum were, without exception, copied from prints after other artists, and were significantly images of pathos, like the Good Samaritan and the Dead Christ. His sincerity, requiring always faithful-ness to direct experience, kept him from inventing religious pictures. When inspired by the vision of the *Starry Night* [Fig. 22], he put into his painting of the sky the exaltation of his desire for a mystical union and release, but no theology, no allegories of the divine. He had written to Theo some time before, after describing his plan to do difficult scenes from life: "That does not keep me from having a terrible need of— shall I say the word—of religion. Then I go out at night to paint the

stars" [Letter 543]. There is, however, in the gigantic coiling nebula and in the strangely luminous crescent—an anomalous complex of moon and sun and earth shadow, locked in an eclipse—a possible unconscious reminiscence of the apocalyptic theme of the woman in pain of birth, girded with the sun and moon and crowned with the stars, whose new-born child is threatened by the dragon (Revelations 12, 1 ff.).[3] What submerged feelings and memories underlie this work is hinted also by the church spire in the foreground, Northern in its steepness and acuity, a spire which in the earlier drawing [F 1540] is lost in the profusion of writhing vertical trees—the monotony of uncontrolled emotion—but is disengaged in the final work where a pictorial intelligence, in clarifying the form, strengthens also the expression of feeling.

This painting is the limit of Vincent's attempt to go beyond the overtness of everyday objects, and it is, interestingly enough, an experience of the Provencal night sky, an image of the actual place and moment of religious incitation to his lonely soul. Here, in contradiction of his avowed principles and in spite of his fear of the vague, the mystical, and the passive surrender to God, he allows a freer rein to fantasy and hitherto repressed trends of feeling. Yet his vision remains anchored to the ground of the given, the common spatial world that he has lived with his own eyes. Thus even in this exceptional work of a spontaneous religious tendency we discern the tenaciousness of his objective spirit.

In the same way his effusive color symbolism—the "heartbreak-ing" malachite green or the deeper green which represents the "terrible passions of mankind" [Letter 533] and the intense blue background which would evoke infinity in the portrait of an artist-friend whom he loves—all this concerns the qualities of particular visible objects and his feelings about them.

But his interest in symbolic coloring is already a shift in attitude. Togther with it he resolves to paint less accurately, to forget perspective and to apply color in a more emphatic, emotional way. In this change which is legible in certain pictures and letters of the summer of 1888, I think we shall not be wrong in seeing a suggestion from the Paris milieu which Vincent had come to know the year before and with which he maintained his intimacy by correspondence all through 1888, especially with Gauguin and Bernard, the leaders of the new trend of

[3] A student of mine, Richard Held, has pointed out the unnatural character of the moon. He observed that van Gogh, in describing a previous painting of the night sky [F 683/H 695] in a letter to Gauguin [Letter 643], speaks of the moon crescent as emerging from the earth shadow. But no lunar eclipse was visible in France in the years around 1888. It is therefore possible that the artist, who might have read of such an eclipse, has confused it with the explanation of the phases of the moon. Mr. Held has suggested further that the relation of moon, earth shadow, and sun in this painting symbolizes unconsciously a family—father, mother, and child—whence my own comparison with the apocalyptic incident, which is often represented with great splendor in the Middle Ages and identified with an eclipse.

Symbolism in painting. Vincent was a deeply receptive man, eager always for friendship and collaboration; while in Arles, far from his friends, he constantly stirred in his mind common projects which would reunite him with these Parisian friends. In the letter to Theo expressing his Symbolist ideas about color he attributes them to Delacroix [Letter 520]; we can scarcely doubt that they are more recent and represent the viewpoint of the young *avant-garde* in Paris. If, in the following year, he criticizes Bernard severely for his religious paintings, Vincent in that same summer undertakes several himself, not so much to emulate Bernard and Gauguin—we have seen that his religious pictures are copies—but out of sympathy and brotherliness and a desire to share their problems. Yet these impulses toward religious themes are momentary and slight deflections. There is an inner growth in his art, so closely bound to his state of mind and the working out of his interior conflicts, so compulsive in its inventions, that he seems to originate Symbolism and Expressionism entirely from within, apart from all that is going on around him. Most likely he could not have formed his art without the spur of his Parisian experience and the contact with men whose congenial spiritual independence was joined to an attitude of artistic innovation, such as he had not suspected before he met them. He retained, however, to the end the fidelity to the world of objects and human beings that he had sworn at the beginning of his studies. The pictures of his last months, no matter how fantastic certain of their forms may appear, are among the most penetrating in their vision of things, their reality. His self-portrait, with the swirling, flamboyant lines of the background [F 627/H 748]—one of the most advanced works of his time in the approach to an abstract Expressionism—is also a marvel of precise portraiture, with an uncanny liveness of the features. He had given his answer once and for all to Bernard in [late] 1889, when most tormented by conflicting impulses: "Above all it's really a question of sinking oneself anew in reality with no preconceived plan and none of the Parisian prejudices" [Letter B21].

When the self at the edge of destruction holds on to objects so persistently, its protective reaction permits us to see that the painter's attachment to things is not passive or photographic, nor due simply to his origin in a period of naturalistic art, but is a constructive function with deep emotional roots. When he comes as a foreigner to Arles, a strange town, he paints everything—day and night scenes, people, children, whole families, houses, cafés, streets, his own room, and the surrounding country—as if to enter completely into this new milieu, unlike an Impressionist, who in painting at a resort or country site gives us little sense of material things and people. Even van Gogh's choice of still-life objects, however trivial or incidental they may seem, is hardly indifferent; they constitute for him an intimate and necessary world. He needs objectivity, the most humble and obvious kind, as others

need angels and God or pure forms; friendly faces, the unproblematic things he sees about him, the flowers and roads and fields, his shoes, his chair and hat and pipe, the utensils on his table, are his personal objects, which come forward and address him. Extensions of his being, they image the qualities and conditions necessary for his health of mind. We may quote here what he said in another context: "It sounds rather crude, but it is perfectly true: the feeling for the things themselves, for reality, is more important than the feeling for pictures; at least it is more fertile and vital."

We understand then why he called imaginative painting "abstraction," although it was still an imagery of living forms, and why, on the other hand, the *Crows in the Wheatfield* for all its abstractness of composition represents with a tormented veracity an experienced landscape. But it is also a moment of crisis in which contrary impulses away from reality assert themselves with a wild throb of feeling. There is in the picture of the *Crows* something of the mood of the *Starry Night*. In its dark pulsating sky the great motor-storm of brush work and the green round spots over the horizon are like the animated clouds and stars of the night painting. After we have seen in the latter its startling, transfigured sky and have felt the pantheistic rapture stirring the immense bluish space with an overpowering turbid emotion, we are prepared to recognize in the later work the traces of a similar yearning. The endless sky of the *Crows* appears to us then an image of totality, as if responding to an hysterical desire to be swallowed up and to lose the self in a vastness. In the abnormal format there is already a submersion of the will. The prevailing horizontal is a quality of the mood more than of the frame or canvas; it has the distinctness and intensity of the blue and belongs to the deeper levels of the work. It is not required by a multiplicity of panoramic objects or a succession in breadth. In the common proportioning of pictures, approximating the golden section (0.618:1), the larger dimension has to contend with a strong subordinate, so that the relation of self and world, expressed in the contrast, is an opposition in which both elements are active and distinct. This is classical in spirit and corresponds to the accepted notion of the harmonious and normal in our own society. In van Gogh's spontaneous, unconventional format, the horizontal governs the space as an enormous dominant beside which the perpendicular hardly comes into being and is without an echo in the composition. (A similar one-sidedness, but ruled by the vertical, occurs in the *Road with Cypress* [F 683/H 695], which includes a star and moon radiating like two suns, an obsessive image of uncontainable excitement.) In his earlier landscapes the convergent lines in depth, intensifying the motion inward, gave a certain energy to the perspective flight; here the endless depth has been transposed into a sheer extension that exceeds the individual's glance and finally absorbs him.

Biographical Data

1853	Born 30 March in Zundert, North Brabant The Netherlands. Eldest surviving son of a Dutch Reformed minister.
1857	Birth of his brother Theodore.
1864–66	Earliest known drawings executed while at boarding school in Zevenbergen.
1869	Enters the art firm of Goupil in The Hague through family connections.
1871	Family moves to Helvoirt.
1872	Correspondence begins with Theo, who was away at school.
1873	Theo joins firm of Goupil in Brussels and Vincent is stationed in London in June. Falls in love with Ursula Loyer, his landlady's daughter.
1874	After failure in the courtship of Ursula and a visit to Holland (more drawings) spends October–December with head office of Goupil in Paris and then returns to London.
1875	In May transferred, against his wishes, to Goupil in Paris. Consuming interest in the Bible. The van Gogh family moves to the vicarage in Etten in October.
1876	Dismissed from Goupil in March. Acquires an etching of *The Angelus* after Millet. Assistant teaching post in Ramsgate, England, in April, and in July becomes assistant teacher-curate in Isleworth, near London. Returns to Etten in December.
1877	Clerk in bookstore at Dordrecht, January–April. Leaves in May for Amsterdam and stays with his uncle Jan, commandant of the naval yard, undergoing private instruction in preparation for university study and a career in the ministry.
1878	Gives up his studies in July and returns to Etten. In August admitted for a three-month period at a school of evangelism in Brussels, but fails to obtain a post as minister. Departs for the coal-mining area near Mons, known as the Borinage, and teaches the Bible to the poor.

1879 In January, begins work as missionary for six months in Wasmes. Period of relative contentment ends with dismissal by the Church Council Committee because of his excessive zeal. Reads much, especially Dickens, Harriet Beecher Stowe, Victor Hugo, Shakespeare, and Michelet. Admires the art of Charles de Groux, Rembrandt, Ruisdael, the Barbizon school, and the Hague school. A period of itineracy in Belgium.

1880 Extended period of estrangement from his family. Travels in spring to Cuesmes where he lives with a mining family. Begins to draw with serious professional intentions, copying works of Millet. Moves in October to Brussels where he studies perspective and anatomy on his own. Financially supported by Theo.

1881 Leaves Brussels in April again to live in Etten. Unsuccessful courtship of his cousin Kee Vos, a widow. In December leaves after family quarrel for The Hague.

1882 Studies briefly with Anton Mauve, a cousin by marriage. Begins living with the pregnant and abandoned Clasina ("Sien") Maria Hoornik. In August the van Gogh family moves from Etten to Nuenen, near Eindhoven. Collects English newspaper illustrations and executes numerous drawings and watercolors of figural studies and landscapes.

1883 In September breaks with Sien and leaves The Hague. Works alone in the Province of Drenthe, now beginning to use the oil medium extensively. In December rejoins the family in Nuenen.

1884 Produces watercolors and painted studies of the weavers. Strained relationship with his father and close friendship with the Dutch painter Anton Ridder van Rappard (1858–92). In June reads about the color theories of Eugène Delacroix.

1885 Paints approximately fifty heads of peasants in preparation for the *Potato Eaters*, Figure 2. Father dies suddenly in March. Deeply moved by Emile Zola's *Germinal* and by other Realist authors. Leaves in November for Antwerp, where he visits the museums, admires Rubens, and acquires some Japanese prints.

1886 January–March, studies at Antwerp Academy, then leaves for Paris where he lives with Theo and studies for several months at the Cormon studio. Paints flower pieces under influence of Delacroix and Monticelli. Tentative approach to French Impressionism.

1887 Palette becomes progressively brighter as contacts with contemporary French art movements increase. Collects and exhibits Japanese prints. Twice exhibits own work on the walls of working-class café-restaurants.

1888 Leaves in February for Arles in Provence, where in May he rents the Yellow House on the place Lamartine. Visits Saintes-Maries de la Mer in the Camargue in June. Joined by Gau-

guin on October 20. In late December mutilates ear during a mental crisis. Gauguin departs for Paris.

1889 Remains in Arles, alternately staying at the mental hospital and the Yellow House, until May when he voluntarily enters the hospital at nearby St. Rémy. (Theo had married Johanna Bonger in April.) Visited by the painter Paul Signac. Despite recurrences of his illness paints profusely, especially landscapes.

1890 Begins year with copies after Delacroix, Millet, Rembrandt, and Gustave Doré. Son born to Theo and Johanna in January. Albert Aurier publishes his article on Vincent. In May leaves the hospital, and, after a brief stopover in Paris, settles in Auvers-sur-Oise under the surveillance of Dr. Paul Gachet, Figure 23. Despite his unremitting capacity for work, shoots himself on July 27 and dies two days later. Theo, profoundly distressed by Vincent's death, falls ill and dies in Utrecht, the Netherlands, January 25, 1891. Later Theo's remains are placed beside those of Vincent in the cemetery of Auvers.

Notes on the Editor and Contributors

Bogomila M. Welsh-Ovcharov (1940–). Born Sofia, Bulgaria, spent early childhood in Germany. 1949 to Canada; 1964 B.A. in Fine Art, University of Toronto. 1965–66 at Sorbonne, Paris. In 1966 married the art historian Robert P. Welsh. 1971 received PhilM in History of Art from U. of Toronto. Publications: *Angrand and Van Gogh* (1971) and *Vincent van Gogh in Paris* (PhD diss. for Utrecht University, in preparation).

Albert Aurier (1865–1892). French poet and Symbolist critic. Although trained in law, in late 1880s began writing for Paris art journals. Instrumental in founding and editing the *Mercure de France* and *Essai d'Art Libre*. While in the process of developing a Symbolist theory of art, died prematurely. His publications are collected in *Oeuvres Posthumes* (1893).

Kurt Badt (1890–). German art historian. Following two decades of independent research, lived in London between 1939 and 1952 where he was associated with the Warburg Institute, University of London, before returning to Germany. Publications: PhD diss. on Andrea Solario (1914), *Eugène Delacroix, Drawings* (1946), *John Constable's Clouds* (1950), and *The Art of Cézanne* (1965; German ed., 1956).

Emile Bernard (1868–1941). Born in Lille. Associated with the birth of the Symbolist movement in painting. Dispute with Gauguin circa 1891 over who had founded "the Pont-Aven school". Departed Paris 1893, spending ten years in Egypt. Published much art criticism, founding in 1905 the art review *La Rénovation Esthétique*.

Jan Bialostocki (1921–). Polish art historian. Since 1962, professor at the University of Warsaw. Also assistant director, National Gallery, Warsaw. Publications: *Spätmittelalter und Beginnende Neuzeit* (1972) and, in Polish, studies on Dürer and art theory (both in 1959), theory and creativity (1961) and art and humanistic thought (1966). Also the following museum catalogues: *Europäische Malerei in Polnischen Sammlungen: 1300–1800* (1957, with M. Walicki; Polish ed., 1956), *Les Musées de Pologne* in series *Les*

Primitifs Flammands (1966), and *Catalogue of Paintings; Foreign Schools* (Nat. Gal., Warsaw, 1969).

H. P. Bremmer (1871–1956). Dutch artist and critic and the art advisor to Mrs. Helene Kröller-Müller. Publications: *Een Inleiding tot het Zien van Beeldende Kunst* (1906) and *Practisch Aesthetische Studies* (1909). Founded the periodical *Beeldende Kunst* in 1914.

Douglas Cooper (1911–). English art historian and critic. Has taught at the universities of Cambridge, London, and Bryn Mawr. Publications: *Fernand Léger et le Nouveau Espace* (1949, with text in French and English), *Henri de Toulouse-Lautrec* (1952, in English), *The Courtauld Collection* (1954), *Pablo Picasso: Les Déjeuners* (1963; French ed., 1962), *Picasso: Theatre* (1968; French ed., 1967), and *The Cubist Epoch* (1971).

Maurice Denis (1870–1943). Artist and art theoretician. In 1888 attended the Académie Julien and the Ecole des Beaux–Arts, Paris. 1890 outlined the Nabi aesthetic in "Définition du Néo-Traditionnisme" for *Art et Critique*. 1901 began writing for *L'Occident;* 1908 taught at the Académie Ranson. His early art credo is found in *Théories: 1890–1910* (1912) and *Journal, Volume 1: 1884–1904* (1957).

Frederik van Eeden (1860–1932). Dutch poet, writer, and playwright. Also a trained doctor and founder in 1887 of a psychotherapeutic clinic in Amsterdam. A member of the Realist literary group known as the "men of the eighties," whose *De Kleine Johannes* (1885), however, already anticipated Symbolist tendencies. Became acquainted with Vincent's work upon being called to Paris to treat Theo (1890). Later a Socialist reformer and founder of the utopian colony Walden near Laren (1898–1907).

Henri Focillon (1881–1943). French art historian. Professor at the university and director of the museums in Lyon. In 1925 professor of medieval art at the Sorbonne, Paris. From 1939 until death taught at Yale University. Publications: PhD diss. on G. B. Piranesi (1918), *The Life of Forms in Art* (1942, rev. ed. 1948; French ed., 1934), and *The Art of the West in the Middle Ages*, 2 vols. (1963; French ed., 1938).

Roger Fry (1866–1934). English artist, aesthetician, editor, and critic. At first interested in Renaissance area. Curator, the Metropolitan Museum, New York (1905–10). Publications: *Vision and Design* (1920), *Transformations* (1926), *Cézanne: A Study of His Development* (1927), and *Last Lectures* (1939).

Paul Gauguin (1848–1903). Although not a professional writer or critic, the great Post-Impressionist painter and sculptor began in the late 1880s to codify his thinking in a series of interrelated manuscripts. These were, in approximate sequence of writing dates: *Ancien Culte Mahorie* (1892–93), *Cahier pour Aline* (1893), *Noa Noa* (with Charles Morice, 1897), and *Avant et Après* (datelined Atuana, 1903).

François Gauzi (1861–1933). Born Toulouse, France. A poet, painter and very close friend of Henri de Toulouse-Lautrec. His memoirs of Toulouse-

Lautrec were published posthumously in 1954 as *Lautrec et son Temps*. Left a number of paintings by Toulouse-Lautrec to the Musée des Augustins, Toulouse, France.

J. G. van Gelder (1903–). Dutch art scholar. Curator, Boymans Museum, Rotterdam (1936–40). Director, Rijksbureau voor Kunsthistorische Documentatie (1940–46) and Mauritshuis Museum (1945–46), The Hague. 1946 professor and 1973 professor emeritus, Utrecht University. Publications: PhD diss. on Jan van de Velde (1933, in Dutch), "Introduction" to *Catalogue . . . of Dutch and Flemish Still Life Pictures . . .* , Ashmolean Museum (1950), *Dutch Drawings and Prints* (1959), and "Jan de Bisschop" in *Oud Holland* (1971, in English). Commission member for the revision of de la Faille, *The Works of Vincent van Gogh*.

Pierre Godet (1876–1951). Swiss artist, critic, and historian. Between 1902 and 1922 private instructor in the history of art and 1925–47 professor of the history of philosophy, University of Neuchâtel. Editor, *L'Art Décoratif* of Paris (1911–12). Publications: *La Pensée de Schopenhauer* (1918) and *Hodler* (1921, in French).

Johanna van Gogh-Bonger (1863–1925). Studied English literature. Worked briefly in the library of the British Museum, London. Taught English in secondary schools in the Netherlands. Through her brother, Andries Bonger, met Theo van Gogh, whom she married in the spring of 1889. After Theo's death spent many years editing the correspondence of Vincent to Theo (published 1914). Translated into English all of the letters written in Dutch and a portion of those written in French.

A. M. Hammacher (1897–). Dutch art historian and former director, the Kröller-Müller Museum. Publications: *Amsterdamsche Impressionisten en hun Kring* (1941), *Jacques Lipchitz: His Sculpture* (1961; Dutch ed., 1960), *Le Monde de Henry van de Velde* (1967; simultaneous eds. in German and Dutch), *The Sculpture of Barbara Hepworth* (1968), *The Evolution of Modern Sculpture* (1969), and *Marino Marini: Sculpture, Painting, Drawing* (1970). Commission member for the revision of de la Faille, *The Works of Vincent van Gogh*.

A. S. Hartrick (1864–1950). Scottish painter and illustrator. Studied under the academic painter A. Legros at the Slade School, London, 1884–85. In Paris worked at Academie Julian and the atelier of Cormon (1886). Exhibited at official Paris Salon in 1887. Was associated with the Glasgow School of Art.

Sven Hedenberg (1888–1966). Swedish psychiatrist who has published studies on misinterpretations in psychiatry (1930), the Roman emperor Tiberius (1930), schizophrenia (1934), and Strindberg (1961).

Karl Jaspers (1883–1969). German psychiatrist and professor at Heidelberg University from 1921. Apart from medical texts, he has published studies on existentialism (1937), Descartes (1937), Nietzsche and Christianity (1952), and Leonardo da Vinci as philosopher (1953).

Gerard Kraus (1898–1956). Dutch psychiatrist. Director, Meerenberg Hospital, Haarlem (1927–31). From 1950 professor, Groningen University.

His publications include studies on the forming and deformation of human personality (1950) and the relationship of Vincent and Theo van Gogh (1954).

Julien Leclercq (1865–1901). French writer and art critic. Collaborated with A. Aurier for the journals *La Pleiade*, *Le Moderniste*, and *Mercure de France*. In articles of 1891 and 1894 favored Gauguin and other Symbolists over the Neo-Impressionists. In 1898 ensured that van Gogh was represented at an exhibition in Stockholm. Died in 1901 shortly after having organized the van Gogh retrospective exhibition at the Bernheim Jeune Gallery, Paris.

Johan de Meester (1860–1931). Dutch journalist, novelist, and literary critic. Between 1886 and 1891 Paris correspondent for the Amsterdam newspaper, *Algemeen Handelsblad;* met both Vincent and Theo. Art editor of the *Nieuwe Rotterdamse Courant* from 1891.

Julius A. Meier-Graefe (1867–1935). German art dealer, aesthetician, lecturer, and art critic. Late 1890s favored the Art Nouveau style at his shop La Maison Moderne, Paris. His publications include studies on Böcklin (1905), Corot (1913), Delacroix (1913), Courbet (1921) and Vincent as draftsman (1928).

Francoise Minkowska (1882–1950). Born in Moscow of Polish descent. Studied psychiatry under Eugène Bleuler in Zürich and practiced in Paris. Her major publications include studies on inheritance of epilepsy and schizophrenia (1937) and Rorschach systems (posthumously in 1956).

Octave Mirbeau (1848–1917). French novelist and art critic. Friend of Monet and Emile Zola. Sympathetic to anarchism. In 1891 was converted to an antinaturalistic outlook and produced sympathetic articles on Gauguin and van Gogh. His art criticism was collected in *Des Artistes*, 2 vols. (1922 and 1924).

Carl A. J. Nordenfalk (1907–). Swedish art historian and medievalist. 1958–69 director, the National Museum of Fine Arts, Stockholm. 1969–71 at the Institute for Advanced Study, Princeton, and since 1972 Mellon Professor, University of Pittsburgh. Publications: *Early Medieval Painting from the Fourth to the Eleventh Century* (1957, with A. Grabar), *Romanesque Painting from the Eleventh to the Thirteenth Century* (1958, with A. Grabar), and *Die Spätantiken Zierbuchstaben*, 2 vols. (1970).

Fritz Novotny (1903–). Austrian art historian. Former director, Austrian Gallery, Vienna, and now professor at the University of Vienna. Publications: *Cézanne und das Ende der Wissenschaftlichen Perspective* (1938), *Painting and Sculpture in Europe: 1780 to 1880* (1960) and *Gustav Klimt Do Kumentation* (1969, with J. Dobei).

Meyer Schapiro (1904–). American art historian and medievalist. Born Lithuania. In 1928 joined faculty of Columbia University (since 1952 professor). Publications: (in field of modern art) *Vincent van Gogh* (1950), *Paul Cézanne* (1952), and pioneering early articles on "Seurat and *La Grande Jatte*" (1935), "On the Nature of Abstract Art" (1937), and "Courbet and Popular Imagery" (1941).

Jean J. Seznec (1905–). French art and literary historian. Has held teaching posts at Cambridge (England), Marseille, Florence, and Harvard universities; since 1950 professor of French literature at Oxford. Publications: *The Survival of the Pagan Gods* (1953; French ed., 1939), *Essais sur Diderot et l'Antiquité* (1957) and two studies of Flaubert's *La Tentation de Saint Antoine* (1940 and 1949, both in French).

A Selected Bibliography

THE OEUVRE AND THE CORRESPONDENCE

BARR, ALFRED H., JR., *Vincent van Gogh*. 1935. Reprint, New York: The Museum of Modern Art, Arno Press, 1966. This exhibition catalogue contains an important van Gogh bibliography compiled by C. M. Brooks, Jr., in 1942.

DE LA FAILLE, J.-B., *The Works of Vincent van Gogh: His paintings and Drawings*, revised by a commission of Dutch scholars. Amsterdam: Meulenhoff International, 1970.

GANS, L., F. GRIBLING, A. M. HAMMACHER and R. W. D. OXENAAR, *Vincent van Gogh Catalogue*, 3rd ed. Otterlo, the Netherlands: State Museum Kröller-Müller, 1970. In English.

VAN GOGH, VINCENT WILLEM, *The Complete Letters of Vincent Van Gogh*. 3 vols. Greenwich, Connecticut: New York Graphic Society, 1958. Includes much additional documentation as well as reproductions of sketches from the correspondence.

VAN GOGH, VINCENT WILLEM, *Verzamelde Brieven van Vincent Van Gogh*, 4th ed. (4 vols. bound in 2). Amsterdam-Antwerp: Wereld-Bibliotheek, 1955. The complete correspondence of Vincent in the original languages.

BOOKS ABOUT VINCENT

COOPER, DOUGLAS, *Drawings and Watercolours by Vincent van Gogh*. New York: The Macmillan Company, 1955.

HAMMACHER, A. M., *Genius and Disaster: The Ten Creative Years of Vincent van Gogh*. New York: Harry N. Abrams, Inc., 1969.

LEYMARIE, JEAN, *Van Gogh*. Paris: Pierre Tisné, 1951. In French.

LÖVGREN, SVEN, *The Genesis of Modernism—Seurat, Gauguin, Van Gogh and*

French Symbolism in the 1880's, rev. ed. Bloomington: Indiana Universit
Press, 1971.

NORDENFALK, CARL, *The Life and Work of Van Gogh.* New York: Philosophic
Library, Inc., 1953.

REWALD, JOHN, *Post-Impressionism from Van Gogh to Gauguin,* 2d ed. Nev
York: The Museum of Modern Art, 1962.

ROSKILL, MARK, *Van Gogh, Gauguin and the Impressionist Circle.* London
Thames and Hudson, 1970.

SCHAPIRO, MEYER, *Vincent van Gogh.* New York: Harry N. Abrams, Inc., 1950

TRALBAUT, M. E., *Vincent van Gogh.* New York: The Viking Press, Inc., 1969